Dramaturgy

Dramaturgy

An Introduction

Cock Dieleman
Ricarda Franzen
Veronika Zangl
Henk Danner

Amsterdam University Press

Originally published as: *Inleiding in de dramaturgie*. Cock Dieleman, Ricarda Franzen, Veronika Zangl, Henk Danner. Amsterdam University Press, 2020

Cover design: Suzan Beijer
Lay-out: Crius Group, Hulshout

ISBN 978 94 6372 496 8
e-ISBN 978 90 4855 464 5
DOI 10.5117/9789463724968
NUR 677

Table of Contents

Introduction

For the past decade or so, dramaturgy has attracted a lot of attention: as a process; as a profession; and as a focus of academic research. This holds particularly true for the Anglo-Saxon part of the world. The emergence of numerous publications on the subject indicates an increasing awareness of dramaturgy in these countries, both in the academic and in the professional field of theatre and performance. However, in the theatre of continental Europe, including Dutch and Flemish theatre, dramaturgy and the profession of the dramaturg have been widely accepted for some time. As teachers within the Theatre Studies department of the University of Amsterdam, and particularly as teachers of the International Dramaturgy Master's programme, we find it important to share our knowledge on this topic, with a special focus on Dutch and Flemish theatre. The field of Dutch and Flemish theatre may not be very large in comparison to that of their surrounding countries, but it is extremely diverse, has an international reputation, and dramaturgy is an intrinsic part of it. Over the past fifteen years, dozens of students have graduated from our (International) Dramaturgy Master's programme, which teaches the subject from both a professional and an academic perspective. Many of these graduates work in the field as professional dramaturgs; in text-based theatre as well as music theatre, mime, youth theatre, and dance. In this book, we bring together the insights that we have assembled during our time teaching Bachelor's and Master's students.

Dramaturgy, understood as the intellectual labour performed while producing theatre performances, has a long history, particularly in German-speaking countries and the German-speaking academic world. Originally, dramaturgy involved focusing on the meaning of the drama text and therefore the dramaturg was both a literary advisor and someone who was able to determine and explain the meaning of the text. But in contemporary theatre, the role of text has changed significantly. It is no longer the all-important layer of meaning, the starting point and guiding principle that determines every part of the performance. Theatre makers nowadays use all kinds of other texts that were not necessarily written to be performed in the theatre. Images, sounds, music, and bodily expressions have become increasingly important. In this process, the rational composition of performance gave way to a more associative approach, which facilitates the composition of a performance from the different elements that theatre has to offer, and that the theatre maker may use. For the spectator, these combined elements generate a theatre event in which the sensory experience

has become more important than merely an understanding of what is shown. Therefore, although most dramaturgs are very good at selecting, adapting, and analysing texts, text is no longer the self-evident layer of meaning that they work from.

Because of this development, the meaning of the term dramaturgy has also changed. It has become broader, pushing forward the boundaries of what dramaturgy entails. Consequently, it is not possible to define and exact meaning of the term in this introduction. To put it more strongly, it is neither our goal, nor our ambition to come to an exact definition in this book. Since dramaturgy today may be, perhaps even has to be, concerned with all aspects of performance, trying to define the term would be a non-committal and meaningless endeavour. Hence we have given this book the somewhat unambitious title *Dramaturgy. An Introduction.* It is not our intention to explain precisely what dramaturgy entails, but rather to point out how broad the term actually is, focusing on the consequences of this infiniteness for dramaturgs and theatre makers. We make use of alternating perspectives to do so.

Although, at the beginning of our endeavours, we spoke about the possibility of a 'handbook', after some time we realised that it is impossible to write a handbook on dramaturgy nowadays. Authors writing a handbook try to capture, establish, and preserve something for the long term. The dramaturgy of today is too comprehensive to be defined in such a way; it is also highly dependent on the particular approach of individual theatre makers. Moreover, to write a handbook on dramaturgy would necessarily entail not only all kinds of methodological tools, but also the inclusion of the whole history of theatre and highlights from dramatic literature, not to mention the history of music, visual arts, film, and philosophy. This book is neither a handbook on dramaturgy, nor a manual for future dramaturgs. Surely, each dramaturg will fill their role in a different manner, depending on ambitions, personality, strengths, weaknesses, and, above all, the theatre makers that they work with. Therefore, the question of whether a dramaturg is a theatre maker, cannot be answered. This also depends on the dramaturg themself and the production team that they are part of.

Instead of trying to define and establish the term, we want to raise questions and emphasise the diverse, fluid, and process-oriented nature of dramaturgy. In Chapter 1, we will further investigate the scope and historical roots of dramaturgy; in Chapter 2, we focus on the material, texts, and other sources that theatre makers work with; Chapter 3 is dedicated to process, including the performance itself; finally, Chapter 4 looks at theatre and dramaturgy from the spectator's perspective. Under the headings of

scope, material, process, and spectatorship, we assemble different aspects of dramaturgy, but these can never be exhaustive. In a way, this book reflects the expertise of its four authors. Fortunately, these are supplementary to one another. They are not only academic, but also reflect practical experiences in different aspects of dramaturgy, such as auditive dramaturgy, scenography, and theatre education. With this supplementary expertise and experience as a starting point we had lengthy discussions on the essence and scope of dramaturgy, on the different ways to teach dramaturgy to students, and on the possible content of this book. This ultimately led to the current publication, the content of which we all endorse, but in which the reader, from time to time, may still detect our separate voices.

As previously mentioned, the University of Amsterdam offers a professional and academic Master's programme on International Dramaturgy, but already in the Theatre Studies Bachelor's programme, dramaturgy is one of the learning trajectories, combining theory with practice. In that trajectory, we emphasise that dramaturgy is essentially different from academia, but also that the two are closely related. If academia is dedicated to collecting and organising knowledge, dramaturgy is directed towards applying this knowledge in theatre practice. Therefore, for a dramaturg, knowledge, not only of theatre, but also of philosophy, literature, visual arts, film, and music is imperative. A dramaturg should also have developed the skills to analyse and examine texts, images, sounds, and music. On the other hand, dramaturgy is not exclusive to the dramaturg. All theatre makers think about the composition and meaning of the performance and therefore all theatre makers are involved in the process of dramaturgy, although they may not recognise and define their work as such and often lack the input of a dramaturg as a central role in the process. One of the main reasons for writing this book is to make more people familiar with the meaning and the process of dramaturgy. It is intended for theatre students in secondary and higher education, but also for directors, scenographers, actors, and even people who are not professionally involved but merely interested in the world of theatre.

Most books on dramaturgy presume a certain knowledge of the current field of theatre, of the history of theatre, and of a canon of drama texts. We do not. We presume no knowledge of Shakespeare's *Hamlet* or Chekhov's *Cherry Orchard*. When we use historic examples or current case studies we always try to explain content and context. We only refer to and elaborate on aspects of theatre history if knowledge thereof is essential for understanding certain aspects of current dramaturgical practices. We assume that our readers are not only future dramaturgs and theatre makers, but also people

that are more generally interested in current developments in theatre and performance. This perspective of the curious reader is very important to us. It is not our intention to deliver a package of knowledge, understandings, and beliefs. On the contrary, we always try to place ourselves in the position of the curious reader. Each year, new Bachelor's students arrive, and Dramaturgy is one of the first courses they study. We know their enthusiasm and their yearning for knowledge and experience, and kept this in mind when writing this book. Our starting point was a desire to feed this enthusiasm, rather than delivering certain convictions or (political) messages. In saying this, we also recognise that no text on theatre and dramaturgy can be neutral, objective, and value-free.

That we do not presume any prior knowledge from our readers, does not mean that our book takes place in a void. We have read recent books and articles on dramaturgy and used them as material, as sources, not unlike current dramaturgs use existing texts and other sources to develop something new. As previously mentioned, in the last couple of years, much has been written on dramaturgy, predominantly in English. In the Netherlands and Flanders, dramaturgy has also been the topic of numerous articles and books. We, of course, feel indebted to the work of the Flemish dramaturg Marianne van Kerkhoven. Since the 1990s, she has put dramaturgy as a topic and as a profession on the map of Dutch and Flemish theatre. Her main articles are collected in *Van het kijken en van het schrijven* ('About Looking and Writing', 2002), which continues to be an important source of inspiration to us. Partly because of her work, dramaturgs in the Netherlands and Flanders are no longer considered 'fallen bookcases', a Dutch expression referring to bigmouths that get their knowledge solely from books without any practical experience, and therefore lack a sense of reality.

In Chapter 1, we deal with the question of what dramaturgy entails, especially in the Netherlands and Flanders. We look at the historical roots of dramaturgy and the relationship between dramaturgy and academia. In Chapter 2, we focus on what we call 'material'; that is, the content but also the tangibility of the sources that dramaturgs use, and how research and analysis allows us to better understand and work with different kinds of material. This chapter emphasises text as a form of material, because text can be preserved as a medium by itself and may be analysed and interpreted over and over again. Moreover, drama texts and their interpretation have long determined reflection on theatre and dramaturgy, well into the latter part of the twentieth century. Chapter 3 is about the process; namely, how material is transformed into a performance. We zoom in on research and interpretation, on manners of translation, on visual aspects of dramaturgy,

and on auditive aspects of dramaturgy. Finally, Chapter 4 is about audience and spectatorship. For whom do we produce theatre performances, how do we involve and include the audience in the performance, and what is the role of dramaturgy and the dramaturg in this process?

Throughout this book, we use text boxes to highlight certain drama texts and performances as explanatory examples. The highlighted performances also form a good and faithful reflection of different genres and trends in Dutch and Flemish theatre.

With special thanks to: Fanne Boland; Ludo Costongs; Luuk van den Dries; Peter Eversmann; Liesbeth Groot Nibbelink; Lucia van Heteren; Joy Jeunink; Peter van Kraaij; Erik Lint; Hubertus Mayr; Ellen McGrath; Jeroen de Nooijer; Berthe Spoelstra; Klaas Tindemans; Jesse Vanhoeck; and all the colleagues and students with whom we have exchanged thoughts and visions, and who have inspired us to write this book.

Cock Dieleman
Ricarda Franzen
Veronika Zangl
Henk Danner

1. What is dramaturgy?

1.1 Dramaturgy with and without a dramaturg

As mentioned in the introduction, it is very difficult to give a final and conclusive definition of the term dramaturgy. The scope, the fluidity, and the process-oriented nature of dramaturgy make that virtually impossible. Moreover, scope, fluidity, and process orientation have become even greater as time has gone on. The more precisely one tries to define the term, the easier it is to find exceptions. In their book *Dramaturgy and Performance*, Turner and Behrndt describe dramaturgy as 'slippery, elastic and inclusive'[1], affirming that the term is both intangible and comprehensive. Intangibility and comprehensiveness also feature in the various tasks of the dramaturg. Already in 1994 Marianne van Kerkhoven, who is frequently quoted in the Netherlands and Flanders on the meaning and scope of dramaturgy, wrote:

> In artistic practice there are no fixed laws of behaviour, or tasks that can be wholly defined in advance, not even for the dramaturge. *Every production forms its own method of work.* It is precisely through the quality of the *method* used that the work of important artists gains its clarity, by their intuitively knowing – at *every* stage in the process – *what* the next step is. One of the abilities a dramaturge must develop is the flexibility to handle the methods used by artists, while at the same time shaping his/her own way of working.[2]

It is important to emphasise that dramaturgy is not necessarily synonymous with the work of the dramaturg. Many academic and professional books and articles on dramaturgy focus on the work of the dramaturg, implying that dramaturgy is limited to a specific task or person within theatre productions. We would like to stress, however, that dramaturgy is a process involving all theatre practitioners, not only the person of the dramaturg. To take this one step further, we argue that the whole course of a theatre production, from the very beginning until the performance itself (and even the afterlife of the performance) can be defined as a dramaturgical process. We would therefore like to focus on dramaturgy as a process and underline that it can never be reduced to an event, a document, a person, a list of tasks, or even a methodology.

Although artistic processes, including dramaturgy and the work of the dramaturg, are basically unpredictable, this does not mean that structure,

internal logic, and meaning are totally absent in plays and performances. Already in 335 BC, Aristotle wrote about the structure of theatre texts and, more particularly, the structure of a tragedy in his *Poetics*. He described the impact a well-written play could have on an audience and how this effect came about. Many authors, directors, and dramaturgs after Aristotle took his classical writings as a starting point and related to his ideas, even when heading in a totally different direction. Aristotle's *Poetics* thus remains an important cornerstone and benchmark for various ways of thinking about theatre and performance.

In this first chapter, we explore the scope of the term dramaturgy and its historical roots. To do so, we first look into the etymology of the term, i.e. the analysis, origin, and meaning of the word itself. We then briefly examine its historical development, from Aristotle's *Poetics* and its important status in later times, for instance its effect on Lessing's ideas on dramaturgy, as recorded in *Hamburgische Dramaturgie* (1767-1769). As will be explained, Lessing may be called the first true dramaturg. Important dramaturgical milestones after Lessing are the epic theatre of Bertolt Brecht and the dramaturgies from the second half of the twentieth century that Hans-Thies Lehmann described as postdramatic. Postdramatic theatre, literally the theatre after the dramatic theatre, is a collective term for all forms of theatre in which the play text is no longer the most important signifier but is replaced with more associative ways of generating meaning by theatre makers and spectators alike. All elements of theatre, such as acting, movement, space, scenery, lighting, and music make their contribution from an equal position. More generally, one could say that in translating and adapting (text) material to a performance, the focus has shifted from the end result to the transformation process itself. And in that process, the expressive powers of actors, dancers, and performers play a crucial role.

Since we operate mainly in the Dutch-speaking field of theatre and performance and take most of our examples from this field, it is important that we also shed some light on the history of dramaturgy and the rise of the dramaturg in the Netherlands and Flanders. Both are closely linked with the emergence of theatre studies as a discipline within Dutch academia. We show how academic studies in the field of theatre and performance relate to applying academic knowledge in dramaturgical practices. At the same time, it is important to acknowledge, throughout this book, the similarities as well as the differences between theatre studies within academia, and dramaturgy as a process and profession in theatre practice.

Although the tasks of the dramaturg vary from process to process, there is inevitably some common ground that cannot be left unspoken. We look

into the distinction between desk dramaturgy and production dramaturgy, but also between major and minor dramaturgy, as introduced by Marianne van Kerkhoven. Additionally, we pay attention to the role of the dramaturg within various forms of theatre and within different genres, such as opera dramaturgy and dance dramaturgy. Finally, the programming of theatre performances can also be considered an artistic as well as dramaturgical position, or at least a position that has a great dramaturgical component to it. This part of the dramaturgical work is comparable with the job of a curator in visual arts, who has a key role in conceptualising, composing, designing, and marketing exhibitions.

1.2 The roots of today's dramaturgy: From *Poetics* to postdramatic theatre

The words dramaturgy and dramaturg originate from ancient Greek and have found their way into several modern European languages, most likely via the French language. The Greek words *dramatourgos* and *dramatourgia* are composed out of two words. According to Aristotle, drama meant action, but it also incorporated our contemporary understanding of the word 'drama'. *Tourgos* and *tourgia* have their origin in the word ergo(n), meaning work or composition. So *dramatourgos* is someone who makes a composition of (dramatic) actions. In Aristotle's era, that essentially meant a playwright. And in many languages, playwright is still one of the meanings of the word dramaturg, and sometimes even the most important one.

If we consider dramaturgy to be the internal structure of a play, one could call Aristotle's *Poetics* (around 335 BC) the first dramaturgical study. Aristotle differentiates between epic (or epos), tragedy, and comedy. Since the section on comedy is lost and Aristotle is rather concise when treating the epic, *Poetics* is mainly concerned with tragedy and its impact on readers and spectators. Aristotle refers to the plays of the three great tragedians of that time, Aeschylus, Sophocles, and Euripides, all of whom wrote their plays in the fifth century BC, so more or less a century before Aristotle wrote his *Poetics*.

According to Aristotle, tragedy is the:

> mimesis of an action which is elevated, complete, and of magnitude; in language embellished by distinct forms in its sections; employing the mode of enactment, not narrative; and through pity and fear accomplishing the catharsis of such emotion.[3]

The quintessential tragic hero is someone who, through a series of fatal events, is faced with an all-important choice. They make the wrong decision, the consequences of which they cannot foresee, and, in the end, this leads to their downfall. So, there is a shift from happiness to misfortune (through which pity and fear are evoked). The most imaginative example of such a tragic hero is undoubtedly Oedipus, who, in the course of the tragedy, discovers that he killed his father and married his mother (see text box). Aristotle considered *King Oedipus* the finest of all tragedies and often uses the play as an example in his *Poetics*.

Sophocles – *King Oedipus* (429 BC)

At the beginning of the tragedy, Thebes, the ancient city where Oedipus is king, is suffering a plague. Oedipus sends Creon, the brother of his wife Iocasta, to the oracle of Delphi for advice. Creon returns with the message that the plague is the consequence of the fact that the murderer of the former king, Laius, was never punished. Oedipus immediately starts a search for the murderer. He summons the blind seer Tiresias, who affirms that he knows who the murderer is, but refuses to reveal his identity, provoking great anger from Oedipus. Ultimately, Tiresias succumbs to the pressure and points to Oedipus himself as the guilty one. Now, Oedipus becomes even more furious and suspects a conspiracy by Tiresias and his brother-in-law, Creon. Iocasta tries to calm him down, stating that even oracles may be wrong. The oracle once said that King Laius would be killed by his own son, while she knows for sure he was killed by bandits at a crossroads on the way to Delphi.

At this stage, something starts to dawn on Oedipus. Long ago he fled his hometown Corinth, because someone had told him he was not the son of his father and mother, the king and queen of Corinth. He went to the oracle of Delphi to find out. The oracle revealed something else: that he would kill his father and marry his mother. He therefore decided not to return to Corinth and he ended up in Thebes, where he became king and married Iocasta, the widow of the former king, Laius. However, on his way to Thebes he got into a quarrel with an old man. Oedipus lost his temper and killed the man.

At the same moment when Oedipus starts to suspect that he himself may be the murderer of Laius, a messenger from Corinth arrives. He announces the death of the king of Corinth and that Oedipus will now be king. Oedipus is much relieved. He thinks it means that he can no longer kill his father and the prophecy cannot come true. However, the messenger reveals that Oedipus is not the true son of the king of Corinth, because he was left behind by a shepherd from Thebes. Laius had ordered the shepherd to leave the baby to die on the mountainside. The messenger himself found the baby and brought him to the

king and queen of Corinth, who raised him as their own son. When the old shepherd, who had left the baby on the mountainside, arrives and reveals, or rather confirms the horrible truth, the tragedy reaches its climax. It appears Iocasta was already aware of the truth and killed herself in the palace. In despair, Oedipus blinds himself before leaving the city as an exile.

In his *Poetics*, Aristotle defines six elements that make up a tragedy: plot; character; diction; thought; lyric poetry; and spectacle.[4] According to Aristotle, action or plot (*muthos*) is the core of tragedy, even more important than character (*ethos*), which reveals itself through actions. *Ethos* is not wholly synonymous with our word 'character', meaning the different personae or agents of a play. *Ethos* is more about the moral character of those agents. However, according to Aristotle, in tragedy it is unity of action that is most important, in the sense that a play should not consist of multiple plot lines and that the action should be completed. Aristotle also mentions unity of time, but it is less normative than it was interpreted in French Classicism[5] in the second half of the seventeenth century. In that period, each play was expected to contain a strict unity, not only of action, but also of place and time (within 24 hours). Although we do find these unities in most Greek tragedies, Aristotle does not present them as strict prerequisites.

Aristotle considered the elements of the tragedy as written down by the poet far more important than their presentation for an audience. *Poetics* is about the art of poetry and therefore cannot be considered a handbook for directors, actors, or scenographers. Despite the rise of the avant-garde in recent history, the leading role of the play text continued to dominate dramaturgical practices in Western theatre until far into the twentieth century. In most cases, other elements of the performance, such as acting, scenography, and music, were meant to support the text, in such a way that the performance would appear as a coherent whole to the spectators and enhance the meaning of the text itself.

The widespread success of *Poetics* in the Western world started in the Renaissance. The rediscovery of the ancient classics also meant new attention for the works and philosophies of Aristotle. Since then, *Poetics* has functioned as a kind of benchmark in Western theatre when it comes to the nature and qualities of a play text. The fact that many twentieth-century theatrical innovators distanced themselves from the rules of Aristotelean dramaturgy merely confirms its canonical status before that period. During French classicism, playwrights such as Racine and Corneille even glorified Aristotle's writings and advocated a strict interpretation of his *Poetics*, focusing on the unity of time, place, and action.

Approximately one century later, in the age of Enlightenment, this neoclassical aspiration was criticised by various authors. Undoubtedly, Gothold Ephraim Lessing (1729-1781) was the most important one when it comes to the development of dramaturgical thinking.[6] Lessing, himself a playwright, contested the rigid aesthetical rules that the neoclassicists advocated. The German theatre of his time, like the French, was dominated by these rules. Lessing, however, was more drawn to the plays of Shakespeare and other Elizabethan poets, which were not restricted by such formalities but, according to Lessing, represented Aristotelian values. In 1767, Lessing was appointed as a literary advisor at the Hamburgische Nationaltheater. In the subsequent period, he wrote a number of essays on theatre, which were published in 1769 under the title *Hamburgische Dramaturgie* (Hamburg Dramaturgy). Whilst we consider Aristotle the author of the first dramaturgical study, one could call Lessing the first true dramaturg. His ideas form the basis of dramaturgical practices and the development of these practices in Europe. This development started in German-speaking countries, but later spread across the rest of continental Europe.

Lessing introduced an important shift in focus and interpretation of Aristotle's work. He considered pity (*éleos*) to be far more important than fear (*phóbos*), which was prioritised by the neoclassicists. According to Lessing, *phóbos* should not be understood as an intense and bodily shock reaction, but rather as an empathetic kind of emotion, comparable to *éleos*. Because of Lessing, empathy and compassion with characters becomes more important and the focus therefore shifts from the action to the characters of the play. They are recognisable and identifiable because they are human and have the same kinds of emotions as the readers or spectators of the play. This shift of attention to the more general human and therefore recognisable emotions of the characters fitted perfectly within the ideas of the Enlightenment and represented the rise of domestic tragedy, of which Lessing was not only an advocate but, as a playwright, also an important exponent.

In the first half of the twentieth century, another German author, dramaturg, and director, Bertolt Brecht (1898-1956), turned against this domestic tragedy and the underlying principles of Aristotelian drama. As a politically motivated Marxist playwright, Brecht was opposed to domestic tragedy because it was based on empathising with the characters and thus prevented an objective view of the events that occurred on stage. Brecht called the theatre that he envisaged the *epic theatre*.[7] For him, theatre was an instrument for demonstrating social relations and making spectators aware of the inequality in society and the role they played in the underlying social conditions. He prevented empathy with characters

by deploying alienating or distancing effects (*Verfremdungseffekte*). One way was to change the common order of the scenes as found in the plays of his time, thus breaking the Aristotelean unity of action. His plays are narratives with multiple and incomplete plotlines that demonstrate how the characters are determined by historical, material, and physical circumstances.

Although Brecht was opposed to Aristotelian unities and wanted to prevent spectators from feeling empathy with fictional characters, he still wrote plays with clearly defined and recognisable individuals. But in the twentieth century, there is also a development in theatre away from the written play text; performances in which a written text is no longer the general guideline or in which no texts at all are used. This development started with the historical avant-garde movements at the beginning of the twentieth century, such as Dadaism, Futurism, and Expressionism. This continued in the fifties and sixties, on the one hand inspired by the happenings and performances of that period, on the other hand as a reaction to the strong rise of audio-visual media. This development of theatre with both a strong visual and a bodily approach, was led by theatre makers such as Robert Wilson, Pina Bausch, and Jan Fabre. It was characterised by theatre scholar Hans-Thies Lehmann as *postdramatic*. These performances were no longer based on text with a strong internal structure and meaning, but occurred as a succession of texts, images, and sounds based on association rather than logic. That does not mean that the written play text was completely abolished in postdramatic theatre, but that 'new' writers such as Heiner Müller, Elfriede Jelinek, and Sarah Kane produced play texts that could no longer be understood or analysed as clear stories or plotlines, acted out by recognisable characters.

It may come as no surprise that all these changes had a huge impact on the development of dramaturgical thinking and on the role of the dramaturg. The dramaturg is no longer a quintessential literary advisor. Nowadays, they must be capable of much more than analysing, translating, editing, and adapting play texts. The range of materials that can be a starting point for a performance has become almost endless. In addition to play texts, other kinds of texts can be utilized, but also art works, music, movies, digital resources, and even the bodies of the performers themselves. Today, a dramaturg must not only have a broad knowledge of the history of theatre and of theatre classics of all the different historical periods, but also of developments in visual arts, literature, film, music, and so on. Hence the contemporary dramaturg is a true *homo universalis*, a person of many talents and the 'spider in the web' of a theatre production.

1.3 Theatre as a process of transformation

In the previous section, we focused on the historical roots of contemporary dramaturgy and described how the emphasis moved away from text as a firm basis of the performance to dramaturgies in which text is considered only one of its possible components. The focus of dramaturgy might also be said to have shifted from (text) material to transformation of that material. Consequently, we consider transformation as one of the main features of theatre and performance. Material, whether text or otherwise, is transformed into something that an audience can perceive in the here and now and recognise as theatre. The aim of this transformation could be that the spectators experience what they witness to be real, or it could be to make them aware of the artificiality of what is presented on stage and to emphasise the form and the meaning of that particular form in the performance, as is the case with the epic theatre of Bertolt Brecht.

Actors, dancers, and other performers play a crucial role in the process of transformation. They are literally the embodiment of this metamorphosis. The way they use their voices and move their bodies may be considered the heart of almost every performance, as it is perceived and experienced by the spectators. If the spectators experience the actions and emotions they perceive as real, it is still undefined how the performers achieve this effect. Numerous philosophers and theatre makers have documented their ideas on acting and transforming, trying to relate the technique of acting to the credibility and truthfulness of what is shown on stage. Already in 1773, Denis Diderot wrote his famous essay *Paradoxe sur le Comédien* (*Paradox of the Actor*). Diderot argues that a good actor has no feelings while displaying the emotions of the character they perform. That is how they are able to thrill the audience with their acting. In other words, great actors show the emotions of their characters in a convincing manner without experiencing these emotions themselves. How else would they be capable of repeating their performance, night after night, in a convincing and credible manner? So, in the eyes of Diderot, actors are trained craftspeople, capable of getting the spectators to empathise with the emotions of their characters while experiencing none of these feelings themselves.

The Russian actor and director Konstantin Stanislavski (1863-1938) had a different opinion. According to him, the emotions that the actors performed on stage should not only be outwardly visible to the spectators, but should have the actor as their source. For Stanislavski, the play text and its analysis were still the starting point of the creative process, but his acting method was directed towards bringing forward the emotions of the characters in a

convincing manner through studying and employing similar situations and emotions in the lives of the actors themselves. So, the actors use their own emotional memory to represent the emotions of their characters. In this manner, the spectators would experience these emotions as real and would empathise and want to connect with the characters on stage. Stanislavski was a successful director at the beginning of the twentieth century, but his views on acting and transformation continued to be influential long after his lifetime. He documented his ideas in three books, the first of which was also published in the United States under the title *An Actor Prepares*. This book continues to have a huge impact on acting throughout the Western world, especially on the way American film stars prepare for their roles. The famous *Method Acting* was developed by Lee Strasberg, but was based on the same acting techniques that were initially described by Stanislavski.

Generally, one could say that the (dramaturgical) labour of the actor and, consequently, the essence of theatre is essentially determined by a choice for one of these two principles in the transformation process: either distancing from or empathising with the character you are performing. The dramaturgical work of the actor consists mainly of investigating and questioning all traits, emotions, and social relations of their character, and, in consultation with the director, determining how to express these in the envisaged performance. Nowadays, most directors and performers have a preference for rather than a blind faith in one or the other acting style. They make pragmatic choices, depending on the skills and training of the actors concerned, but also on the nature of the performance and the way they expect the spectators to experience the performance.

1.4 Dramaturgy in the Netherlands and Flanders[8]

In the Netherlands and Flanders, in contrast with the German-speaking countries in Europe, the rise of dramaturgy started only after the Second World War. During the war, leading figures in Dutch theatre came together and made plans for a Dutch theatre system after the war, with a number of big theatre companies to be subsidised by the government. This system came into being during the 1950s. Seven theatre companies were financed by central government, as well as a big ballet company and an opera company. They were all touring companies; they had a so-called *reisverplichting*, an obligation to travel from playhouse to playhouse to ensure that everyone in the Netherlands had access to their performances. This system was called the geographical or horizontal distribution of theatre.

These theatre companies all employed one or more classically trained dramaturgs to assist artistic leaders and directors in choosing play texts for their repertoire. These dramaturgs had a thorough knowledge of the history of theatre, of plays and playwrights, but also of the historical and social context in which they were written. They were able to translate and adapt play texts, and to explain their form and content to directors, actors, and spectators. Apart from knowledge of plays from the historical canon by famous authors such as Shakespeare, Goethe, and Ibsen, they also had to keep track of new plays by Dutch as well as foreign authors, and decided which were most interesting and more likely to attract a big audience. Moreover, it was not only important to perform serious drama texts, there had to be room for laughter as well. In order to serve all segments of the audience, theatre companies included many comedies in their schedule, in addition to the more serious repertoire. Each of these companies had an ensemble of actors and actresses and the repertoire was adapted to the number and possibilities of these actors and actresses. Taking all this into consideration, a choice had to be made in relation to which plays were the most suitable to be performed by the actors of the company and which best reflected the current zeitgeist.

The system of touring theatre companies that frequented the larger playhouses in the country functioned well in the 1950s. But over the years, more and more blemishes were revealed. Interest in conventional drama started to diminish in the 1960s. Possible causes for this development may have been that other forms of entertainment emerged during this time, notably the persistent rise of television. People no longer had to leave their homes to experience drama. From that moment, they could watch films, television series, and even theatre performances directly through their television screens. Moreover, the social unrest of these years had an impact on the world of theatre. More and more people that operated within the theatre system turned against the big, inflexible, and hierarchically organised repertory companies. They wanted to have more influence on the repertoire and to highlight themes that would better reflect the social and political spirit of these years, as well as their own social commitment. In 1969, a group of students from the theatre school and from the Dramaturgy department of the University of Amsterdam interrupted some performances by De Nederlandse Comedie in the Stadsschouwburg, the Amsterdam City Theatre. They threw tomatoes at the stage and lit smoke bombs. In these years, De Nederlandse Comedie was the largest repertory company of the Netherlands. The activists demanded more social relevance in the repertoire, a different style of acting, and greater democracy within the

companies themselves. Theatre should be at the heart of the community and creators needed more room for experimentation. These incidents have become known as *Aktie Tomaat* (Tomato Action). Similar protests occurred in the Dutch music world, known as *Actie Notenkraker* (Nutcracker Action).

In the end, these developments led to a change in the theatre subsidy system. The system became more diverse and presented opportunities for theatre forms that were different from what conventional companies had to offer. Their performances were often small scale and included direct contact with the audience. Several new companies emerged that no longer performed exclusively in the big playhouses, but also and predominantly in smaller, often multi-functional venues, the so-called black box theatres, which mushroomed in the late 1960s and 1970s. Flemish theatre showed a similar development and flourished mainly in the 1980s and 1990s. In these years, it gained prominence, not only in Flanders, but also within an international network of festivals and playhouses. This movement of directors, choreographers, and artists, such as Jan Fabre, Anne Teresa de Keersmaeker, Wim Vandekeybus, Ivo van Hove, Jan Lauwers, Luk Perceval, and Lucas Vandervost is sometimes referred to as The Flemish Wave (*de Vlaamse golf*). Today, Dutch and Flemish theatre is still well known for its great diversity of theatre companies and venues.

Aktie Tomaat and the major changes in theatre practice that followed, obviously had a huge impact on dramaturgical practice. Besides dramaturgy of the classical drama text, dramaturgy of political theatre emerged, of youth theatre, of mime, of dance, and of musical theatre. Moreover, the relationship between text and performance changed. Creating a performance had always meant giving shape to a fictitious world; a world that the audience could imagine and which was, as it were, already hidden in the text itself. As space, scenography, acting, and music added their own meanings, performances became more layered and complex, and the meaning of the text more ambiguous. As a result of such changes, it is no longer self-evident that the dramaturgy of a play text coincides with the dramaturgy of a performance.

Thus, in less than a decade, the Dutch and Flemish theatre landscape changed from rather conventional to progressive and diverse. This may also have been due to the fact that playwriting had never flourished in the Netherlands and Flanders. They had no great playwrights of the stature of Shakespeare in England, Goethe and Schiller in Germany, and Racine and Molière in France. Of course, in the Netherlands we have Vondel and Heijermans, and in Flanders Hugo Claus, but these writers never had as much of a decisive influence on the repertoire as the English, French, and German playwrights mentioned. On the contrary, the Dutch-language repertoire

that has been built up over the centuries and is still regularly performed, is almost non-existent. Culturally as well as economically, the Netherlands and Flanders are predominantly internationally oriented. Plays from famous authors abroad were translated and, in many cases, adapted. The lack of a strong tradition in playwriting meant that actors, directors, and dramatists increasingly began to see texts as material that they could manipulate to their own ends. They also made use of other kinds of texts, such as stories, novels, and film scenarios, which they transformed into stage texts. At the same time, more and more new texts were written, which inherently had an open character and were open to different interpretations. Many Dutch and Flemish directors and dramaturgs also write for the stage.

It is self-evident that in such a diverse theatre landscape, dramaturgy and the role of the dramaturg are subject to change. Dramaturgy has become more diverse and complex. At one end of the spectrum, there are still dramaturgs who are primarily concerned with texts; at the other end, we see dramaturgs that spend more time in the rehearsal room than behind a desk. In addition, acting collectives and other forms in which theatre makers have organised themselves, operate without any dramaturg being involved. But even in these companies, dramaturgy, in the sense of reflecting on structure and meaning and the creation of meaning in the performance, is an important part of the creative process.

1.5 Perspectives on dramaturgy

When discussing the tasks of a dramaturg and the nature of dramaturgical work, a distinction is often made between desk dramaturgy and institutional dramaturgy, on the one hand, and production dramaturgy, on the other. Desk dramaturgy involves research activities that can literally be performed behind a desk: reading, analysing, translating, and adapting (theatre) texts; collecting background information on the play and on previous performances; writing texts for publicity and education purposes. In terms of institutional dramaturgy, we can add activities that have to do with artistic policy, such as writing policy documents and grant applications, but also choice of repertoire and ensemble building.

The term 'production dramaturgy' goes back to Brecht. Brecht saw a play not only as a literary or artistic expression, as something that had to be passed on, but, above all, as a way of realising an ideological concept. The audience had to be stimulated to relate critically to what was shown on stage and incited to social change. In order to achieve this and to serve as working

material for the performance, the text had to be approached critically first. One could say that Brecht and his dramaturgs definitively bridged the gap between the play text and the staging process itself. Nowadays, production dramaturgy is understood as those activities for which the dramaturg literally has to leave their desk: supporting and advising the director, actors, and designers during the rehearsal process; being a sounding board for the director; attending rehearsals and fulfilling the role of the first spectator; promoting communication and cooperation between the various departments; but also being active in communication with the audience by means of introductory talks, debates, interviews and, more generally, acting as a representative of the company and the performance to the outside world.

Although this distinction between desk dramaturgy and production dramaturgy may manifest itself as a division of tasks within large repertory companies, most dramaturgs take on both tasks. Which of these tasks prevails depends not only on the material, the working methods of the company and, more specifically, of the director involved, but also and perhaps above all on the dramaturg's own preference and personal qualities. The smaller the company, the more obvious it is that all dramaturgical tasks come together in one person.

In addition to the difference between desk dramaturgy and production dramaturgy, Marianne van Kerkhoven distinguishes between 'minor dramaturgy' and 'major dramaturgy'. According to Van Kerkhoven, 'minor dramaturgy' concerns the dramaturgical work on a specific theatre production, whereas 'major dramaturgy' is rather the dramaturgical work 'in which the theatre gives shape to its social function.'[9] According to Van Kerkhoven, the theatre, as a living art, is pre-eminently capable of reflecting on current political and social issues because it can address an audience directly and it can explore new forms of communication, in which the reality of the here and now is the core element, far more important than the pretence of acting 'as if'. But this requires a form of 'permanent dramaturgy' to which all participants in the artistic process contribute. According to Van Kerkhoven, that process requires an 'interlocutor', someone with whom they can discuss their work. This dramaturgical function does not necessarily have to be fulfilled by the person of a dramaturg, but, according to Van Kerkhoven, the function itself is always part of the artistic process.

Dramaturgy is more than just the handiwork surrounding one specific theatre production, it is also far more than some artistic form of project management. Although in most cases a dramaturg is closely involved in the choice of the play text, its analysis and adaptation, and supports the director in the rehearsal process, this does not mean that the whole process starts

from scratch every time. Dramaturgy is characterised by a cyclical process rather than a linear progression. Certain themes, questions, experiments, and design principles from one performance may serve as the basis for the next. Just as an artistic development can be discerned in the oeuvre of individual artists, in which new materials and methods are constantly being investigated and tried out, while, at the same time, existing themes and techniques are also reused, so directors, choreographers, dramaturgs, and scenographers forge individual performances into an oeuvre in which different choices for material, repertoire, casting, mise-en-scène, stage techniques, scenography, and other dramaturgical variables can play a key role.

Artistic director of the Internationaal Theater Amsterdam, Ivo van Hove, has often explored the use of audio-visual means to add an extra layer of meaning to his performances. His visual language and his arsenal of possible ways to create meaning on stage has been enriched by following actors / characters live with the camera, even behind the scenes, and by the magnification of video images on monitors and large projection screens during the performance. With the use of these kinds of audio-visual techniques, it is now possible to make more spaces visible on stage and thus to follow characters, even when they are no longer physically present. Through image projection in close-up and sound amplification of the actor's voice different acting techniques may be used. By employing these new techniques, experimenting with them, repeatedly questioning them, and incorporating the results of one production process into the next in different ways in various performances, Van Hove and his regular scenographer Jan Versweyveld, with the help of various dramaturgs, have developed the visual language for which they are appreciated worldwide. In performances such as *Opening Night* (2005), *Roman Tragedies* (2007), and *Kings of War* (2015), these audio-visual tools are not only a technological but above all a dramaturgical enrichment of the scenic possibilities.

In dance, choreographers Emio Greco and Pieter C. Scholten built an oeuvre in a different, yet comparable way. They met each other in 1995 and shared an ambition to develop a new dance vocabulary in which the physical impulses of the body should be the core element. Initially, they did this by producing solo performances, in which Emio Greco himself performed as a dancer. In those years, the development of their repertoire was strongly linked to the unique expressive possibilities of Greco's own dancing body. Later, the two choreographers started their own company, in which there was room for other dancers. They created choreographies that, at first, included Greco as one of the dancers, but which later took shape without his characteristic physical presence. Today, they are the artistic

directors of ICK Amsterdam (International Choreographic Arts Centre), which produces dance productions and enters (international) collaborations with other companies and choreographers. The search for what they call 'a new dramaturgy of the body'[10] remains central to their work. Whereas Greco was the only dancer on stage in the duo's first performances, *Extremalism* (2015), a collaboration between ICK and Ballet National de Marseille, no fewer than thirty dancers filled the stage of Theatre Carré in Amsterdam with their bodies and intense movements.

1.6 Dramaturgy and theatre research

Dramaturgs are usually academically trained. They apply their knowledge and their analytical research skills as an important component of creating a performance, and in the dialogue they have with the audience. In this sense, one could call them the brains of theatre companies; they represent the intellectual aspect of theatre making. For that reason, they were sometimes considered purely theoreticians that could get in the way of the intuitive and creative process. But although there are major differences between the worlds of academia and art, there are also important similarities. Both are concerned with the unknown. Artists are always looking for new ways to create, researchers seek new ways to gain knowledge. Both researcher and artist must therefore be prepared to take risks and face the unknown with an open mind.

Despite these important resemblances, in today's society, art and academia represent two different cultures that only meet sporadically. Dramaturgy is one of these meeting points. According to Marianne van Kerkhoven, 'dramaturgy is always concerned with the conversion of feeling into knowledge, and vice versa.'[11] Therefore, dramaturgy is located in the twilight zone, in the no man's land between art and academia. Dramaturgy is capable of connecting these two worlds: art and research, theory and practice, intellect and emotion.

To give an example of the academic tools that the dramaturg may use, we introduce a specific systematic method to analyse aesthetic products, including theatre performances. This method, called semiotics, was originally developed by linguists. In semiotics, works of art are conceived as a collection of signs, each of which can convey a particular meaning or message to the audience. The signs used in theatre can be divided into three categories according to the way they generate meaning. This three-way division in the relationship between the sign (signifier) and what the sign

refers to (signified) was first used by Charles Sanders Peirce. Peirce and Ferdinand de Saussure were the founders of modern semiotics in the early twentieth century. The first category is that of iconic signs. These work through representing a direct image of what is signified. For example, an actor is always a sign for a person or character in the fictional world, a chair on stage is a sign for a chair in that imagined reality. Indexical or deictic signs, on the other hand, generate meaning through pointing references. For example, smoke can refer to fire as a sign, and a door or window on stage can refer to a world outside the scenic space that is represented. The third category is that of symbolic signs. These operate according to cultural conventions. Our language is one of the most important sign systems that generates meaning through symbols (letters). A traffic light turning red or green also has a symbolic meaning. Those who have not learned the code do not know the meaning.

Theatre is an art form that works primarily through iconic identity. According to Aristotle, tragedy is a mimesis or resemblance of an action. An actor playing Hamlet always uses iconic signs to impersonate his character, primarily because he is a human taking on the role of another human. In addition to iconic signs, theatre also makes frequent use of indexical and symbolic signs. Therefore, signs on stage may generate multiple meanings that can be interpreted differently by various spectators at the same time.

Apart from this distinction between different types of signs, we can also distinguish different *sign systems*. In theatre, multiple sign systems are active simultaneously and they can reinforce or contradict each other's meaning. In theatre semiotics, we distinguish ten to fifteen different sign systems, including text, delivery of text (voice), facial expressions, gestures, space, set, costume, lighting, sound, and music. These signs and sign systems can be recognised by the spectator. But they also correspond largely to the division of tasks within a theatre company itself. The actor, for example, is responsible for text, facial expressions, and gestures, while the scenographer and technicians deal with space, set, and lighting.

So, the actor thinks about the impersonation of their character and how it comes across to the audience through voice, movement, and facial expressions; the scenographer thinks about how space, set, and light generate meaning. However, the structure and meaning of the performance as a whole is more than the total sum of these different components. This meaning is ambiguous and layered and arises from the simultaneous presence of the various signs and sign systems and the way in which they interact, reinforce, negate, or challenge each other's meaning. This is the field of directing and dramaturgy.

This reflection on structure and meaning is closely linked to and nurtured by academic education. Consequently, a dramaturg not only needs knowledge and understanding of theatre, but also of philosophy, literature, visual arts, film, and music. In addition, they must have the skills to study and analyse texts, images, and music. Research and analysis are thus not only the skills that a university graduate should have mastered, they are also the skills that a good dramaturg must possess, alongside a number of other essential qualities. Dramaturgy, in the sense of practicing the profession of a dramaturg, is therefore the obvious field of the academically trained theatre scholar.

Besides the fact that university theatre programmes are undoubtedly the most important providers of dramaturgs, dramaturgy and the work of the dramaturg are, vice versa, attracting increasing attention from academic scholars. The International Federation for Theatre Research (IFTR) even has a separate working group on 'Translation, Adaptation & Dramaturgy'. University education thus not only makes an important contribution to the knowledge and skills of dramaturgs, but dramaturgy and the work of the dramaturg have themselves become objects of academic research. In recent years, this has resulted in a large number of publications on dramaturgy, the totality of which gives an accurate image of the enormous diversity of topics and views that lie hidden behind the concept of dramaturgy.

1.7 Dramaturgy within and across disciplines, styles, and genres

The dramaturg is, as it were, a company's specialist in the processes of assigning meaning to the individual elements of a performance, and to the performance as a whole. Moreover, they function as a mediator and translator between theory and practice, between art and science, between reason and emotion and, last but not least, between theatre makers and spectators. Because, in conventional theatre, meaning was primarily conveyed through the play text and the other elements of the performance were drawn from it, the play text is still considered to be an important focus of the dramaturg. The dramaturg analyses, adapts, and translates the text. But in today's theatre, the text no longer represents the exclusive and all-decisive layer of meaning of the performance. Although most dramaturgs are still comfortable with text, there are now dramaturgs working in dance, mime, and musical theatre. Nowadays, dramaturgy is considered to be an essential part of the creative process across all theatre genres, including interdisciplinary forms of theatre.

Thus, in many contemporary productions text is less prominent than it was during the aforementioned blooming period of dramatic theatre. Yet, this movement away from text is not the same as the development within theatre forms in which the text has always been absent or only played a minor role. This applies to dance and mime, two genres in which the text has never been the core element of interaction with the audience, but in which the most important means of expression are the bodies of dancers and players. According to Van Kerkhoven, however, there is 'no *essential* difference between theatre and dance dramaturgy. Dramaturgy is always about the mastering of structures; the achievement of a *global* view; the gaining of insight into how to deal with the *material*, whatever its origin may be – visual, musical, textual, filmic, philosophical etc.'[12] Still, one could say that within dance dramaturgy, at least a certain amount of knowledge of dance history, of the body's means of expression, of choreography, and perhaps even of dance notation systems is necessary to be able to talk to choreographers and dancers on an equal level. Just like drama has always related and continues to relate to the tradition of action and dialogue, which goes back as far as Aristotle, contemporary dance in a certain sense still relates to tradition, the established techniques and fixed rules of classical ballet, even if these rules have been abandoned.

In this respect, mime has developed more independently and perhaps more on the fringe, although contemporary mime is also indebted to, for example, the *mime corporel* established by the Frenchman Étienne Decroux from the mid-twentieth century, in which the body of the mime player is the most important medium. Mime, as a mode of creating and thinking, has exerted a great influence on Dutch theatre. Although Dutch mime practice is multifaceted and difficult to categorise, it can be distinguished as a separate theatre form with its own history, development, and vocabulary. This has even led to a distinct mime programme at the Amsterdam School of the Arts. Mime is different from drama or dance, it has its own tradition and way of working. This mime tradition, with its focus on the actor's body, has also acquired international fame and has been the basis for typical Dutch theatre forms such as site-specific theatre and immersive theatre. Mime has also exerted great influence on Dutch youth theatre, in which the body is not only central to the creative process and the performances, but also to their associated educational programmes.

Whereas in dance and mime the body as a means of expression is the starting point of the creative process, in opera this applies to the libretto, the musical composition, and the vocal qualities of the performers. This means that opera dramaturgs (and musical dramaturgs) should have some kind

of musical training, should have developed a musical ear, and preferably must be able to read music. Furthermore, they must also be able to use their dramaturgical vision and ear within the large scale and hierarchical structure of such music theatre productions. Opera and musical are monumental art forms, in which all artistic disciplines come together, but which are often rather inflexible, due to their complexity, large-scale organisational structures, and high costs. Although numerous small-scale and experimental initiatives are a key feature of the diverse Dutch and Flemish (music) theatre field, they are rare in opera and musical.

Within conventional repertory companies, the dramaturg, in the role of literary advisor, which goes back to Lessing, is largely responsible for the composition of the repertoire. Although the role of literary advisor has lost some of its importance, another dramaturgical practice is emerging that is equally focused on the selection and composition of the company's programme. This applies to the regular programming of individual theatres, especially those that support and guide talented young theatre makers in the creation of their performances. It applies even more to the programming of events and festivals. This kind of dramaturgical function can best be compared to the rise of the curator in the visual arts, who selects works of art for an exhibition that fit together thematically or historically, but in which the curator's personal taste is also a distinguishing feature. The function of curator in the visual arts has become increasingly important in recent decades. Whereas, initially, museums concentrated on their permanent collections, the focus has shifted over the years to curated exhibitions. In those exhibitions, the individual works of art become part of a larger whole, which may be considered a new work of art itself. Such exhibitions provide space for new forms of visual art, such as conceptual art, performance art, and video art, which are often better displayed in such an exhibition than in the permanent collection of museums. In the meantime, the words 'curator' and 'curating' have become more widely used than in the visual arts, and these terms are also used in the programming of theatre festivals. After all, the programme of a festival may also be considered as more than the sum of its parts. Curating for festivals has thus become a specific dramaturgical and perhaps also artistic practice, comparable to that of 'creative producer' in the world of movies and musicals.

2. Material

2.1 Text as material

Historically, text as a material has dominated thinking about theatre and the dramaturgy of performances. In order to reflect upon this (historical) basis, this chapter will focus on text. Despite the fact that texts can be preserved as independent entities, which can be studied time and again, in a dramaturgical process text as material can take on quite divergent manifestations. For these reasons, text will be approached from two perspectives: from the stance of textual analysis and dramaturgical analysis, i.e. what aesthetic elements characterise theatre texts throughout history; and how is a text aesthetically and dramaturgically given form in a performance? By aesthetic, we mean the way actions are given shape, how time and space are organised; in short, how the various manifestations of theatre texts and performances structure the spectator's perception and experience. We emphasise these two perspectives by elucidating dramaturgical choices in the staging of several specific theatre texts in special text boxes. Of course, work on performances can also start with other material. The body, visual media, objects, etc. are also important points of departure for theatrical productions, but these are more likely to be given expression in the course of the work process. We will look in more detail at aspects of theatrical translation processes, i.e. how are artistic considerations transformed into an aesthetic, i.e. tangible and experienceable form, in Chapter 3. The following deliberations are by no means complete and do not aim to provide conclusive answers; they are intended as a means to describe the constantly changing organisation of fiction, theatrical productions, and audience; in short, they are exercises in dramaturgical thinking.

In 1994, the international and multilingual journal *Theaterschrift* dedicated an entire issue to dramaturgy. Among other things, an attempt was made to collect terms and conceptual images that could clarify new theatre forms and new dramaturgies. This endeavour resulted in four parts of "Fragments of 'The Intersubjective Encyclopaedia of Contemporary Theatre'" inserted throughout the issue. Although the materiality of bodies (actor and spectator), of sounds, of images, etc. is of particular importance in a process described as 'new dramaturgy', 'material', and 'materiality' are not mentioned as key words. Material in the broad sense corresponds to what is called 'source', 'matter', or 'story' in the context of text-based theatre or musical theatre. This can be a newspaper article, a historical,

mythical, or literary story, a concept, a social issue, an image, a sculpture, etc. It can just as easily be a motion sequence, a composition, a song, or sound, if we are thinking of dance; an overlapping subject such as travelling, seasons, mythology, utopia if we are considering vaudeville or circus. In fact, everything that is conceivable and imaginable can serve as material for a performance.

From a dramaturgical perspective, this prompts the question of how a particular material is transformed into an artistic form. The Dutch drama-turg and theatre scholar Bart Dieho calls the relationship to material vision. But how is this vision given expression? Which formal elements are chosen? How is time, space, body, sound, etc. given form in the mise-en-scène?[1] How do theatre makers and dramaturgs relate to the chosen material? And how does the material relate to materiality, i.e. to the physical forms of expression in staging? Does a particular material pose certain requirements to a creative process? How do the various materials relate to each other? All these questions require an investigative attitude before and during a dramaturgical process.

Since the end of the Second World War, two developments can be identi-fied that have had a significant influence on dramaturgic research: the blurring of the line between fiction and reality (which is also referred to as the 'crisis of representation'); and the erosion of characters. In her essay "Samenvallen met wat je denkt" ("Coinciding with What You Think"), the Flemish dramaturg Marianne van Kerkhoven observes that 'the state of the real is not necessarily more convincing than that of the theatrical'.[2] This statement has rather far-reaching consequences for the familiar distinction between reality and (dramatic) theatre, or fiction. Van Kerkhoven arrives at this conclusion after juxtaposing 'the dramatic character as fictitious shell' with the 'living reality of the actor'.[3] Thus, there appears to be a con-nection between the 'crisis of representation' and the 'crisis of the dramatic character'.

Elinor Fuchs even pronounces *The Death of Character* in her eponymous book; she notices the beginning of an increasingly critical approach to dramatic 'characters' as early as the late nineteenth century. Debates about the relationship between fiction and reality, or the relationship between role and actor/actress are far from new; they characterise Western thinking about theatre throughout (usually under the key words of truth or veracity). What is new, however, is that it is not a question of clearly delineating the different states (of reality, fiction, role, actor), but of linking them relationally to each other – and that has consequences both for what we understand as reality and for artistic practices and thus for dramaturgy.

Contemporary dramaturgy is usually denoted by key terms like hybrid, multi-perspective, polyphonic, intercultural, process-based, non-mimetic, and open. All of these concepts discharge dramatic forms of theatre that are characterised by a central perspective, linear organisation of time, recognisable characters, and recognisable (national) subjects; dramaturgies that are based on the representation of a conceivable reality and that must represent a closed and coherent unity. This is not to imply that dramatic theatre has completely disappeared or that text no longer plays a role. Since the publication of Hans-Thies Lehmann's influential book *Postdramatic Theatre* (2006 [1999]), it has been repeatedly emphasised that the status of the text as the central element of the mise-en-scène has changed. This often also applies to typically dramatic texts that are adapted into a theatrically open form. After discussing Aristotle's account on tragedy, we illustrate by means of Aeschylus' *The Persians* how different perspectives on the text and of the text as material can be expressed in a performance.

2.2 Aristotle: Language as medium of imitation (mimesis)

Aristotle's *Poetics* was written roughly 2,400 years ago and has decisively influenced Western thinking about dramatic texts in general and tragedy in particular. It is important to note, however, that each period of time reads, comments on, and translates the *Poetics* with a different viewpoint. Typical in this regard are Lessing's reflections in the eighteenth century on the emotions *éleos* and *phóbos*, which he translates as pity and fear.[4] These are humanistic-moralistic emotions that fit bourgeois characters of the time. After the Second World War, the German classical philologists Wolfgang Schadewaldt and Manfred Fuhrmann translated the emotions with *'Jammer und Schauder'* (misery and terror), thus emphasising the physical aspect of the feelings. In Anglo-Saxon countries, the concepts of *praxis* (action) and *êthos* (character) have been under discussion since the 1960s. John Jones, for instance, suggests in his study *On Aristotle and Greek Tragedy*, 'that we have imported the tragic hero into the *Poetics*, where the concept has no place.'[5] His considerations continue to influence classical philologists, philosophers, and theatre scholars. A reading and understanding of the *Poetics* is thus moulded by the (theatre) culture, discipline, and the thought patterns of the voices of authority who read and interpret it.

Despite these differing perspectives, when it comes to a dramaturgical investigation of theatre texts, the questions Aristotle raised in the *Poetics* remain of vital relevance: what is the *aim* of an artistic work; what are the

subject matters of a specific genre; what are the *means* to achieve this aim; and, finally, what are the *formal elements* to give expression to the subject matters? These questions could be translated by: what is the vision or the perspective; what is the material; how is the material processed to give shape to the vision or a certain standpoint?

As delineated in Chapter 1, Aristotle defines tragedy in the *Poetics* as the imitation (*mimêsis*) of action with the aim of purification/purgation (*katharsis*) from pity (*éleos*) and fear/terror (*phóbos*).[6] He mentions six elements of tragedy: plot; character; diction; thought; lyric poetry; and spectacle. This classification of elements is not structured hierarchically; but they differ significantly in their relation to mimesis. Plot, character, and thought are the *objects* that are imitated; diction and lyric poetry are the *media* of imitation; spectacle is the *mode* of imitation. Regarding poetry, the structure of events (*muthos*) is, according to Aristotle, the most important part. He calls *muthos* 'as it were, soul of tragedy'.[7] It is well-known that Aristotle considered spectacle an irrelevant means to an end. Less well-known, but important for the state of the text, is his remark that the most important element is not language but *muthos*, because 'the poet should be more a maker of plots than of verses, in so far as he is a poet by virtue of mimesis, and his mimesis is of actions.'[8]

Before we turn to a more detailed exploration of the plot, let us draw attention to one of the most discussed sentences in Aristotle's *Poetics*. It concerns his statement: '[...] because tragedy is mimesis not of persons but of action and life; and happiness and unhappiness consist in action, and the goal is a certain kind of action, not a qualitative state [...]. Besides, without action there could be no tragedy, but without character there could be.'[9] In order to put this statement into context, it is important to acknowledge that, according to Aristotle, 'character' is an (ethical) condition or quality and therefore cannot be understood as a synonym for 'dramatic character/ dramatis personae,' as is the case today.[10] Whereas character is understood as static quality, actions have a purpose, they employ a certain dynamic. Development and change in a tragedy therefore relate to action and not to character.

Finally, of interest are Aristotle's brief remarks on thought as object of mimesis. Thought, Aristotle argues, is 'the capacity to say what is pertinent and apt, which in formal speeches is the task of politics and rhetoric.'[11] 'Politics' and 'rhetoric' address public life, matters of a (political) community. Therefore, actions always concern societal questions and refer to (urgent) issues of a particular community. The public context also becomes apparent in two striking aspects of Greek tragedies: they are always performed in the

public sphere and the characters always face a chorus as representatives of a community. In sum, character and thought can barely be regarded as independent objects of mimesis; they are related to the main object of mimesis and that is action. Acting persons have a certain colour (character), but it is their actions and not their 'qualitative state' (character) that lead to change.

Although the *Poetics* does not apply as a blueprint for most contemporary theatre productions, Aristotle's description of the plot is nevertheless important: be it affirming, be it consciously denying, undermining, and problematising the principles. So, how should a plot be composed according to Aristotle? The central feature of a tragic plot is the unity/wholeness of a single action; the structuring elements are *peripeteia* (sudden reversal) and *anagnôrisis* (recognition); the third element Aristotle mentions is *pathos* (suffering).

The emphasis on the imitation of a single, whole, and complete action with a beginning, middle, and end demands that incidents must follow each other according to the principles of necessity and probability, i.e. each incident must be strictly causally connected to the preceding and following incident. This causal connection of incidents has consequences for the organisation of time. If every act is connected in a necessary and/or probable way with the preceding and the following act, there is a continuous progress of time in the present, or unity of time. Aristotle notes in the *Poetics* that tragedy strives 'to stay within a single revolution of the sun'[12] but this indication concerns a quantitative characteristic, which does not necessarily guarantee that the acts succeed one another and not just one *after* another. Only acts that necessarily succeed each other are able to create an incessant 'now'. Otherwise, we are dealing with an episodic tragedy, i.e. the depiction of a series of acts without coherence.

In terms of the arrangements of the action, Aristotle distinguishes between single and complex plots. In single plots, a reversal of the situation takes place without *peripeteia* (reversal) or *anagnôrisis* (recognition), whereas complex plots depend on *peripeteia* or *anagnôrisis* or both.[13] Aristotle defines *peripeteia* as the reversal of a situation into its opposite, it usually involves a change from happiness to unhappiness. *Peripeteia* also results directly from a course of action and may not be related to character. The reversal from happiness to unhappiness should not concern a virtuous character (that would shock our feelings), or a bad character (that would satisfy the moral sense), but rather it should be caused by 'some kind of error' (*hamartia*).[14] *Hamartia* means 'to miss the mark', to make an error, and can be interpreted as a moral aberration or as a misjudgement of a situation. Both forms of *hamartia* can be found in Greek tragedies: in Aeschylus' *Persians*, the cause

of the misfortune, the disastrous destruction of the Persian army, can be attributed to the hubris of King Xerxes; in Sophocles' *Oedipus*, it rather concerns the misjudgement of the situation.[15]

Anagnôrisis, the second element of a plot mentioned by Aristotle, refers to a change from ignorance to knowledge (or recognition). There are various forms of recognition (by signs such as birthmarks or scars, by memory, by reasoning). But knowledge/recognition always involves acting persons, e.g. as Oedipus comes to realise that he has killed his father, married his mother, and is both the father and brother of his children. According to Aristotle, tragedies best achieve their goal when *peripeteia* and *anagnôrisis* coincide.

Finally, with respect to the dramaturgical analysis of tragedies, it is of interest that, according to Aristotle, the actions are put together according to the principles of complication and unravelling/denouement. He uses the terms *desis* and *lysis*, which literally mean 'knot together' and 'unknot'. These terms illustrate the composition or structure of a tragedy, i.e. to identify the knots that determine the movement or dynamics of the action and how they are related to character and thought. Basically, it is a matter of exploring the montage principles of a text.

Besides these key concepts that Aristotle regards as qualitative formal elements of a tragedy, he mentions quantitative parts of the tragedy: *prologue* (the part that precedes the first choral passage); *epeisodion* (the part between two choral songs); *exodos* (the part after the last choral song); and, finally, the choral song itself. The latter can be a *parodos* (first choral passage when chorus enters the orchestra) or a *stasimon* (choral song between two *epeisodion*, usually sung with chorus standing in its place).[16] Thus, all episodes of the tragedy are defined in relation to the chorus. It would therefore be precipitous to understand the parts between the choral songs as a dramatic act, as they take shape in dramatic literature from the Renaissance onwards. The chorus is an essential part of the action, it is not an ornament or a minor detail.

In sum: firstly, all elements of tragedy are connected to *mimesis*. To put it differently, tragedy presents a closed fictitious world, i.e. all dramatic elements and means are intended to give shape to a fictitious world. Secondly, it is worthwhile to consider *action* and not dramatic figures as the structuring concept when analysing tragedies. Presupposing the imitation of a single, whole, and complete action results in a *continuous progress of time in the present*. Since, according to Aristotle, acts are embedded in the socio-political sphere, *public spaces* are the appropriate places for action. Thirdly, although Aristotle mentions character as the object of tragedy, crucially, he does not necessarily mean dramatic figures.[17] The differences between the tragedies of Aeschylus, Sophocles, and Euripides nevertheless

make it clear that a concept of character is in the process of emerging. Over time, the dialogues between 'actants' and chorus become more extended, conflicts arise between 'actants', and the chorus passages decrease in length and are not directly connected to the action.[18] Fourthly, from a dramaturgical point of view, it is important to investigate how and from which formal elements the text is composed. Finally, it is worth exploring how qualitative and quantitative elements relate to each other. *Peripeteia*, one of the two crucial elements of the plot, is, for example, often carried out by a messenger. This is a quantitative element, which Aristotle does not even mention, but since in almost every tragedy the reversal is brought about by a messenger, it is certainly an important part of any analysis of Greek tragedy.

Aeschylus – *Persians* (472 B.C.)

Aeschylus' tragedy *Persians* is remarkable in several respects: it is the oldest of Aeschylus' surviving tragedies; its subject is a contemporary event (the fall of the Persian Empire); Aeschylus himself took part in the Persian wars as a Greek soldier; and he writes the tragedy from a Greek perspective. Queen Mother Atossa, the deceased King Darius, and the defeated King Xerxes, as representatives of the Persian Empire, enter into dialogue with a chorus of elderly advisors. All three protagonists are unfit to act: as a woman, Atossa has no authority, Darius is dead, and Xerxes returns defeated from the war. At first sight, the tragedy is based on hubris (overconfidence, exaggerated pride), thus character seems to be the object of mimesis, and *pathos* (suffering) the structuring element of the plot. So, to what extent does action come into play?

The action is set in motion by the chorus of elders, who anxiously discuss the situation of Sousa, the capital of the Persian Empire. Xerxes, the young king, committed to undertaking a war expedition against Greece. The elders mention the names and virtues of the Persian warriors and praise the greatness and wealth of the Persian Empire. At the same time, they fear the outcome of the war, because Xerxes has, against the will of the gods, opted for a sea battle, instead of a battle on land. This starting point exposes the fragility of the situation. Wealth and fortune are things of the past. Those who would be able to continue the 'good life' are absent and involved in an unpredictable war. The fragility of the situation is reinforced by a dream of Atossa and the omens she sees within it. Both the worries of the chorus and Atossa's dream, predict the coming disaster. A dialogic part between the chorus and Atossa depicts the virtues and military strength of the Greeks. At the end, the chorus recalls the defeat suffered by Darius, the father of Xerxes, thus establishing a link with the subsequent report from a messenger that brings about the *peripeteia*. With the messenger's words, the imaginary misery becomes a fact.

The messenger first informs Atossa that Xerxes is alive; this is followed by an account of the battle of Salamis in which the names of the fallen warriors are recounted. Whereas, initially, the names still allow for the possibility of success and a prosperous future, now the message transforms them into a recollection. The inescapability of death and destruction is reinforced by the summoning of the dead king, Darius. He condemns Xerxes' pride against the gods, i.e. his decision to engage in a sea battle against the will of the gods.

Moreover, he predicts more suffering and finally gives the advice: 'remember Athens and remember Greece!' He advises his son Xerxes to be moderate and to stop offending the gods. This denouement is unexpected because it not only blames the Persians themselves for the downfall, i.e. bad leadership driven by inappropriate aims, but it also contains a new memory-narrative. It is not the magnificence of the past and the expansion of the empire that guarantee a prosperous future, but the future rests on recognising and respecting the power of Greece. The factuality of the fall of the empire is finally embodied by the appearance of an utterly shattered Xerxes. The dialogic part between the chorus and Xerxes begins with an accusation and ends with joint mourning. The chorus holds Xerxes to account by repeatedly confronting him with the question 'where is?', followed by recalling the names of the fallen troops; finally, the elders accompany Xerxes to the palace in lamentation.

The tragedy contains lucidly connected parts of action: fearful presentiment; accusation; lamentation; and it is structured by *peripeteia* and denouement. The reversal of the action is not brought about by choices or actions of the dramatic characters, rather it is embedded in the (altering) situation. The question of whether the tragedy focuses on character (hubris) or suffering (pathos) is ultimately a question of interpretation and staging. Both aspects are undoubtedly present, but from Aristotle's point of view they give colour to the action, while the aim, to evoke pity and fear, must be embedded in the action itself.

This descriptive analysis intends to emphasise the fact that artistic choices and interpretations imply the collection of more background information. In analysing this tragedy, it is important to consider that it was written by a Greek author for a Greek audience. But how, for example, does the threefold invocation of the names of the Persian army affect a Greek audience? The Persians, who started the expedition and lost the battle, encounter destruction and suffering. Greece, on the other hand, won the war. Is it, then, still a matter of pathos or heavy suffering? What is the function of repeating the names? Are there different contexts in which they are evoked? The tragedy can also be understood as a critique of tyranny, of Xerxes' autocratic rule and the hubris that resulted from it, but then it should be known that the Greek success at Marathon resulted in the strengthening of democracy in the city-state of Athens. There are several refer-

ences to the different forms of leadership in the text, so this perspective could certainly be further explored through staging.

De Perzen (The Persians) – De Nieuwe Komedie (1963)

In 1963, eighteen years after the end of the Second World War, at a time of slow recovery, Erik Vos, one of the most innovative Dutch post-war theatre directors, stages Aeschylus' tragedy. There is no registration of the performance, so it must be reconstructed on the basis of visual material, sketches, a short television fragment about the making of the staging, and a sound document. The location, the former Circus theatre Carré in Amsterdam with its arena stage, reflects Greek theatre conventions. The set is stylised, with the most characteristic element being a monumental staircase flanked by a bunker-like construction. Vos chooses to use masks for the chorus. The masks refer to the heads of ancient Greek sculptures, the costumes consist of solemn robes. Vos choreographs the chorus as a unit, the movement patterns organise the spectators' gaze and structure and restructure the space. The sound recordings illustrate that the text was recited in a stately and rhythmic manner. In contrast to this stylised clarity and unity of the scenography and the chorus, Atossa, Darius, and Xerxes are, as it were, put on trial.

Vos' directing of The Persians was one of the most convincing theatre successes in post-war Dutch theatre history. As far as the staging can be reconstructed, two aspects in particular resonated with the zeitgeist of the sixties: the contrast between the monumental, almost violent scenography and the vulnerability of humans/actors, and the repeated recalling of names. In May 2010, literary critic Elsbeth Etty wrote in the newspaper NRC:

> One of my first theatrical experiences, I was still at school, was a performance of Aeschylus' tragedy The Persians, directed by Erik Vos. The most beautiful thing, I remember, was the lament of the chorus calling out the names of those who had not returned from the war to the Persian king, Xerxes. 'Where are Sousas, Pelagon... where are Pharnoukhos, Ariomardos... where are Lilaios, Memphis...?' The rhythmic pounding of the seemingly endless enumeration of names was a lament and an accusation at the same time. Unforgettable.[19]

The title of Etty's article is "De namen der gevallenen" ('The names of the fallen'). It reflects clearly the still present experience of repression and resistance in the postwar Netherlands. To Vos, language is the bearer of meaning, the means of communication, be it as an accusation or a complaint. The various voices of the chorus were condensed into one voice against the queen mother, Darius, and Xerxes. Vos stages the tragedy as a closed drama with the chorus at its centre as the carrier of the story.

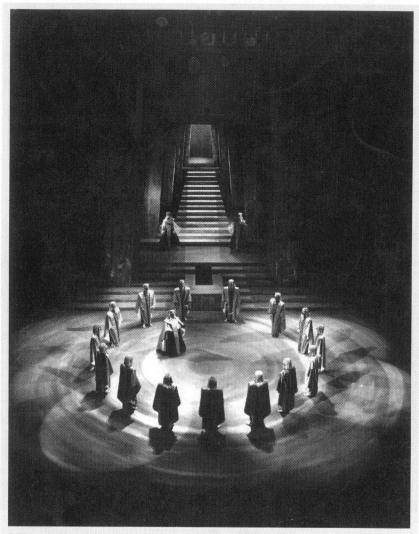

Erik Vos' staging of *De Perzen* in Theater Carré / Nieuwe Komedie (Amsterdam, 1963).
© Particam/MAI.

Perzen (Persians) – Theatergroep Hollandia (1994)

Barely five years after the end of the Cold War, Johan Simons and Paul Koek, founders of the influential Theatergroep Hollandia, staged the tragedy. The location of this production is a scrapyard, a desolate shed on the periphery of the conurbation of Western Holland. The scenography emphasises the general sense of decay. In the middle of the proscenium a part of the floor is broken up, perfectly reflecting the play's vision. Simons and Koek accentuated the musicality of the text. The performance begins with a recitative by three musicians

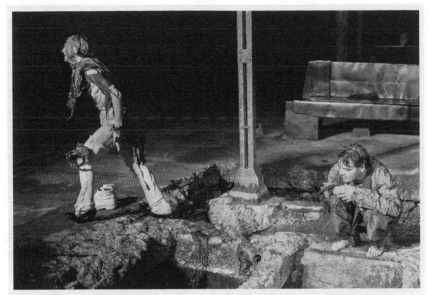

Perzen, directed by Johan Simons and Paul Koek / Hollandia (1994). Photo: Ben van Duin.

behind music stands and three elderly amateur actors in suits who represent
the chorus. They recite the text in alternating vocals, sometimes in unison. The
recitation is solemn, the gestures large, so that especially the amateur actors
have an alienating effect. Elsie de Brauw as Queen Atossa appears in a stiff black
dress that seems to restrict her movements; she walks with unsteady steps, her
hands move incessantly. Jeroen Willems embodies all the male roles, the mes-
senger, King Darius, and Xerxes. Both actors are timidly searching for the words
they speak, stuttering, repeating sounds. The language seems to be shattered;
the words no longer carry the story.

In the Simons and Koek staging, the text of the Greek tragedy is either
incomprehensible (chorus, singing) or presented as a broken language (Atossa,
messenger, Darius, Xerxes). The musicality of the text does not serve to evoke
emotions, but rather makes the materiality of the text audible and tangible,
especially in the passages spoken by Elsie de Brauw and Jeroen Willems. They
are constantly in search of words, virtually sensing them, but their whole bodies
seem to fight this. In short: the words no longer carry the story and the story no
longer carries the general decay (omnipresent in the scenography and cos-
tumes). The chorus still speaks in recitatives but not as a collective, it dissolves
into individuals who, in turn, are estranged from the text. Simons and Koek thus
translate the text of Aeschylus into a postdramatic theatre text.

2.3 Theatre landscape until the eighteenth century

On 5 February 1768, an apparently slightly irritated Lessing begins the eightieth chapter of his *Hamburg Dramaturgy* with the question: 'Why build a theater, costume men and women, rack one's memories, invite the whole city to one place [...]?'[20] His answer is: because only the dramatic form can arouse compassion and fear. But are those the effects the audience is looking for? Apparently not, because Lessing first refers to the enthusiasm with which he says the Greeks and Romans looked forward to tragedies, and then mentions the motives for going to the theatre that he observes in the Germany of his time: people go to the theatre because it is fashionable, out of boredom, to stare and to be stared at. This catalogue of erroneous reasons combined with Lessing's question about 'why theatre?', gives a glimpse of a 'different' theatre or a different theatre tradition that dramatic theatre apparently contests. And this tradition (or traditions) flourished and not necessarily based on text. Lessing's question also illustrates that each era, with its own social formations, applies specific purposes to theatre, which, in turn, contribute to determining its form.

If we consider how the ancient Roman poet and critic Horace discusses Greek tragedies in his work *Ars poetica*, we see a clear shift from an emphasis on action to an emphasis on dramatic characters. Characters assume a central position and become the carriers of the action. The development of a dramatic progression is based on a conflict between dramatic characters or on a character's inner conflict. The chorus is not so much an interlocutor as it comments on or contrasts the events of and between characters; as a result, ancient Roman tragedies partly take on an epic or narrative character and do not follow the causal logic of the Greek tragedies in a strict sense. We find these characteristics, for example, in Seneca's tragedies, one of the most influential philosophers and playwrights of the Roman era. Language is of great importance in Roman tragedies. However, it not only serves to imitate an action, but also to express the feelings and good taste of characters. *Decorum*, understood as the correct or appropriate manner of speech, is given a central function. Here, we see a theatre with an educational (moral) function emerging, theatre as a mirror of appropriate moral values expressed through, among other things, language.

While Roman tragedies already showed a tendency towards an epic or episodic form, medieval morality and mystery plays, as well as various forms of court theatre and popular theatre, increasingly reveal an episodic structure. That is, the single scenes are only loosely connected. It is precisely these episodic, incoherent, stylised, mime-based theatrical forms, and

not primarily dramatic forms based on Roman theatre conventions, that Lessing and other contemporaries opposed, because, according to these critics, they primarily stimulated the public's desire for sensation and spectacle.

An example of such a form of non-text-based theatre is the *Scenari più scelti d'istrioni*, a collection of scenarios for improvisation artists or commedia dell'arte theatre groups in the sixteenth and seventeenth century.[21] This collection primarily features comedies and farces, but also tragicomedies, operas, and a tragedy. The scenarios describe the actions and interactions of the actors, the entrances and exits of characters; in short, they roughly outline the storyline. The scripts do not indicate the text spoken by the actors, but they do include so-called *lazzi*, which are simultaneously intertwined with and interrupt the scenes. *Lazzi* are grotesque, stylised, mainly pantomimic acts by an actor or a group of actors. Although they contain textual aspects, the emphasis is on bodily expressions.

When it comes to material and the materiality of dramaturgical processes, *lazzi* as a theatrical phenomenon focuses on the body or the expressiveness of the body. Therefore, in this 'excursion', we will primarily look at the dramatic figures or the so-called stock characters of the scenarios. Briefly, *dramatic figures* undergo a development and show a broad set of distinguishing features, whereas *types* or *stock characters* are determined by one specific feature or a small set of features (such as the greedy old man, the lover, the servant, etc.), which limit the stock characters to moral qualities and/or social class. In almost all scenarios we encounter the stock characters Pantalone, Capitanio, and Zanni. Pantalone is always the old, wealthy, usually sly merchant with the desire to seduce or marry a young woman. Capitanio is a vain, unreliable brag, and Zanni is the servant or slave of peasant or migrant origin. In addition, there are female types, which are variations on the young, seductive woman and the old, shrewd, and crooked woman. All stock characters of the commedia dell'arte have set masks, costumes, and acting styles and are therefore immediately recognisable. The scenarios contain a large number of farces that vary the 'old man desires young woman' motif, seemingly endlessly. There are always mistaken identities and disguises, sons and daughters disappear remarkably often to distant regions, work as villeins, and are recognised at the last moment. After the most unlikely complications, the lovers come together and a (wedding) party is celebrated.

At first glance, then, it seems to be an endless repetition of rather trivial stories, often involving an exotic element. Stefan Hulfeld argues that:

> [N]ot the construction of a plausible story to which all episodes refer, not the motivation of the episodes, not the finesse of the construction of the plot, but (varied) repetition, contrast, strong statements and convincing visual appeal are criteria according to which the scenes are connected.[22]

In addition, it is remarkable that the stock characters are, to an extent, concurrently universal and specific, or at least they are depicted as such. The stock characters move seemingly effortlessly from scenario to scenario and remain the same, even though they constantly change context. They are both predefined and fluid. A number of scenarios and stock characters can easily be recognised in comedies by Shakespeare. In the seventeenth and eighteenth centuries, the Netherlands and Flanders also had a rich tradition of comedy that referred directly and indirectly to these stock characters.[23] The set masks and pantomimes are thus continually placed in a new context, their distinctive features challenged, confirmed, or redefined.

If we study this theatrical form in terms of representation or imitation, we can see that an interesting, layered structure emerges. The stock characters always encompass their history of representation, i.e. they represent a particular stock character in a particular play, but they also refer to the plays before and, in a certain sense, after. It is a world of histories, which we encounter in morality plays, comedies and farces, histories that begin again and again as soon as they have ended. They always bring chaos and, as soon as order seems to be restored, they refer to the next repetition and thus take on a cyclical character. In this way, they are diametrically opposed to a linear, progressive concept of history and the ideal of consolidation and uniformity, as propagated from the Renaissance and the emerging humanism.

2.4 Absolute drama

In contrast to the heterogeneity and episodic nature of both popular and court theatre, a dramatic form emerged from the Renaissance based on unity, consistency, regularity, and verisimilitude. Peter Szondi aptly characterises this dramatic form as 'absolute drama'.[24] During the Enlightenment and in the context of humanism, drama in the sense of 'absolute drama' assumed the status of the norm. It is still considered to be the prototype of drama today, even if it is critically approached, undermined, or outright dismissed. According to Szondi, at the centre of 'absolute drama' we find the human

being as fellow human being, resulting in the dramatic character, whose conflicts, decisions, and desires motivate the action of the drama. The medium of this interpersonal world is dialogue, a dialogue, according to Szondi, that knows nothing outside of itself. In other words, the world of the 'absolute drama' is an absolutely closed fictional world. Hence components that render the boundary between spectator and stage visible (such as prologue, chorus, and epilogue) disappear. Thus, the separation between spectator and stage is absolute. Szondi comes to a surprising conclusion: '[Drama] is not a (secondary) representation of something else (primary); it presents itself, is itself. Its action, like each of its lines, is "original"; it is accomplished as it occurs. The Drama has no more room for quotation than it does for variation.'[25]

This statement is as fascinating as it is paradoxical. Drama as a work of art is, of course, still based on representation, but in its form and occurrence it presents an autonomous fictional world, independent of the world of the spectator. The most important formal elements to ensure the drama's absoluteness are unity of action, unity of time, and unity of space. Everything expressed in 'absolute drama', including historical, social, and political aspects, must arise from interpersonal relationships and situations: everything must be expressed through dramatic characters. The unity of action is closely related to the unity of time. The time of the drama, Szondi states, is always present, i.e. each situation includes both the preceding and the following situation. This way, a continuous 'now' is created. The passage of time is thus strictly linear and causal-logical. Unity of space supports the consistent linear development because a frequent change of space complicates the absoluteness of the dramatic scene. One aspect that Szondi does not mention is that the space of absolute drama is increasingly found indoors, it is the space of the bourgeois subject.

2.5 Concepts of drama analysis

Before continuing our more or less historical exploration of different types of (text) material, it is worth discussing some of the basic concepts of drama analysis. Within the field of literary studies, there is a repertoire of terms and concepts that can help us to get a grip on and gain insight into text as material. The concepts have also been taken up by dramaturgs and theatre scholars. They reflect a large part of the Western theatre repertoire but can be particularly applied to dramatic texts that are, in principle, based on the concept of absolute drama.

Primary text / Secondary text

A special feature of dramatic texts are the so-called stage directions and/
or scene descriptions. Historically, we find this phenomenon already in
liturgical dramas in the Middle Ages, in the Baroque theatre, and, to a
larger extent, in French Classicism. Before stage directions became an
explicit dramatic convention, we find implicit stage directions that were
incorporated into the spoken parts of a play, for example in the form of
spoken localisation techniques or the expression of feelings as occurred in
Elizabethan theatre.[26]

Stage directions are often described as a secondary text in contrast to
the spoken text, which is then referred to as the primary text or main text.
However, the hierarchical nature of these terms undermines the function
of a secondary text with regard to the generation of meaning. Concepts
like 'paratext' or 'text space' try to circumvent this hierarchy. The term
'paratext' refers not only to stage directions, but also to genre indications
(such as drama, tragicomedy, lyric theatre, etc.), dedications, the list of
dramatis personae, etc. Anke Detken's concept of 'text spaces' emphasises the
interconnectedness of the various phenomena of text within a theatre text.
The debate around the concepts also relates to the function of secondary text
from the historical avant-garde onwards, which can no longer be understood
as mere stage directions. For instance, in 1992, Peter Handke wrote a play
Die Stunde da wir nichts voneinander wußten (*The Hour We Knew Nothing
of Each Other*) that consists entirely of secondary text.

The question is, then, what function a secondary text plays and how
the various forms of text relate to each other. If we look at realistic or
naturalistic theatre, secondary texts indeed take the form of stage direc-
tions. They can be understood as an attempt to control the reception of a
play. But what about a secondary text written by, for example, Ödön van
Horváth, an Austro-Hungarian playwright who radically renewed the folk
play at the beginning of the twentieth century? He describes the stage at
the beginning of his play *Hin und Her* (*Back and Forth*) as follows: 'There
are thick bushes on both banks and the branches of the weeping willows
droop down into the border river, it is a somewhat monotonous region,
flat everywhere – even on the horizon there are only clouds instead of
any hills. But beautiful clouds.'[27] The description itself can be read as a
parody of realistic stage directions by referring to a repertoire of kitschy
scenarios. The concluding ironic sentence, 'But beautiful clouds,' turns the
scenario completely upside down. Such a direction is difficult to translate
onto stage, but refers to conventions of the folk theatre at that time. The

involved theatricality of the scene description exceeds the function of stage directions.

Another example is the beginning of Lodewijk de Boer's play *De herin-nering (The Remembrance)*, a play about the role of the Swedish singer Zarah Leander, who was highly popular in Nazi Germany during the Second World War. The play begins with 'Theses by Zarah Leander', which mention Zarah Leander as the speaker. However, this is followed by a text in italics, a typical feature of stage directions, even though the text suggests a spoken text: *'As Luther once proclaimed his ninety-five thesis, I would like to document the following points:* [...].'[28] One by one, the nine theses deny any responsibility on Leander's part for her contribution to Nazi propaganda. The theses are followed by a description of the stage setting and the list of dramatis personae. So, what is the function of the theses marked as spoken text in relation to the primary text? Is it the intention to speak the propositions before the play begins? Is it a different Zarah Leander than the Zarah Leander who appears on stage after a Prologue with Anne Frank in Scene 1? De Boer challenges dramatic text conventions, albeit in a different way to Horváth. The text spaces he creates or the secondary texts he provides are markedly different from simple stage directions. Here, too, the question is how the texts relate to each other, how they structure fictional spaces or introduce different layers of fiction, in short: what theatrical possibilities do these secondary texts provide, how do they contribute to processes of creating meaning or undermining it, and in what way can they be actively explored in creative processes?

Story & plot

When analysing theatre texts, we can distinguish between story and plot. Story is understood as a chronological sequence of events, whereas the plot is the concrete organisation (causal, chronological, etc.) of a story. Foster, who introduced these concepts, gives the following as an example of a story: 'The king died and then the queen died,' a possible plot could be depicted as 'The king died and then the queen died of grief.'[29] Thus, the plot gives perspective to a story. But that does not necessarily tell us how a story is transformed into a plot. The plot can just as easily be used to write a novel, tragedy, comedy, poem, song, opera, or dance. The essence of Foster's example is the causal connection between two successive events; the plot then determines how the events follow each other. For a dramatic adaptation of a story, it is in fact enough if the story contains a change. In this sense, the story 'The king died' would be sufficient; after all, death is

an irreversible change. There are dozens of plays that have transformed this very story to plot, from most of Shakespeare's royal dramas, to Ionesco's play *Le Roi se meurt*. More specific than Foster's approach is to understand plot not only as a perspective on a story but as the concrete organisation of that which is meant to be rendered visible on stage. In many cases, the plot is much more compact than the story. The story of *Oedipus*[30] is in fact the entire life story of Oedipus, but the tragedy is only about one moment in time within that story. Thus, plot is not only the concrete organisation of the story, but the story contains more than the plot, namely the events of the plot plus the entire previous and subsequent history. The moment in the story at which the plot begins is then the *point of attack*.

If we look at the composition of a dramatic plot, we can distinguish between closed and open drama. In a closed drama, the actions are connected in a causal-logical way (linear). At the centre is a conflict that is structured as a struggle between two forces that inevitably leads to a climax. Closed dramas have a clear beginning (exposition), which is followed by a complicating action that sets the dramatic development in motion (for example, by an antagonist or an incident). The increasing complication and complexity of the action (or action in an ascending line) leads to the crisis (the climax, often in the form of *peripeteia* or reversal) followed by the denouement (falling action, often including postponement) which, in tragedy, eventually culminates in a catastrophe. In principle, most Greek tragedies and absolute drama follow this composition of plot. What is crucial is that the actions follow each other in a logical, necessary, and probable way.

The plot of an open drama often consists of several storylines or subplots. The scenes are only loosely connected and sometimes even interchangeable. The unity of space and time is rather unimportant, spaces regularly change and time leaps are no exception. In contrast to closed drama, the end does not lead to an unambiguous denouement. Many of Shakespeare's plays, especially the comedies, have an open plot structure. In comedies, the different plot lines serve, among other things, the function of creating contrasts and a comic effect. But open plots are not only found in comedies. Writers such as Strindberg, Büchner, and Brecht also apply open dramatic forms in their plays.

For analysis of a theatre text, it is important, firstly, that the composition of a plot reflects dramatic conventions, i.e. concepts such as open or closed drama do not involve value judgements but reflect the historical contexts and aims of the drama. Secondly, the plot indicates how formal elements (dramatic character, dialogue, conflict, time structure, space, etc.) relate to each other; and thirdly, the vision or the perspective on a certain story

becomes recognisable in the plot. Looking ahead to theatrical conventions of the late twentieth and early twenty-first centuries, it is striking that the minimum requirement for a plot to involve the development of an action or simply a reversal/*peripeteia* no longer applies. Instead of an action, a situation is often the starting point of a theatrical adaptation. The aim, then, is not so much to depict an action or an event, but to investigate a situation by theatrical means. Although the aforementioned dramatic conventions no longer apply to these theatre forms, the underlying questions remain relevant as guiding principles: How is the connection between fiction and reality given shape? What (aesthetic) formal principles are employed? How are space, time, etc. organised?

Dramatic characters

Like a guiding thread, the conception of characters and the accompanying discourse plays a pivotal role in both theatre texts and dramaturgical processes. The dramatic character can be understood as the hinge point between body and text, to which the actor must relate. From a dramaturgical perspective, the character therefore occupies a central position with regard to the text. Hence when analysing dramatic characters, it is relevant to look at what kind of 'dramatic character' we are dealing with, how the characters relate to each other, in what way they are characterised in the drama, and how they address (or do not address) the world of the spectator.

In his study *The Theory and Analysis of Drama*, Manfred Pfister distinguishes between different conceptions of dramatic characters.[31] Depending on the genre or the historical context, dramatic characters can be open, multidimensional, and dynamic. These are characters with multiple, sometimes contradictory features, who undergo a development in the course of the plot. Along with their opponents, they are often the leading figures, i.e. the protagonists and antagonists in tragedies and dramas. On the other hand, there are closed, one-dimensional, and static characters who have only one or a few characteristic features and undergo no development. In this case, therefore, we are not dealing with round characters but with types or stock characters. Serving or subordinate characters in tragedies, but particularly characters in comedies, meet these criteria. Such a distinction becomes particularly interesting when, in a play, both concepts are deliberately put right next to each other, as is often the case with Brecht, for instance. Brecht uses stock characters to designate nameless subjects such as the peasant or the servant. He does this to, among other things, make social power relations visible. However, the various conceptions of dramatic characters always

refer to the image of humanity of a specific time. Open, multidimensional, and dynamic characters, for example, represent the ideal of the acting and self-aware representative of an emerging bourgeois world.

An important way of gaining insight into the processes of the production of meaning is to examine the *constellation* of the characters. This process of signification is brought about by, among other things, similarities and contrasts between characters. The combination of similarities and differences not only moulds the characters, but also the environment and time in which they are situated. Which characters belong to each other? How do protagonist and antagonist, protagonist and serving characters, female and male characters, relate to each other? Which characters refer to each other with sympathy or antipathy, collaboration or antagonism, etc.? How are the different groups characterised? Do the constellations of sympathy/ antipathy change during the plot? Characters also gain meaning from the space in which they move: are they in the house, in a city, in a palace, in the countryside, or in a forest? Do the spaces represent desirable or undesirable spaces, and how do the characters relate to the spaces?

In his book, Pfister also provides quantitative possibilities for analysing characters, such as the *configuration* of characters. The configuration of characters indicates which characters are on stage at a certain point in the text. The configuration thus changes with each entrance and exit of a character. Although such an analysis only considers the presence or absence of characters in the course of the dramatic development, a number of conclusions can be drawn from it. It reveals, for example, alternating characters, i.e. characters who avoid each other, or concomitant characters, i.e. characters who are always on stage together. Sometimes, the configuration gives additional insight into the relationship between characters, as in Lessing's *Emilia Galotti*. In this play, the eponymous character Emilia only appears in the second act and has only seven appearances in the 43 scenes, one of which is without text. Her presence on stage therefore hardly justifies her status as the title character; without an analysis of the configuration, this could easily be overlooked. In the case of *Emilia Galotti*, the configuration elucidates that the main character is mainly discussed, manipulated, and determined by other characters.

Besides analysing the constellation and configuration of characters, an investigation of the *characterisation of characters* in a theatre text is important. Pfister distinguishes between a figural and an authorial characterisation of dramatis personae. Figural characterisation relates to expressions of characters in the primary text, while authorial characterisation relates to stage directions and secondary texts, i.e. passages of text

that can be directly attributed to the author of the play. Both figural and authorial characterisations can be explicit or implicit. As explicit figural techniques of characterisation, Pfister mentions soliloquy, which can be in the form of a monologue, comments by others, or in dialogues. In the latter case, it is relevant to analyse whether the character being characterised is present at that moment, and whether characterisation takes place before the character first appears on stage or not. For example, protagonists are often characterised by several different characters and in different ways before their first entrance on stage, thus creating a controversial image. Alternatively, a character introduces themselves by means of a monologue at the beginning of a play and the image we get of them is corrected, confirmed, or undermined by the comments and dialogues that follow. As implicit figurative characterisation techniques, Pfister mentions non-verbal characteristics such as physical stature, facial expression, gesture, costume, or props. These are features that, although non-verbal, are expressed through the primary text. A famous example is Shakespeare's *King Richard III*, who is known as the 'hunchback king'. Shakespeare gives no concrete stage directions for his physical stature, but has Richard describe himself in his first monologue as follows:

> But I, that am not shaped for sportive tricks,
> Nor made to court an amorous looking-glass;
> I, that am rudely stamped, and want love's majesty
> To strut before a wanton ambling nymph,
> I, that am curtailed of this fair proportion,
> Cheated of feature by dissembling nature,
> Deformed, unfinished, sent before my time
> Into this breathing world, scarce half made up,
> And that so lamely and unfashionable
> That dogs bark at me as I halt by them –[37]

Moreover, Pfister mentions verbal qualities of the dramatic characters such as verbal behaviour, word usage, dialect, and stylised language as aspects of characterisation.

As explicitly authorial techniques of characterisation, Pfister mentions the description of dramatis personae at the beginning of a play and telling names. The overview of dramatis personae at the beginning of a play is a convention that was only systematically applied in the nineteenth century. The dramatis personae not only show how the characters relate to each other, but also provide insight into the power relations between characters.

Aristocratic characters are usually at the top, servants at the bottom, women follow men, and are often indicated as 'the wife of', children are always designated as daughter of or son of, etc. Telling names are especially common in comedies. In terms of implicit authorial techniques, Pfister mentions implicitly characterising names, and similarities and contrasts between characters.

These analytical concepts are particularly applicable to dramatic texts with characters as the bearers of the action. As Elinor Fuchs, Marianne van Kerkhoven, and Peter Szondi, among others, have noted, a profound transformation of the concept of the dramatic character started to take place at the end of the nineteenth century. Although such characters can still be examined by using the aforementioned analytical criteria, one must realise that, in view of a considerable number of contemporary plays, we can no longer speak of psychologically developed, round characters.[33] A different analytical vocabulary is needed to examine contemporary theatre texts where characters are not indicated by names, but by letters or numbers, or by the name of the actor/actress. Instead of characters, actors and actresses then function as mouthpieces of social discourses, they do not represent actions but present a polyphonic textual material to which spectators can/must relate. Dramaturgical research is then based not so much on the analysis of characters but on the analysis of the polyphony of the textual material in relation to other theatrical sign systems.

Monologue

The 'crisis of drama', as formulated by Szondi, manifests itself in, among other things, the impossibility of addressing one's fellow humans. In writers such as Chekhov, Szondi observes a shift from what takes place *between* individuals, to what takes place *within* an individual. Although Chekhov maintains the form of a dialogue, his characters are in fact responding with monologic speech acts. Below, we will elaborate on the differences between monologic speech and distinguish four manifestations of monologues: 1) monologic speech; 2) inner monologues as part of a dramatic text; 3) monologue as a genre; and 4) monologic-polyphonic theatre texts.

Monologic speech is a phenomenon that we encounter in the plays of Chekhov and Ibsen, and increasingly among post-Second World War writers, from Samuel Beckett, Thomas Bernhard, Bernard-Marie Koltès, and Judith Herzberg, to Sarah Kane. If, as Van Kerkhoven argues, following Szondi, theatrical forms are determined by the needs of the particular matter or material, what is made manifest by monologic speech? Her answer is that

monologues can be seen as a metaphor for social isolation, the individualisation of the modern citizen, and for the collapse of social communication, but also as a moment of pause and reflection.[34] But there are differences when it comes to the reasons for isolation or loneliness. Chekhov's characters are at odds with themselves, longing for the past because they cannot get a grip on the present. In Ibsen's case, the characters are solitary due to a secret that they cannot share with others. In the case of post-Second World War writers, it is the ravages of the war that lead to the impossibility of communication, as in the plays of Beckett. This is also true, to some extent, of Thomas Bernhard's characters. In Sarah Kane's play *Crave*, the characters C, M, B, and A can be understood as disintegrated aspects of one character that are in conflict with each other. Thus, it is not only a question of social isolation and social alienation, but of unbridgeable alienation from oneself. The use of a variety of languages by theatre makers such as Jan Lauwers, Jan Fabre, or Wim Vandekeybus also resonates with this. The Flemish dramaturg and theatre scholar Erwin Jans observes that all these performances start from 'silence and stillness or from a certain form of stuttering or non-communication.'[35] Although monologic speech is used as a formal element in all these plays, the reasons for the impossibility of dialogue thus vary considerably.

Inner monologues have a long tradition in dramatic theatre; the most famous example is probably Hamlet's 'To be or not to be' monologue. Inner monologues are an opportunity to depict the internal struggle of characters, to show the complexity of their emotions and thoughts, or to expose the abysses of self-deception, as in the aforementioned monologue by Shakespeare's *Richard III*. The conflict of feelings can also become the main subject of a play, as in Seneca's *Medea*. The play is basically a long monologue by Medea, in which she first tries to get a grip on her rancour against Jason, then to stir up her revenge, and finally to carry it out. In dramatic texts, inner monologues have the function of elaborating the psychological features of characters, they are then more like dialogues with oneself.

Although monologic speech and inner monologues *interrupt* the inner-fictional world of the stage, they do not necessarily imply the *rupture* of this inner-fictional world. They may even reinforce it (as is often the case in Shakespeare's plays). The relationship between the inner-fictional world and the outer-fictional world, however, always contains a tension when it comes to the monologue as a genre. Monologues as a genre (or monodramas) gained ground in the twentieth century, exploring the presence of the audience in very different ways. The monologue *Een herenhuis te koop* (*A Mansion for Sale*) by Herman Heijermans (1914), for example, takes place

in an auction house and puts the audience in the position of potential buyers. In Heijermans' monologue, the audience becomes part of the fiction, or at least the audience must actively relate to the fictional world. Jean Cocteau makes a completely different choice in his monologue *La Voix humaine* (*The Human Voice*, 1928). Here, a woman is on the phone with her ex-husband, who is going to remarry the next day. We hear only her part of the conversation and witness her increasing despair, which ends in suicide. Due to the private atmosphere and the personal nature of the conversation, Cocteau positions the audience in the uncomfortable position of voyeurs, of involuntary witnesses, or of the imaginary character at the other end of the line. The telephone represents, as it were, the collapse of communication, but also the absence of communication. In 2016, almost ninety years later, the Dutch actor, playwright, and director Ramsey Nasr performs the man's answers in *De andere stem* (*The Other Voice*). Although the man is also situated in a living room, he is now equipped with an iPhone and a laptop. In *The Other Voice*, not only does the audience bear witness to his attempts to break out of a suffocating relationship, but also his new girlfriend. The audience is still in a voyeuristic position, but the presence of the new girlfriend shifts the existential crisis that holds the audience accountable as a potential addressee to a dramatic situation that excludes the audience.

Monologues often accentuate the precarious situation created by the distance between fellow humans, or between humans and the world. In addition to expressing the existential crises of individuals who have become isolated as a result of their social position or social norms, monologues can also articulate accusations against societal failures. This concerns questions of identity, the choice to consciously oppose an incomprehensible reality, to choose isolation in order not to (have to) become an accomplice.

A monologue like *Para* by the Belgium cultural historian and writer David Van Reybrouck (2016) problematises the role of military peace missions, in particular the Belgian mission in Somalia. A former member of a paratrooper commando looks back on the mission in a speech that assumes the form of a TED talk. The speaker continuously loses his position in time and to himself: there is a narrating voice; a reporting voice; a voice that re-experiences incidents; a voice that stammers; a voice that tries to give itself a posture. The audience is assigned the role of listener, as in Heijermans' monologue. But the story of *Para* is not fictional; it refers to a recent historical event. Because Van Reybrouck continuously intertwines changing voices, perspectives, and standpoints in the text, a theatricality emerges that continuously destabilises the inner-fictional world of the stage. Alternating

stories of idealism, violence, amateurism, boasting, racism, cynicism, and institutional irresponsibility make it impossible for the audience to adopt a steady viewpoint; they are hurled back and forth with the speaker in search of a solid position. Texts like *Para* reveal that the speaker loses the authorship of their story. Unlike the messenger in Greek tragedies, they are unable to carry the story; the story shatters into a multitude of perspectives that cross and overlap each other.

The fourth manifestation of monologue shows, to an extent, resemblances with monologues such as *Para*. For want of a better term, we would like to typify them as monologic-polyphonic theatre texts. These are texts such as Jelinek's play *Die Schutzbefohlenen* (*Charges* [*The Supplicants*],[36] or Sarah Kane's play *4.48 Psychosis*, or texts such as DAM or GOD from the Flemish-Dutch theatre makers BOG.[37] Sometimes, writers like Jelinek or Kane do not mention characters or actors or names of speakers at all. Yet different voices can clearly be recognised, allowing these texts to be described as polyphonic. In Kane's text *4.48 Psychosis*, the different voices may be individualised in the form of a patient, psychiatrist, or visitor, but are we actually dealing with concrete voices or rather with inner voices, or voices that are imagined, invoked? What significance can be attributed to the layout of the text? Many passages resemble visual poems — how can these texts be translated into a staging? Kane's text undermines the stability of a coherent narrative and of representation, as the different voices can never be accurately captured; the endless stream of thoughts, words, pleas, and curses only revolve around themselves, only refer to themselves. It is up to the spectator to construct a story out of the labyrinth of utterances, to relate to it or not.

In Jelinek's texts, individual positions are completely absent; the voices often reverse the speaking agency within a single sentence by continuously attributing different personal pronouns. Her texts are, as it were, a realisation of the postmodern dictum 'not speaking but being spoken'. It is the polyphony or rather cacophony of different discourses, politics, media, advertising, economy, etc. that undermines a clear subject's position. Although BOG. designates speakers by numbers, no individual positions can be established in their texts either. Similar to Jelinek, their texts are streams of thought, records of oscillating positions that emerge during the process of creating a performance. As the self-description 'collection of theatre makers' suggests, they refuse to tie the collection together into a collective. Nor can the voices of their texts be condensed into a story. To a certain extent, monologic-polyphonic theatre texts leave behind the dialectic between subject and object, and between human and society.

They are texts that stage language itself, they problematise language as a material and as subject matter, and in a paradoxical way they instigate new processes of meaning. The dialogue does not take place on stage but shifts to a dialogue or polylogue between stage and audience.

Re-definitions of processes of meaning production

The techniques and methods of analysis mentioned above all apply to theatre texts that represent an open or closed fictional world. But as Gerda Poschmann notes, with good reason, in her study *Der nicht mehr dramatische Theatertext* (*The No Longer Dramatic Theatre Text*), concepts such as open and closed drama, the distinction between story and plot, or the conception of dramatic character mainly concern the outward construction of theatre texts.[38] If, however, we assume that the 'outward' formal choices reflect a content-related perspective on the material, the dichotomy between form and content becomes less rigorous. Moreover, it opens up the possibility of examining, also with regard to dramatic theatre texts, how 'the theatre gives shape to its social function,' in line with Marianne van Kerkhoven's description of 'major dramaturgy.'[39] What Poschmann, but also Van Kerkhoven, Fuchs, or Delgado-García are ultimately referring to, is an increasingly critical attitude towards the dramatic form over the course of the twentieth century that has consequences for the conception of dramatic characters and the organisation of dramatic time and space. Along with the varying approaches to these formal elements, there are redefinitions of the aims and purposes of theatrical productions and the questioning of processes of meaning production.

2.6 Brecht: Epic theatre

At the beginning of the twentieth century, theatre makers like Edward Gordon Craig, Oskar Schlemmer, Filippo Tommaso Marinetti, or Vsevolod Meyerhold tried to renew theatre in general and drama in particular, in sometimes quite radical ways. All attempts involved a change in the conception of dramatic character and/or the role of the actor/actress. Although their texts and manifestos continue to inspire theatre makers today, the influence of Bertolt Brecht's epic theatre is still prominent in theatre landscapes on a worldwide scale. Brecht's vision of theatre becomes clear in his well-known description of the differences between dramatic and epic forms of theatre, which we render here in short.[40]

Dramatic theatre	Epic theatre
plot	narrative
implicates the spectator in a stage situation and wears down his capacity for action	turns the spectator into an observer, but arouses his capacity for action
provides him with sensations	forces him to take decisions
experience	picture of the world
the spectator is involved in something [...]	he is made to face something
the human being is taken for granted	the human being is the object of the inquiry
he is unalterable	he is alterable and able to alter
eyes on the finish	eyes on the course
one scene makes another [...]	each scene for itself
man as a fixed point	man as a process
thought determines being	social being determines thought

It is noteworthy that central aspects of the dramatic form such as action, decisions, thought, or recognition are shifted from the dramatic characters to the spectator. The Brechtian spectator does not empathise with the events depicted on stage but, as Walter Benjamin puts it, watches with interest and astonishment.[41] This attitude of the spectator is enabled by shifting the focus from the 'hero' to the conditions, and by showing the conditions not in the form of a causal-logical linear event, but as a series of situations. Central concepts of Brecht's epic theatre are therefore 'showing' and 'interruption'.[42] Both concepts interrupt a continuous representation of events and belong to the so-called alienation effects. The notion of showing actions makes a clear distinction between what has happened and *demonstrating* what has happened. Brecht illustrates the difference in his notes on the Street Scene: an accident has happened, and a witness shows his view of what has happened. The witness does not empathise with the events but shows/demonstrates what he has seen. This attitude of showing is what Brecht asks of his actors. They are not meant to identify with the dramatic characters, but rather to show their attitude and their emotions towards them. Through this double presence – as actor/actress and as dramatic character – the spectators are asked to take up their own viewpoint, i.e. to become active. The meaning of what is shown is therefore not imposed on the spectator, they have to draw a conclusion themselves.

Brecht's vision of the relationship between society and human beings implies that the situations and social conditions are placed at the centre of

theatre texts. The characters stand opposite situations, are determined by social conditions, and/or have to relate to them. The characters in Brecht's plays are often one-dimensional or have the characteristics of stock characters. It is precisely in this way that Brecht displays not only the alienation of the possibility of interpersonal dialogue, but also the alienation between humans and the world. We do not need any Marxist ideas to perceive this alienation between humans and the world; we can just as easily find traces of this alienation in Ibsen, Chekhov, or Heijermans. The difference is that Brecht's critical approach to dramatic theatre involves a transformation of central formal elements such as dramatic character, time, and space.

As mentioned before, interruption plays an important role in the 'composition of events'. According to Brecht, the focus is not on the outcome but on the course of events. The sequence of events is not causal-logical, but each scene stands for itself. The illusion of a continuous now of the dramatic action is thus interrupted and connections are disassembled. Multiple plot lines, as they are often found in comedies, no longer control the production of meaning by depicting contrasts, but contrasts cause a shock to enable new insights. Instead of a homogeneous plot line that connects dramatic characters, action, time, and space into an apparently inevitable whole, the principle of montage comes into play. A key principle of montage is juxtaposition: juxtaposition of (dramatic) situations; of different theatrical elements such as body/acting, sound, music, images, media; but also juxtaposition of time and space.

Through the principle of montage, a continuous linear passage of time is interrupted, brought to a standstill, fragmented, accelerated and/or extended, with the result that processes of meaning production are also constantly interrupted. Montage in Brecht's sense involves making transitions visible; the focus is on the relationship *between* the images, *between* the situations. In contrast to absolute drama, this space of 'between' is not the space in which humans reveal themselves as fellow humans, but rather signifies the gap between humans and the wider world, between the particular and the general. Montage as a dramaturgical principle disrupts the symbolic unity of the humanist image of the human, which finds its expression in absolute drama. Instead, according to Szondi 'the subject-object opposition that is at the origin of epic theatre (the self-alienation of the individual, whose own social being has become reified) is precipitated formally on all levels of the work and, thus, becomes its general formal principal.'[43] Montage as a dramaturgical tool thus has fundamental consequences for the relationship between stage and spectator and ultimately for the concept of drama as a closed fictional world.

Interruption, alienation, demonstrating situations, and montage interrupt the constructed closeness of a fictional world by referring to and quoting the real world, the world of the spectator. In this way, theatrical sign systems are restructured. Dramatic form elements such as dramatic character, space, and time are not only aimed at maintaining an inner-fictional reality (i.e. the reality depicted on stage) but explicitly refer to an outer-fictional reality (i.e. of the spectators and their social, historical context). The dialogue 'between' human beings and their fellow human beings of absolute drama shifts to an exploratory investigation of the relationship between the events on stage and the world of the spectators. The dramatic 'now' on stage is interrupted and pushed right into the audience space. In short: the almost magical definition of theatre as a mutual here and now is defined in a completely different way by epic dramaturgy than it is by dramatic theatre.

As in many other parts of the world, the emancipatory aspect of epic theatre was embraced, varied, and further developed in the Netherlands and Flanders from the 1960s onwards. However, it is important not to subsume all theatre texts and theatre productions with characteristics of fragmentation, montage, or multiple storylines under the denominator of 'epic theatre'. The question that always arises is whether theatrical sign systems refer only to an inner-fictional reality or also to the outer-fictional reality; whether there is a closed fictional world or layered fictional worlds and social and historical realities; whether and how spectators are addressed by the organisation of the various dramaturgical means.

A good example is Judith Herzberg's play *The Wedding Party*, which she wrote in 1981/82 for, and partly together with, the Baal theatre group. As the name of the theatre group already suggests, there is an affinity with Brecht (*Baal* is the title of one of Brecht's plays), and since the play contains more than 94 scenes with scattered scraps of conversations that show little connection with each other and are interrupted by songs, an epic approach is evident. Herzberg situates the play in 1972; the action takes place in the side rooms of Lea and Nico's wedding party. The fourteen characters are survivors of concentration camps, children who had to go into hiding, a war mother and some non-Jewish relatives, colleagues, and two waitresses. The conversations reveal, above all, the impossibility of dialogue. Misunderstanding characterises the relationship between the generations, between concentration camp survivors and their children, between the experience of the war mother and the mother who had to leave her child behind, between the young people who lived through the war and those who were born after the war. The songs between all these impossible conversations either give a surreal insight into the emotional world of

the characters or quote documents, such as letters of instruction to foster parents and biological parents. At the same time, these reconstructed war documents are contrasted with quotes from the apparently new normality, as found in travel guides.

In his analysis of Herzberg's work, the distinguished Dutch writer Arnon Grunberg remarks: 'In her plays, the characters do not relate to other characters but to what they conceal. The hidden is neither a part of the plot, which in any case hardly interests her. Rather, the secret is a fundamental incommunicability [...].'[44] In other words, the estrangement between humans and the world has become absolute as a result of the experience of the Second World War in general, and the Holocaust in particular. Instead of problematising the relationship between subject and object or between subject and world, as in Brecht's epic theatre, the incommunicable, the unspeakable, intervenes the space between human and human, but also between humans and the world; or, as Alexander, one of Lea's ex-husbands, observes at the end: 'Living is what they used to do.'[45] Dramaturgically, it is important that theatrical means such as songs or fragmentation of actions and situations, or even very concrete information such as the year of birth of characters,[46] do not interrupt the inner-fictional action as in Brecht's work. On the contrary, they relate to and strengthen the inner-fictional world of the play. 'Incommunicability' as a fundamental aspect of surviving ultimately also marks the boundaries between stage and spectator.

2.7 Metatheatricality

Metatheatricality is a dramaturgical concept that can be expressed in very different ways. By metatheatricality we understand the instances when theatre reflects on itself. This can be done either by text, characters, acting, scenery, or other theatrical means. Here, too, we must look at the ways in which metatheatrical means organise the relationship between stage and audience, and to what ends metatheatricality is used. In principle, any play-within-a-play structure, as we frequently find in Shakespeare, can be understood as a mode of metatheatricality. Consider the scene in which Hamlet instructs the actors how to play honestly (i.e. to observe nature), so that the actors' play will reveal the truth: that his uncle Claudius has murdered his brother, i.e. Hamlet's father. This scene is packed with meandering layers of theatricality: the entrance of the players; Hamlet's instructions to the players; the positioning of the (fictional) audience on the

stage; the actors' performance of the play; and Hamlet's comments on the play in his whispers with Ophelia. Although all these layers of theatricality double the relationship of stage and audience (of seeing and being seen) the fictional world is maintained, i.e. all theatrical sign systems focus on the inner-fictional world and relate to the meaning production of this world. Nevertheless, it is fascinating that, in recent years, theatre makers have frequently evoked Hamlet's request to Polonius: '[...] Do you hear, let them [the actors] be well used, for they are the abstract and brief chronicles of the time.'[47] As we will discuss later, theatre makers regularly use theatre as a means to explore reality.

Luigi Pirandello uses metatheatricality in a completely different way in his play *Six Characters in Search of an Author*. Elinor Fuchs refers to this play as 'the theatricalist *Ur*-text in the modern period'[48] on which authors like Beckett, Handke, and Heiner Müller have built on. At its premiere in 1921, the play caused an enormous scandal. In short, six characters appear in the theatre and ask the rehearsing actors, actresses, and director to develop their story. Although an author created them as fictitious characters, he never completed the story. The play is about the composition of their story in front of the audience, or rather the failure of its dramatisation. The shortcomings of dramatic conventions become clear again and again: several things happen at the same time, in different spaces, and it is up to the director to explain that these kinds of realities do not meet the requirements of drama or the space of the theatre. The actors do not succeed in fulfilling the claims of the characters, their attempts to depict the characters are but a hollow representation of what they believe themselves to be. Therefore, the key concepts of drama – plot, character, time, and space – become problematic. The play constantly oscillates between representation and presentation. There is the plot of the play (beginning of rehearsal, entrance of characters, putting together the story, failure, return to normality) and the elaboration of the plot of the six characters. Time is both represented time (the story of the six characters) and presented time (the construction of the play in the here and now of the audience) and the same applies to space. Pirandello's play problematises both dramatic textual conventions and staging conventions, the subject of his play is thus the drama of the drama.[49]

2.8 Theatre of the Absurd

The relationship between character, space, and time is further problematised in the various forms of theatre of the absurd. In plays by Beckett, Ionesco,

Havel, Arrabal, and Pinter, there is hardly any action. The characters are placed in a situation, or rather, they are, as it were, subjected to a situation. Interestingly, spatial constellation plays an active role. In dramatic theatre, space is often seen as a self-evident background that is barely noticed. It is the space in which actions take place and in which conflicts are carried out. It can contribute to the production of meaning or to the characterisation of dramatic characters, as in realistic or naturalistic theatre, but the spatial order never becomes fatal to the characters. However, this is the case in plays by Ionesco such as *Exit the King* or *Rhinoceros*, in which public and private spaces collapse or permeate each other and the characters no longer have solid ground under their feet. With Beckett, the characters literally and figuratively find themselves stuck, regardless of whether they are in a closed space (*Endgame*) or an open space (*Waiting for Godot, Happy Days*). Not only are they stuck in space, but their possibilities of movement seem to be determined from the start and doomed to be repeated endlessly. In addition to space, time becomes problematic. It seems as if recent history, i.e. the Second World War, has destroyed any sense of time; characters are subjected to endless repetitions that do not structure time but completely erode it. Time becomes an endless mush of the same thing over and over again. Finally, the possibility of expressing oneself is exposed as impossible. The characters' speech is quotation, self-citation, repetition, phrase. The different approaches to the theatre of the absurd actually undermine all the fundamental principles of dramatic theatre, i.e. linearity of time, stable space of action, and acting of dramatic characters. Erwin Jans emphasises the connection between the human condition after the Second World War and dramaturgical developments:

> The anonymity that dominates and gives shape to the modern post-war world escapes the categories of the dramatic (dialogue, conflict). Only in showing its own catastrophe and dissolution – as in the plays of Beckett – can the dramatic form evoke something of that anonymity. [...] There is no longer any (verbal) grip on reality. Both reality and language have become elusive and unreliable.[50]

A world that has become intangible and unreliable also withdraws from representation, at least from representation in the sense of realism. The crisis of representation that becomes evident in theatre of the absurd can also be understood as a crisis of the ability to perceive reality. Paradoxically, the plays of Beckett and Ionesco can be considered as representations of the non-representable, of the unspeakable, the silence, the void, which is

experienced as reality but which, at the same time, withdraws from the logic of realism.

Similar developments can also be found in dance theatre, where both coherent storylines and traditional hierarchical production conditions are abandoned; think of Merce Cunningham, Pina Bausch, or the Nederlands Danstheater. Although critical approaches to dramatic theatre have strongly influenced theatre makers to this day, the dystopian worldview that these theatre productions evoke would give a distorted picture of the theatre landscape of the 1950s and later. Parallel to these fairly profound revisions of (dramatic) theatre, we also witness the so-called golden age of the (Broadway) musical, with productions such as *My Fair Lady*, *Westside Story*, *Sound of Music*, or *Fiddler on the Roof*. The success of these musicals was largely due to a coherent storyline and a homogeneous composition of all theatrical means such as music, singing, dancing, and scenography. In the Netherlands, musicals were not only imported, but original Dutch musicals were also produced, such as *Heerlijk duurt het langst* [*Wonderful lasts longest*][51] by Annie M. G. Schmidt and Harry Bannink in 1965. The performance ultimately never came about, but the studio recording of the songs was nevertheless a success.

Along with the rise of non-dramatic theatre forms and the shift from dramatic conventions to musicals, there were also theatre productions in those years that show a more or less engaged repertoire, but still maintain traditional production processes and acting styles, such as those of the Nederlandse Comedie, one of the leading theatre companies in post-war Netherlands. In addition, revues and cabaret were revived after the war and again from the 1960s. As in many other Western and Eastern European countries, we also see experiments in the Netherlands and Flanders with theatrical events outside of theatres, like happenings, performances, Fluxus events, Provo-cultures, etc. In other words, a theatre landscape is emerging in which theatre makers are continuing, renewing, or undermining theatre conventions in very different ways.

Turning our attention to the theatrical conventions that came to the fore in the 1970s and 1980s, one new medium, which may seem rather outdated from a digital perspective, is undoubtedly important: television. The general accessibility of television from the 1960s onwards had a profound impact on cultures of perception. We can even speak of a shift from a listening culture (radio) to a visual culture (television, film). Although theatre is by definition a place of viewing (from ancient Greek, *théatron*), in theatre, too, we can identify a shift from a focus on the word and on listening, to a focus on the image.

2.9 Textual montage techniques

As we have noted in the context of absurdist theatre, dialogue has become problematic. The words dramatic characters utter are incapable of creating meaning; rather, they refer to the meaninglessness of existence. Characters do not speak, they are spoken, by their historical context, traditions, religion; ideologies that after the Second World War increasingly lost their authority to grasp reality in the Western world. And yet, characters are still present in absurdist theatre, even if they appear as parodies of the concept of character.

The status of the text[52] as a means of representation (action, character, conflict) and central to the creative process, however, changed fundamentally in the 1960s. Theatre makers such as Jerzy Grotowski, Richard Foreman with his Ontological-Hysteric Theatre, and The Living Theatre do not consider (dramatic) texts as material for representation or enactment, but instead text and language are subjected to a theatrical investigation. In Flanders, Jan Decorte, Peter De Graef, Tom Lanoye, Paul Pourveur, and others are redefining the theatrical text; in the Netherlands, Maatschappij Discordia and the theatre collective werkteater, among others, have taken an innovative approach to the theatrical text since the 1980s. This approach to text by theatre makers is characterised by Erwin Jans 'as a text in which the dramatic categories are perhaps not completely obliterated, but are flooded by some sort of excess: a poetic, epic, philosophical, fragmentary, rhetorical, musical ... excess.'[53] Nevertheless, it is worthwhile looking at the various ways in which theatre makers structure this 'excess'. Broadly speaking, we can distinguish three dramaturgical strategies in terms of structural principles as applied to theatre texts: accumulation; juxtaposition; and dissipation. All three of these dramaturgical approaches decentralise the text, problematise the concept of dramatic character, and undermine representation as a structuring and meaning-producing principle of theatre.

Accumulation as a principle of montage

Heiner Müller is a theatre maker and writer who applies the dramaturgical principle of accumulation. If we look at his work, we see that text and character drift even further apart than in the theatre of the absurd. A typical example is his play *Hamletmachine* from 1977. The play is comprised of five parts and thus loosely refers to the traditional five acts of a dramatic text. Each part is given a title as a kind of motto, image, or subject matter. The play begins with 'Family Scrapbook', which is immediately followed by the

text: 'I was Hamlet. I stood on the shore and talked with the surf BLABLA, the ruins of Europe in back of me.'[54] Who is speaking? Is it Hamlet, who is assigned a voice in parts two, three, and four? Is it the Hamlet-Actor, who is indicated as a character in part four? Is it an actor or the author? We cannot answer the question, as it is simply a speaking voice. Already in these first sentences, time, as a dramatically present time, is problematised and a contrast is produced between word and image. The statement 'I was Hamlet' manifests a narrative voice, a remembering voice, not necessarily a dramatic 'now'. Who is being spoken to? The public? Is it a *monologue intérieur*? A 'stream of consciousness'? The obsolescence of language '(BLABLA)' is contrasted with the image of the ruins of Europe. Does the image refer to the ruins of Europe in the seventeenth, eighteenth, nineteenth, or twentieth century? Or to all of them? The character that was Hamlet, but which now seems to be a character without a portfolio, is clearly furious: not at his uncle Claudius, the murderer of Hamlet's father, but at stories that he tears apart word for word as the following example shows:

I'M GOOD HAMLET GI'ME A CAUSE FOR GRIEF
AH THE WHOLE GLOBE FOR A REAL SORROW
RICHARD THE THIRD I THE PRINCE-KILLING KING
OH MY PEOPLE WHAT HAVE I DONE UNTO THEE
I'M LUGGING MY OVERWEIGHT BRAIN LIKE A HUNCHBACK
CLOWN NUMBER TWO IN THE SPRING OF COMMUNISM
SOMETHING IS ROTTEN IN THIS AGE OF HOPE
LET'S DELVE IN EARTH AND BLOW HER AT THE MOON.[55]

The eight lines contain references to and quotations from Shakespeare's *Richard III* and *Hamlet*, the Bible, and T.S. Eliot.[56] Although it is possible to trace the sources of the texts that Müller assembles, quotes, and adapts, it is not possible to determine the meaning of all the twists and shifts he applies. The montage and adaptation of texts destabilises, as it were, processes of signification, but also structures of time and space. Müller regards 'flooding' (*Überschwemmung*) and 'anachronism' (*Anachronismus*) as important dramaturgical means for interrupting the supposed inevitability of history or the closedness of a story, which, in turn, allow for not presenting history/stories as a structured, ordered whole.[57] Both means are apparent in *Hamletmachine*. Fragments of stories and histories from different time periods are mounted on and into each other, problematising stories as well as quotes and words and taking them out of context, hence revealing new perspectives.

This dramaturgy profoundly transforms the relationship between stage and audience. Neither action, nor character constitutes a closed fictional world vis-à-vis the audience. The dramaturgical principle of 'anachronism' interrupts both a unity-based structure of time on stage and a lucid perception of time by the audience. Moreover, in Müller's theatre texts, as with Brecht, we do not encounter a narrative instance, which structures theatrical signs to some extent. It is up to the audience to find an attitude towards the plethora of theatrical signs. The 'here and now' of dramatic theatre is redefined, i.e. it no longer describes a fictional world on stage viewed voyeuristically by the audience, rather the 'here and now' takes place between stage and audience; it is enacted, as it were, in the process of the performance.

Despite this far-reaching deconstruction, Müller does not completely abandon the concept of the character. It is evident that the characters can no longer be described as 'acting', but rather as speaking instances. The texts that characters speak are no longer psychologically motivated. The aim is not to present 'rounded' or 'authentic' characters; instead, they refer to different discourses (literary, scientific, political, economic, etc.), and explore different possibilities or different points of view within these discourses.

Juxtaposition as a principle of montage

The Dutch theatre collective Maatschappij Discordia applies another dramaturgical strategy in order to decentralise text. This strategy can be described as the principle of juxtaposition. Brecht already used montage and juxtaposition to disrupt causal-logical dramatic structures, and to create a space to reflect on possibilities for action. However, in the case of Maatschappij Discordia's juxtaposition, all theatrical means are decentralised and placed next to each other. They thus gain a spatial dimension. Typically, theatre makers completely distance themselves from the concept of character. They do not represent characters, not even when they play texts by Bernhard, Goethe, Schiller, Handke, Ibsen, Chekhov, and others. Rather, they engage in a dialogue with existing texts as theatre makers. In his review of *Stijl* (*Style;* 1980), one of their first performances, the eminent Dutch theatre critic Jac Heijer describes their approach to text as follows:

> The constitution of the text is manifold. Quotations from plays (Goethe, Wilde), other literature (Thomas Bernhard, Peter Handke) and advertising brochures. Aphorisms and statements written by themselves in the form of dialogues. As with the objects, their origin is not indicated; they acquire a life of their own, are shards of cultural artefacts. They relate to design,

to style, to architecture and theatre, to unavoidable innovation in art, to attitudes to life.[58]

In contrast to Heiner Müller, Maatschappij Discordia does not rework or adapt the 'shards of cultural artefacts,' but with their presentation the actors give space for comments: for an investigating glance. Typical of many of their performances is a certain serenity and emptiness; an almost contemplative attitude towards the texts and objects they place in the space. Because of this attitude, a certain astonishment becomes visible and this is echoed in Annette Kouwenhoven's retrospective on the creative process of *Stijl*: 'With this performance, for the first time, a different direction was taken, that of the collage. Different things that apparently had nothing to do with each other came together to produce something that was more than the sum of its parts.'[59] The theatre makers of Maatschappij Discordia thus share an attitude of astonishment with the audience, which Brecht primarily reserved for the spectators. Like Heiner Müller's theatre, it is about making the audience uncertain by presenting the dissonances of texts, voices, and things. In her essay "Over kritiek" ("On Criticism"), Marianne van Kerkhoven reflects on the performance by Discordia *Het rad van de geschiedenis. Der Theatermacher* (*The Wheel of History. Der Theatermacher*) by Thomas Bernhard:

> I know of few companies [...] that deal so consequently and authentically with the repertoire, with the heritage of texts, with calling to mind what earlier theatre makers did/wrote/thought. Discordia tackles these texts, strips them down to the bone, *breaks them*, until something new becomes visible.[60]

Unlike Müller, they do not present the shards of memory in the form of the plethora of a rubbish dump, but rather with the exploratory gaze of the collector; or, to allude to Walter Benjamin, with the allegorical gaze of the melancholic. In the Netherlands and Flanders, this way of dealing with repertoire, acting, montage, as well as the collective working method of Maatschappij Discordia, has become highly influential and is clearly recognisable in the productions of Dutch and Flemish theatre groups such as 't Barre Land, Dood Paard, or STAN.

Dissipation as a principle of montage

The third dramaturgical strategy of montage, dissipation, also undermines concepts of representation, dramatic character, and a closed fictional world.

We find this form of montage in, among others, the texts of Elfriede Jelinek. Her texts are cascades of words, word plays, text genres, voices, and perspectives that put language at stake in an apparently endless *écriture automatique* (automatic writing).[61] Unlike with the surrealists, however, the aim is not to reach out to the unconscious; Jelinek dissects and makes visible language processes. She particularly opposes constructions based on identity; in her theatre texts, this results in the problematisation of dramatic characters, actions, and language utterances. Jelinek's technique of montage broadly corresponds to what Elinor Fuchs calls the 'literalisation' of theatre:

> This literalization or textualization of the theater event has appeared in a number of forms, as subject, as setting, as stage business. [...] The price of this emergence, and perhaps its aim, has been to complicate the spectator's experience of theatrical presence. This has important implications for dramatic character, which begins to re-assume its cursive, pre-psychological meaning – character as impression or inscription.[62]

In an interview, Jelinek criticises, in particular, the representation of psychologically motivated characters and corresponding acting styles: 'The actors should not get involved, they should not act, not pretend that the play on stage is life. Under no circumstances should they speak. They should be "speech machines".'[63] Hence in theatre texts like *Die Schutzbefohlenen* (*Charges* [*The Supplicants*]), Jelinek refrains from designating characters. The points of departure for her work are often political and social incidents.[64] But her theatre works are never dramatisations of these incidents. As the titles of her plays indicate, she combines and contrasts the events with historical text layers. For example, the subtitle of *Rechnitz, The Exterminating Angel*, refers to Buñuel's film *El ángel exterminador*; the title of *The Merchant's Contracts* contains a reference to Shakespeare (*The Merchant of Venice*), *Charges* (*The Supplicants*) refers to Aeschylus (*The Suppliants*). But even these references are shallow; they are part of a continuous stream of associations spinning around words, concepts, and understanding.

As with Heiner Müller, polyphony is a characteristic of Jelinek's texts. However, whereas in Müller's texts speaking instances are still recognisable and layers of meaning are piled up, in Jelinek's the voices are in constant flux, they continuously change perspective, and dissipate in space. In this way, the unity of signifier and signified is disrupted. Her principle of montage is not accumulation but dissipation of language processes in order to interweave language utterances, speaking instances, and perspectives over and over

again. A typical example can be found at the beginning of *Charges* (*The Supplicants*)/*Coda*:

> [...] this is the way to Greece, to the gods, you might never get there, you and your buddies, I mean this boat is like – now I can't think of the word, like a densely covered pincushion in the women's world, I don't want to say full, yes but full it is nonetheless. No pine forest nearby, the boat avoided it, the water is denser than glass but unbreakable – parting, merging – what belongs together flows together, all one, all the same, water. Only people, those who fall in, go kaput. They don't break, the water takes them in, it opens its trap, no, can't say trap, just as one can't say tremble, could somebody please hand me new words, many thanks, [...].[65]

In this passage, the speaking voice changes perspectives continuously. Whereas in the first sentence there seems to be a situation between an 'I' and a 'you', already by the second sentence the situation has switched to an 'I' opposite a boat full of people, and in the last sentence it changes into an 'I' as opposed to a 'them'. In this passage, both the perspective and the distance between an incident (a boat full of people at sea) and the one facing the incident vary. It involves a difference of involvement and of ways of perception. But the text is also full of constantly shifting layers of meaning. Greece, for example, is evoked as the destination of refugees and, at the same time, as classical Greece with its world of gods, as a tourist destination, and as a source of Western culture. The text meanders from comparing the boat to a pincushion or pillow of needles (a term with connotations of softness and sharpness, which cites both the fragility of the people and of the boat) to a pine forest (or needleleaf forest).[66] There are references to different discourses on refugees such as 'the boat is full.'

The phrase 'the water is denser than glass' is also full of layers of meaning, tensions, and references. In German, the phrase reads 'das Wasser satter als Glas,' where '*satt*' refers to being satisfied, as well as to being fed up. At the same time, '*satt/sättigen*' refers to saturated solutions. The German sentence is constructed without a verb so that the relationship between the words begins to shift. Neither water, nor glass can be sated or saturated. Metaphorically, glass could be saturated by being filled with water, and water could be saturated by glass waste, plastic waste, or by people who 'fall in' and 'go kaput'. The water is more saturated than glass. In the water, more people 'go kaput' than there is water in the glass. The people 'go kaput' because there is no water in the glass. The water is saturated by people, the water is fed up with being saturated by people, and so on. The stream

of associations is an almost endless process of dissipation. Moreover, stop words such as 'thank you', 'please', and 'of course not' are typical, interrupting the flow of words and associations like bar lines in a score. They not only contribute to the rhythm of the text, but also comment on what has been said, as counterpoint, as ironic sneer, as thoughtlessly uttered phrases that unsettle the spoken words even more and enhance the theatricality of the text. It is a theatricality that is generated by the montage and decollage of different layers of text and meaning, with the aim of destabilising uniform and unifying processes of signification.

Of course, the three principles of montage, accumulation, juxtaposition, and dissipation, are not always applied in such a prototypical way by theatre makers, but the various techniques are often varied and combined. Dramaturgically important are the questions of how montage techniques structure and restructure theatrical processes and processes of perception, how the relationship between representation and presentation is given shape, how dramatic concepts such as dramatic character, time, and space are approached, and in what way societal issues are reflected by the chosen dramaturgies.

Grensgeval (Borderline Case) – Toneelhuis (2017)

In 2017, the Antwerp municipal theatre Toneelhuis staged Elfriede Jelinek's series of theatre texts Die Schutzbefohlenen, Coda, and Appendix under the title Grensgeval (Borderline Case). Jelinek wrote the first part Die Schutzbefohlenen in 2013/14. In 2015, she added two additional parts, entitled Coda and Appendix. A protest by refugees occupying the Votivkirche in Vienna forms the background to her text Die Schutzbefohlenen. The subsequent pieces respond to the so-called refugee crisis in 2016. Her focus in Appendix lies on the refugees who came to Austria via, among other places, Hungary; in Coda the focus falls on the so-called boat people. As the brief discussion of her texts above illustrates, concrete events are only a starting point for Jelinek's writing. Her series of texts problematises discourses around refugees, whether political, media related, economic, cultural, or scholarly. Jelinek's theatre texts Charges (The Supplicants), Coda, and Appendix commence with a critique at the local level (the 'refugee church' in Vienna); she subsequently engages in a critique of the rhetoric of crisis that emerged when refugees attempted to reach Europe via land routes in 2015, and, ultimately, she addresses the impasse surrounding boat refugees.

Guy Cassiers takes the exact opposite route with his staging. At the start, the dancers and actors walk to their places on stage, accompanied by the song 'Sail Away', recorded by Noel Coward in the 1950s; a song emphasising hope and the

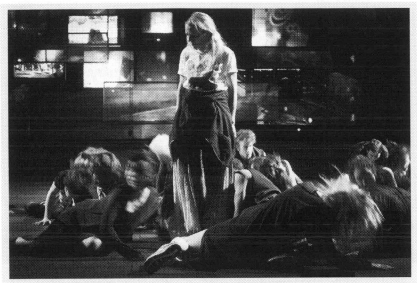

Grensgeval (Borderline Case), directed by Guy Cassiers / Toneelhuis (2017). Photo: Kurt Van der Elst.

longing for freedom. The dancers, dressed in several layers of clothing, pick up large planks of wood lying around, lift the planks, and place themselves underneath. The actors take their places behind two tables equipped with cameras.

The first part of the performance deals with the position of a distant observer. The stage is divided into two sections. The four actors, Katelijne Damen, Abke Haring, Han Kerckhoffs, and Lucas Smolders sit downstage left, behind tables opposite the group of dancers (centre stage) who seem to represent refugees. The texts are sometimes spoken in an interested tone, often with irony, cynicism, and slight boredom. At the same time, the faces of the actors appear on a projection screen across the entire upstage area; most of the time, the faces are doubled, sometimes all four faces appear at the same time, merged and superimposed. The voices and images are repeatably out of sync.

The projections are in black and white, the emphasis is on the pose of watching and observing. The actresses Katelijne Damen and Abke Haring sit with their backs to the dancers. The actors Han Kerckhoffs and Lucas Smolders would be able to see the dancers, but because they constantly direct their attention to the camera, they do not look at what happens on the stage. As a result, an image of consciously looking away emerges. The projected faces of the speakers seem to observe the events at sea, while the speakers behind the tables only look at themselves and interact with the camera. Meanwhile, the dancers move under the wooden planks and lift the planks, which, after some time, start to resemble a kind of rickety raft.

After a while, the wooden planks disappear, and the dancers stand huddled up and floodlit upstage right. The actors no longer address the camera, but each other. Moments later, a mosaic-like installation of projection screens emerges in front of the backdrop. The first sentence of *Appendix*, 'the conquest of the world as image', spoken by Abke Haring, can be regarded as programmatical for this part. Katelijne Damen gets involved in the group of dancers, who take over the stage with energetic movements. The sound of a tech house mix alternates with the rhythmic sound of the dancers breathing. On the screens, images of refugees appear, both historic and contemporary. After a while, the group of dancers are lying on the stage like a pulpy mass, Abke Haring kicks against it and voices revulsion and disgust. The male actors keep aloof, watch, clear the tables. The images change to a festival atmosphere, both on stage and on the projection screens, accompanied by a kind of psychedelic tech-rock. As the dancers slowly move back towards their places upstage left, images of environmental disasters and catastrophes appear, followed by images from the Western canon of art history.

At the beginning of the third part, massive black shutters are pulled up, enclosing the dancers and actors completely. It is a space without images. The space is dark. Dancers and actors are spread across the stage and start singing and humming a cynical variation on the song 'Let the Little Ones Come to Me', which ends with 'on top of each coffin we put a little teddy bear, as a good Christian'. The actors and the dancers now form a group together. The actors mostly speak from the viewpoint of refugees. The gesture of speaking is akin to lament and accusation (or, as the English title suggests, to charge). The dancers form a mass that repeatedly expands and contracts, they form a tableau vivant against the walls, an attempt to break out? Some dancers silently mimic the words that are spoken. When Katelijne Damen speaks the words 'no one speaks for us', dancers and actors stand together in a line, only their faces are spotlighted. One by one, the dancers recede into the dark, followed by the four actors. The shutters are slowly pulled up, but all, dancers and actors, end up on the ground in darkness.

Cassiers unravels Jelinek's multilayered texts into a staging that employs aspects of dramatic development. He begins by juxtaposing the 'we, who are watching' and 'they, who are the refugees'. This turns into a situation of 'we, the refugees', versus 'those, who are not present', or rather those who are present as audience in the setting of the theatre. Nevertheless, the performance does not transform Jelinek's text into dramatic theatre. The staging remains too layered, presents too many contrasting and conflicting images, and thus refuses to provide conclusive answers.

2.10 Material and materiality

The three approaches to montage discussed above are not limited to structures of text and text production; in fact, they concern all theatrical sign systems. The focus, as Erwin Jans points out, 'shifts from the signified to the signifier, from the content and the subject matter to the materiality of writing, from intentionality to intensity.'[67] Despite the textualisation of theatre as outlined above, text no longer occupies the centre of the creative process. Jans articulates the shift as follows:

> The relationship between text and performance changes fundamentally: the gap between what is shown and what is said, between form and text, is established as *deconstructionist* working method. This gap leaves room for commentary, for alternative and critical readings of the classical and bourgeois repertoire. Interpretations are kept open and ambiguous as much as possible. The text is dramaturgically dismantled and reorganised in the staging. Notions such as dramatic character, story, psychology and development are also put under considerable pressure and in some cases are even rejected altogether, being replaced by the purely physical presence of the actors.[68]

In her lecture, published under the title "Vervaging aller grenzen" ("Blurring of All Boundaries"), Marianne van Kerkhoven draws a connection between working conditions, modes of organisation, and the renewal of the theatre. A number of outstanding theatre makers, such as Jan Lauwers, come from the visual arts or music. They not only withdraw more easily from dramatic conventions, but also add their own perspective to making processes, resulting in a high degree of interdisciplinarity and, as the title of the essay announces, the blurring of (artistic) boundaries. The starting point for creative processes, Van Kerkhoven argues, is no longer a particular subject matter or material, but the materiality of working conditions.[69] One of these factors is language, which is explored in terms of its materiality. The shift from material to materiality, from material as a means of representation to materiality as a means of investigation, of searching for attitudes and points of view towards material and materiality, changes the relationship between stage and audience. The aim is no longer to present a coherent story, but rather to question its preconditions and to allow the audience to become part of this process.

The questions 'what?' and 'how?' are communicated by focusing on the materiality of the means of the theatre itself, such as body, language,

sound, light, and objects. The way in which bodies, with their experiences and particularities, relate to things and their materiality becomes the guiding principle of production processes. This results in a 'spatialisation' of theatre. Gertrude Stein's term *landscape play* illustrates this concept of spatialisation perfectly. Stein obviously struggled with the central perspective and the linear structure of dramatic theatre. The principle of a shared here and now apparently did not apply to her, as the following passage makes clear:

> Your sensation as one in the audience in relation to the play played before you your sensation I say your emotion concerning the play is always either behind or ahead of the play at which you are looking and to which you are listening. So your emotion as a member of the audience is never going on at the same time as the action of the play.[70]

She calls this asynchronous experience of time 'syncopated time'; the rhythm of the performance does not correspond to the rhythm of the spectators. Her response to the experience of time in dramatic theatre was so-called *landscape plays* where all theatrical phenomena relate to each other as in a landscape (trees to hills, trees to trees, hill to clouds, clouds to meadows, etc.). The spectator, like a walker, strolls through the landscape at his or her own pace. The image is not imposed by a pre-selected perspective, but created, rejected, and recreated by the choices of the spectator. The concept of landscape as a guiding principle of creative processes can be seen in performances in which the materiality of theatrical signs (language, space, costume, objects, etc.) are juxtaposed without harmonising the relations between the various sign systems.

The strategies for accentuating materiality are many and diverse. Performances by theatre makers such as Joachim Robbrecht in *The Great Warmachine*, Warme Winkel in *Poëten & Bandieten* (*Poets & Bandits*), or Naomi Velissariou with her concert series *Permanent Destruction* do not show a fictional *world*, but rather explorative *processes*. Robbrecht examines the influence of war strategies in the context of economics, politics, and marketing; Warme Winkel focuses on the life and work of the Russian poet Ryzhy; and Velissariou investigates and dissects the texts of, among others, Sarah Kane and Heiner Müller. The actors are on stage not only as actors, but in several capacities: as persons; as actors; as roles; or, in Velissariou's case, as rock stars. Their relationship to a subject matter, their perspective, their investigation is part of the theatrical form of the performance.

In "Vervaging aller grenzen" ("Blurring of All Boundaries"), Van Kerkhoven wonders 'whether the attention for the material – for how something *is* the way it *is* – cannot be interpreted as a reaction to the abundance of fictionalisation, of the de-realisation of reality, with which we are confronted today by television.'[71] Some thirty years later, and due to the profound influence of digital and social media on the perception of reality, this question is perhaps more urgent than ever.

Theatre makers Bianca van der Schoot and Suzan Boogaerdt asked the question 'how real is reality?' quite tangibly in their theatre installation *Bimbo* (2011). In *Bimbo*, they place physical reality opposite images of pornification. In other words, they make how these images are created visible to the spectator. To the incessant pounding of the song 'My back, my neck' by the singer Khia, with its repetitive refrain 'All my ladies pop your pussy like this,' they produce pornographic images on a stage, which appear on large screens. The audience is seated with their backs to the stage, the screens in front of them. This set-up can be seen as a metaphor for the illusion of reality, or for reality as illusion. The reality of the images literally takes place behind the backs of the spectator; if they want to see the production of the images, they have to turn around.

This performance, too, produces theatrical signs according to the logic of landscape, but although materiality plays an important role, Van der Schoot and Boogaerdt's exploration concerns the mode of perception itself. The question of how we perceive reality has become the subject/matter of the performance. Questions that occur in production processes with a focus on materiality are questions about how we experience and understand our social and political reality. They are artistic investigations into subject positions and identities, into production processes, including those of theatre, and their political implications.[72]

2.11 Theatre as a means of exploration

Since the Second World War, the experience of reality as un-reality appears to be a common thread in theatre productions. The reality of war, and in particular the hyperreality of the Holocaust, palpably withdrew from frameworks of experience and perception with which we can understand the world. Hyperreality indicates a reality that is beyond words, beyond meaning, beyond experience. Silence as a point of departure and the breakdown of communication can be seen as a reaction to this experience or non-experience. To a certain extent, today we are confronted with the

other end of the spectrum. Reality is experienced as unreal because it apparently lacks something like factuality or a real core. Van Kerkhoven characterises this phenomenon as 'abundance of fictionalisation.'

In recent years, a number of theatre makers in the Netherlands, Belgium, and elsewhere have used theatre as a means of investigating reality. For example, the Dutch theatre collective Firma Mes investigates, in the production *Rishi*, the events that occurred on 24 November 2012 on platform 4 of The Hague's Hollands Spoor station, when the Surinamese-Hindu Chandrikasing Rishi was shot dead by a police officer. The makers use interviews with friends and family, police interrogations, and witness reports to reconstruct the event by theatrical means. The different perspectives are not merged into one story, but rather reveal the shortcomings of different institutions and the (racist) frameworks of perception that contributed to the fatal incident.

In the performance series *Simple as ABC*, the Flemish theatre maker Thomas Bellinck documents various aspects of European migration policy, such as surveillance technology, high-tech registration technology, and detection technology. Bellinck collects material by travelling to places like Athens or Marseille and conducting interviews with refugees, border guards, human traffickers, and journalists. He organises the material, such as audio fragments in various languages, into so-called musical theatre essays or theatre installations. In *La Reprise – Histoire(s) du théâtre (I)*, Milo Rau investigates the murder of Ihsane Jarfi, who was beaten to death by four men in Liège in 2012. In this performance, Rau explicitly uses the aesthetic means of theatre to re-enact the murder while simultaneously reflecting on the theatrical means themselves. In all of the above-mentioned performances, documentary material is transformed into a theatrical event. In these performances, reality breaks through the world of fiction, not by means of materiality or forms of theatricality, but by using theatre as a means to reassess the material and factual content of a world perceived as fictional and to make it palpable.

3. Process: From material to performance

3.1 The material and the envisioned performance

This chapter is about aspects of dramaturgical thinking in the process of staging material for performance. We discuss which questions of dramaturgical thinking become relevant with respect to the realisation of the performance. How do you interrogate material in preparation for the stage? What is context, and when does context become a dramaturgical task? How can we speak about context as a complex of time and location sensitive concrete, but also abstract, aspects?

Important dramaturgical decisions are made during the creative process. These decisions concern both the (source) material as well as the envisioned concept of the performance. If we depart from certain types of material or sources such as text, it is somewhat reminiscent of, if not a representative for, the exercises and formats of our classes. Therefore, we distinguish the sources and their analysis from the processes in the rehearsal room and the realisation in the theatre space.

How the material develops and how it becomes legible on stage depends on the topic, the intention, and the artistic style of the production process and performance. How can you approach dramaturgical decisions in a relevant manner, which is just open-ended enough to be applicable to different situations, and yet concrete enough to be more than a hopeless generalisation? While we have decided to stay true to the division of the two aspects of the source, on the one hand, and the performance, on the other, in this chapter in particular we have decided to stay close to our own expertise as a starting point. Hence, we focus particularly on auditory and visual aspects.

First, however, we introduce more general questions concerning the bigger whole of the dramaturgy of a performance: how are all theatrical elements (such as actors, time, and space) coordinated to form an expressive or coherent dramaturgy of the performance? What role do rehearsals play in emergent and collective meaning-making? And how do dramaturgical decisions relate to the collective process? To what extent do theory or concepts more generally, and contemporary and historical theories about theatre making and acting more specifically, inform the process? What position can the dramaturg take in negotiating and facilitating the process from source to stage?[1]

A crucial process between material and the performance is the rehearsal phase. However, it is difficult to speak of this abstractly without reiterating the unsatisfying formula of 'every process is different.' Recent publications emphasise the procedural character of dramaturgy,[2] but rehearsals themselves have rarely been conceptualised[3] outside of the practice of specific makers.[4] It might be helpful therefore to distinguish between individual preparation and group rehearsals. Individual preparation for the dramaturg differs from that of the actor. An actor prepares by learning the text by heart. In addition to the circumstance and requirements of context, own training, and specific director, the actor might develop their own more or less systematic way of training. Only in the rehearsal room does the focus shift towards the 'here and now' of collective presence. Then, it is about animating all the relations between all theatrical means, and about performing.

Stanislavski's book *An Actor Prepares* consists of historically famous didactic sequences that take place in a fictional rehearsal space. In the Netherlands, Stanislavski's student Peter Scharoff introduced extensive preparatory work on text in the rehearsal room while rehearsing dramas by Chekhov. In Katie Mitchell's book *The Director's Craft* (2009), she uses scenes from the rehearsal room to give instructions, both general and exemplary, for directors to navigate a systematic approach to rehearsals.

Over the course of the rehearsals, the whole artistic team is increasingly busy with dramaturgical decisions. Part of the challenge of being a dramaturg is to understand what the process might need at different points, while keeping the process accessible and transparent for the whole artistic team. For that to work, it is necessary for the dramaturg to acknowledge the different artistic languages, but also to be able to communicate about them and mediate between them. It is not necessary for the dramaturg to "speak" all the languages.

In this chapter, we map (using the example of sound and visuals) what kind of dramaturgical knowledge there might be to discover, to navigate, and to learn more about. First, we address translation processes more generally and the resulting expectations directed towards the dramaturg. In this chapter, aspects such as context and actualization are discussed as part of translation processes in theatre and we return to them when we discuss the phase of 'making'.

In the second part of this chapter, we discuss aspects of visual and auditory dramaturgy and we conclude with aspects on the aesthetic of a performance.

3.2 Translational processes in theatre

At the beginning of the performance *By Heart* (premiere 2013), the Portu-guese theatre director Tiago Rodrigues invites ten participants from the audience to come onto the stage and to use the length of the performance to learn a Shakespeare sonnet by heart. What starts as a practical collec-tive exercise in 'learning by heart', is embedded into the personal story of Rodrigues' grandmother and her resistance to her own physical decline, which can be viewed on a meta-level as a story about political resistance. 'What you have learned by heart, the bastards cannot touch, they cannot take it away from you,' Rodrigues quotes the French-American literature critic and philosopher George Steiner, who discusses 'learning by heart' as a method of resistance to totalitarian regimes.

By making the performance of the freshly rehearsed sonnet the goal of the performance, *By Heart* can be said to make use of the dramaturgy of a rehearsal process for the performance. In front of the eyes and ears of the audience, one single source forms the starting point. From then on, the audience follows the gradual contextualisation and interpretation of this one source, almost as though it was spontaneous. Rodrigues makes 'translation' an important theme. The most common form of translation, understood as a transfer of words from one language to another, is evident to the audience: Shakespeare's sonnet was translated into the language of each of the countries in which the performance toured. Rodrigues learned the sonnet in the local language of the place that he performed in, without speaking the language, but simply by studying the sonnet phonetically and subsequently relying on auditory memory.

The text of the sonnet is present in the performance in written form as well, as a memory aid and possibility to cheat: the text is printed on edible paper. By letting the ten participants eat the paper at the end of the performance, Rodrigues symbolically plays with the radical transformations a language can undergo through translation, going as far as to let it pass through the participants' stomach.

The different layers of translation are equivalent to the different phases of the performance. Until the collective recitation of the poem as a culmination of the performance, the text undergoes transformations, translations, if you will, into theatrical material. It thus changes its form and significance. Having been translated into the language of the location of the performance, the participant spectators are instructed to learn each line by heart; in between, the lines of a story of a grandmother resisting blindness by learning books by heart unfolds. The action of resistance is evoked more generally

and, gradually, the sonnet is embedded in a new context. The collective recitation of the poem becomes a shared experience, and the culmination of an ultimately shared memory. The process of learning by heart, once it is framed as an act of resistance, renders the collective recitation a victory of memory, and Shakespeare's words resonate against this background.

We understand quickly from this example how dramaturgical decisions on the *what* to translate (text and context) are narrowly interlinked with the *how* to translate. Form and content appear as interestingly related. The collective learning by heart can be seen as the performance of the kind of memory that is also the topic of the performance. Yet, as we have described above, to theatrically translate in this case is more than to follow a simple transfer from one medium to the other. Instead, what starts with an originally written text, transforms into a new kind of material. We can inquire more generally into the process from text to performance and observe: how do sources such as this sonnet, and for that matter theatre texts or any other material at the start of the process, get translated in the process of staging? What role does context play? How is the source interpreted and how is this interpretation part of the staging? Over the course of the rehearsals, which of the makers involved in the staging process takes responsibility for which aspect of what we see on stage? How can we identify dramaturgical decisions and how do certain attitudes towards theory transpire? And what is the role of the dramaturg in this process?

Context – location

The transformation and translation of the source of the above example, and its recontextualisation during its introduction to new communities, speaking different languages, forms part of the dramaturgy of this performance. While the principle of 'learning by heart' offers a playful access to language, the relationship of different language communities to Shakespeare's poetry becomes a focus point of the performance. It is not about language or the specific translation of words alone. As dramaturge Duška Radosavljević describes: 'The notion of translation presupposes therefore not only the verbal content is rendered from one idiom to another but also its contextual meaning.'[5]

But how can you speak of a performance adapting to a new context? Internationally travelling performances such as *By Heart* are confronted with the challenge that there is not simply one clear context within which the performance is going to be perceived. For dramaturgs of travelling performances, and within the Netherlands performances travel a lot,[6] the

question of what context means in relation to location is a useful one. Where does the performance premiere? Which elements of the performance might be regionally specific and might therefore need to change? What renders aspects incomprehensible to one audience but not to another? What does a performance need in order to 'work' within different contexts? At what point does a performance become untranslatable?

One of the dramaturgical principles of Rodrigues' performance is to let the audience experience a poetic triumph by successfully learning and reciting the poem. We can understand it as a dramaturgical choice to render this triumph as both aesthetic as well as socially symbolic, and as translatable and meaningful to different locations. Scholar on theatre adaptation Margherita Laera sees a potential social role for theatre in this type of translatability: 'How does theatre contribute to the formation, deformation, and hybridization of cultures? What relationship is there between adaptation, performance and change?'[7]

Context – time

When a historical theatre text is adapted, the transfer takes place between two different times. But theatre productions that reflect on politics and society also have to deal with a translation to the 'here and now' of the contemporary context. Updating such pieces does not mean finding a contemporary equivalent in every possible way. There is a difference between a literary adaptation of a text (sometimes done by writing dramaturges)[8] and a dramaturgical idea underlying an otherwise unchanged text.

To give an example of the latter: In a recent staging of *Ivanov* from Chekhov's eponymous play, it was decided not to adapt the text or any suggestion of nineteenth-century Russia in it. The stage design and the shared central interpretation in the rehearsal process were coordinated to emphasise both the claustrophobia caused by others, and the mental vulnerability of the main character that is relatable from a contemporary perspective. What if Ivanov was depressed? What if the people in his environment failed to recognise this? How can an environment close in on someone? Such (dramaturgical) considerations and choices of perspective can lead to practical research by designers and actors that translate visibly into stage design, music, and subtext per scene.[9]

In current Dutch (-speaking) theatre practice, 'fidelity' to an original play is barely an ideal or a criterium at all. More familiar to opera, *Werktreue* (literally: 'fidelity to work') is, however, but one extreme principle of the more common dramaturgical considerations about which aspects to

translate. In addition, recognising what might be untranslatable is important, especially when theatre texts travel. These examples of dramaturgical considerations also make clear how decisions operate on various levels and beyond a normative framework of a right or wrong translation. The idea of the 'original' then makes way for the idea of the 'starting point', which, in our assessment, makes it worth analysing the 'source' (see Chapter 2) and understanding the (in)compatibilities and possibilities in the relationship between source and context.

Speaking on the translation of theatrical texts, Argentinian translator and theatre writer Rafael Spregelburd notes:

> The real question of what's at stake in theatrical translation is, precisely, the life of nuance: what makes plays translatable as ambiguous, suggestively rich, true experiences and not simply redundant information about a world beyond words.[10]

Spregelburd gives an example from his own practice, mentioning a play by English playwright Harold Pinter, which, in his translation, had to be transferred from the British context to the Argentinian context. Spregelburd had to consider how, for example, class differences and cultural codes can be translated with social responsibility, yet remain artistically interesting as well as dramaturgically sound.[11]

The search for solutions might rely, to a degree, on comparison of both cultures, but it also demands that words and actions stand in a purposeful relation to the play as a whole and its envisioned cultural context and reception. While dramaturgs do not always translate theatre texts themselves, it is the affinity with detail and the knowledge of how decisions on the level of word choice can have an effect on atmosphere, aesthetic, potential interpretation and acting, thus making the dramaturg a translator in any step of the staging process.

Translation for accessibility

A quite common and, moreover, visible practice of translation in theatre is the incorporation of subtitles. To date, subtitles have received little attention as an object of study. However, their influence on the spectator cannot be overestimated. Subtitles in theatre must follow the principles of simultaneous translation, which often has consequences for the quality and choices of what is communicated. Parallel to theatre's move towards multilingualism on stage, subtitles are increasing in importance. In contrast to literary

translation, subtitles are functional and geared towards an audience that relies on them for an understanding of the performance, the underlying dramaturgical concern being one of accessibility for the audience.

At the time of writing, one of the translations for access is, when compared internationally, strikingly underdeveloped in the Netherlands: in addition to the translations between languages (interlingual), there are also translations within the same language (intralingual). *Audio description* is such a practice; it ensures visually impaired audience members are able to follow a performance. Adding live commentary via headphones, the words and spoken language of the stage are not translated, but instead visual cues are translated into auditory descriptions. Was there a meaningful gesture by an actor, which an audience with an impairment might have missed? How does the stage design look? To think along with how someone who predominantly listens to theatre perceives of the stage, can be an important dramaturgical thinking exercise. It can help the dramaturg become more aware and unpack how an atmosphere is created and how emotions and the unspoken elements are expressed. The practice of audio description makes other types of dramaturgical considerations more explicit than the literary translation. To actively put yourself in the shoes not only of an audience member from a different background, but also with a different set of abilities than their own helps the dramaturg to perceive the performance from different perspectives.

Starting point: The source

Let us get back to the process (from source to performance) as far as it concerns the different stages of dramaturgical considerations. Performances usually start from a central idea, often in the form of a source, at least that is the suggestion we will depart from. Source is then understood as material, more concrete than an idea or a starting point. It can be a text, something that is fixed or described in a report, an interview, or a newspaper article (i.e. the current situation of the Dutch family farmer, the history of intimacy, a revolution). Commonly, it is an already existing story in the form of a novel, a song, a libretto, a film, or a theatre text.

The choice to start from a theatre text at all, is a dramaturgical decision. In the current Dutch theatre practice this stage of decision-making might mean that makers and dramaturgs decide on a different type of source, for example interviews that still need to be conducted. The interest in a specific type of source might already be read as an expression of an aesthetic direction and a professional or social urgency. How might the theatre texts

by Herman Heijermans resonate in the twenty-first century?[12] What can they communicate to an audience here and now? How do Couperus' novels, such as *De kleine zielen*, sound on a contemporary stage? Why should we see *Romeo and Juliet* staged today as opposed to just read it?

In an adaptation of *Romeo & Juliet* by Toneelgroep Oostpool (2017) this question is actually quite present in the staging. Shakespeare's characters are adapted so that they appear especially young and speak informal contemporary language. This adaptation triggers reflection on the conscious distance between the historical plot and the contemporary bodies. One can call the other into question and, at times, the performance plays with laying the different contexts over each other.

This playful interweaving of the original story with the new interpretation becomes palpable. Compared to the Anglo-Saxon tradition, the translation to the Dutch language (together with quite a different theatre tradition) might open the door to a more radical textual adaptation of Shakespeare.

Relevance and inspiration

Artistically speaking, at the beginning of the creative process inspiration and the inquiry into inspiration is central. Why does a certain text or image spark the imagination of a single maker or a collective? The desire to stage a certain piece in one's own time can also form the beginning of a process. As Marianne van Kerkhoven puts it:

> How can theatre, which exists by the grace of the moment, of the here and now, capture the complexity and ambiguity of the moment? How can the artist give an answer to the life that they experience as a chaotic accumulation of sensations, which follow one another in speed and in countless, ever-changing combinations?[13]

Research and interpretation

While defining the relevance and inspiration is of great importance, this alone will not carry the production process. Theatre is a medium that unfolds in time. This time-based aspect can be understood as an opportunity for the theatre maker to explore a topic in its development, to unfold its complexity, and to make the audience experience it. In order to grasp the potential, significance, and materiality of a source for the envisioned theatre performance, it is crucial to study and analyse the source. Questions, which were discussed more extensively in Chapter 2,

and which were directed at the theatre text, can be enlightening to that end. In fact, the kinds of questions you might ask in order to understand a theatre text might be helpful for other types of sources. For non-textual sources you will find additional medium-specific methods in the respective disciplines.

As discussed above, the triangulation between source, aesthetic concept of the staging, and envisioned (effect on the) audience will return throughout the process from source to the stage. How does a source speak to the current historical moment? How does it relate to one's/ the team's own context and frame of reference? How does it relate to the location, both in the geographical and in the institutional sense? What is a central idea presented by the source that is worth amplifying?

Within the literary tradition of hermeneutics, Hans-Georg Gadamer spoke of the 'merging' of two different 'horizons'. By this he means two different contexts: the historical context of, in his examples, a text, and the context of the reader. We can follow his point that there is always already an interpretation, through the distance of the reader, which a source, for example text, displays, as writing and reading usually belong to two separate time frames. With Gadamer, then, we can increase the awareness that the dramaturg and their team even interpret already in the moment of reading or watching or engaging with their source.

To render explicit the gap between the time of a theatre text being written and its perception today, in this case for the example of the Norwegian author Henrik Ibsen, let us examine the premise of the series *Crashtest Ibsen* by Joachim Robbrecht. In this series, it is the characters themselves who display the meta-awareness of the gap between the time of writing and the time of reading/performing. When Regina, in *Ik zie spoken* (*I see ghosts*), emphasises her loneliness, by, on the one hand, complaining about having to live the 'fjord-lifestyle' (*fjordenbestaan*) of 1881 while, on the other hand, lamenting that there are no dating apps yet, the absurd awareness of being a historical character eases the contemporary audience in with a wink, while also making a meta-theatrical reflection on the piece.

You could say that the characters flex some dramaturgical muscles on stage by presenting a commentary on the historical material. Historical and contemporary conditions and choices are compared; the characters themselves perform the 'crash test': does Ibsen stand the test of time? How do his theatre texts resonate with contemporary culture?

If we call these questions dramaturgical work, it is often this type of work, that, while not usually presented as explicitly on stage as part of the text, a dramaturg researches in preparation for the rehearsal process.

In her essay "Against Interpretation" (1966), Susan Sontag cautions against seeing 'interpretation' as a value in itself. While her essay is mainly about criticism, her sceptical remarks on the possible effects of interpretation as 'reactionary, impertinent, cowardly, stifling' present the dramaturg with a relevant reminder. If taken as a value in itself, interpretation threatens to rush the team to conclusions, instead of enabling an informed decision.

It is not enough to work schematically and ask every text the same questions for the sake of a quick conclusion. Each text comes with its own characteristics and context both of which should be identified in their own right. Not striving for a seamless presentation, but for an appeal to interesting controversies and a productive problem serves to unite the artistic team as well as to eventually engage the audience.

Teaching dramaturgy in the academic context frequently brings up questions of a perceived binary between theory and practice, with the dramaturg being associated with unflattering images of an avid reader's ivory tower (the 'stuffy librarian' as we call it on the book cover). These images might feed into the existing insecurity of fledgling dramaturgs and a certain fear of the rehearsal room: how do you translate your research into something useful for the rehearsal process? What do we do with abstract findings, when all other members of artistic the team are busy with literally bringing the material to the stage, when the material finally becomes concrete and we start to experience it? However understandable, these questions seem to speak to an internalisation of the binary between theory and practice, which a distinction between desk dramaturgy and production dramaturgy might extrapolate. In fact, Marianne van Kerkhoven formulates the importance of abstraction as a working method and this is not bound to a time or place in the production process, it does not halt at the door to the rehearsal room:

> Getting the increasing, self-imposed complexity in the work of art under control does not exactly work as an invitation to use notions such as content, analysis of meaning, psychology, narrative. These are often too concrete, too unambiguous, too anecdotal. Due to being related to content or coherence they coerce too much linearity; it is difficult to give them a constantly different place within a larger whole. Consequently, other working methods emerge within the rehearsal process, which rely more and more on handling abstractions and could almost be described as 'musical'. [...] Thanks to abstraction, aspects receive an added value and take a different shape: through the added distance, we are able to look at them differently and to get access to their complexity.[14]

This step towards abstraction is, in our view, part of the dramaturg's register and a university education can be considered as essential training for this. Analytical vocabulary and the skill to abstract (the basis of Chapter 2) enables the dramaturg to zoom out at any moment in the production process, as well as to watch rehearsals with a dual attention to particular parts and the overall goal of the envisioned performance.

In what follows, we aim to provide specific historical aspects, vocabulary, and to rehearse some dramaturgical thinking for aspects of the visual and the auditory aspects of the staging process, bringing us to an interesting area between narrative, aesthetics, and musicality.

Kings of War – Toneelgroep Amsterdam (ITA) (2015)

When actor Hans Kesting starts the famous monologue 'Now is the winter of our discontent' from Shakespeare's *Richard III*, it is not the first time that the audience of *Kings of War* have seen him on stage that evening. He had already made his appearance as Richard Gloucester killing King Henry VI. *Kings of War* is a translation, adaptation, and compilation of *Henry V*, *Henry VI*, and *Richard III* into one performance. Over four and a half hours, the audience witnesses Shakespeare's texts shortened and coordinated to expose facets of leadership and the desire for power.

Richard's monologue is an example of a translation in which the choice of words contributes subtly to the character's portrayal as salacious and sarcastic.

The textual sophistication and orientation towards power and its mechanisms is complemented by a scenography that strikes a compatible balance between focusing on the necessary suggestive props (crown and insignia, office furniture, and at one point a strategic war room) and an otherwise predominantly sterile white environment as the 'inside of the palace'. Scenes from the underbelly of power, such as several backstabbing murders but also famous scenes from the war in France, take place backstage and are made visible via live video projections. When describing the characteristics of the stage design as an alternation between spaces for both political strategising in group scenes, and for introspection in intimate setting, the search for a focus on power and leadership transpires textually as well as visually.

The credits reveal no less than the name of three dramaturgs: Rob Klinkenberg, who translated the text, and Bart van den Eynde and Peter van Kraaij, who are mentioned under 'adaptation and dramaturgy'. The production premiered on 5 June 2015, four hundred years after Shakespeare's death. According to the programme book, the creative team shares their vision on 'leadership' within Shakespeare's pieces.

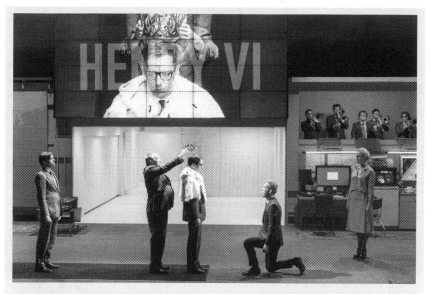

Kings of War, directed by Ivo van Hove / Toneelgroep Amsterdam (ITA) (2015). Photo: Jan Versweyveld.

How can one identify specific dramaturgical decisions, or the dramaturgical work? It might be interesting to look at what is not there (anymore) and the decisions to cut out subplots and characters. In *Henry V*, there are merely eleven characters left, compared to the original forty. In line with the focus on leadership, the famous St Crispin's Day speech by Henry V, which in film history became famous through Kenneth Branagh's pathos when speaking to a large group of soldiers, is spoken by Ramsey Nasr powerfully yet intimately in the presence of no more than three men. Attention goes less to the speech's great impact and more towards its motivation and formulation.

After touring the performance, the adaptation was received positively, often with particular mention of its extraordinarily sensitive and profound engagement with the material. Even in the Anglo-Saxon context, the simultaneous respect to Shakespeare and the impulse to create new material out of it was recognised and celebrated, although such freedom in adapting Shakespeare remains an exception.

3.3 Visual aspects of dramaturgy

Going to the theatre entails a conscious choice to see a specific performance. Often, this choice is determined by our interest in the play, the music, actors, singers, and performers who participate in the performance. But what do

we actually see when we sit in the auditorium? In general, we hardly ever choose a performance because of the set design, the lighting, the costumes, or the use of video.

However, the visual aspects of a performance contribute significantly to how we experience it. The designers of the set, the lighting, the costumes, and the video images make an important contribution to the meaning of what is shown on stage. Or, as Pamela Howard writes in "What is Scenography": 'It is the seamless synthesis of space, text, research, art, directors and spectators that contributes to an original creation."[5] This means we are talking about the visual aspects of dramaturgy; the dramaturgy of everything we can perceive visually. The text below provides an insight into the dramaturgical thinking involved in creating the visual aspects of performances.

When discussing the design of performances, many handbooks (especially Anglo-Saxon ones) make a distinction between space, stage design, and the appearance of the characters. By 'space', the authors mean the place, the building where the performance takes place, and the relationship between the performance and the audience who come see it. By 'stage image' they mean the set, the lighting, projection (video), the props, and sometimes also the sound and the music. By the 'appearance of the characters', they mean the costumes, props, the make-up, and the hair design. Different words, sometimes meaning the same thing, but all referring to one aspect, namely what a performance *looks* like.

What really is 'design' and how does it work in the theatre? What makes design in the theatre different from design in other contexts? The Netherlands is perhaps one of the most 'designed' countries in the world. Our dikes, cities, parks, polders, shops, even our 'wild' nature reserves have been designed. It is design that encourages us to buy more, that tells us that we should relax outdoors, that tells us that we should dress more beautifully, or that we should decorate our homes in a spectacular way. It is design with a great utility factor or design that has a purely aesthetic function. Of course, both utility and aesthetics also play an important role in theatre design. But there is one big difference between design in our daily lives and the design of theatre performances. Perhaps part of the reason for this difference can be found in the World Centre Transportation HUB in New York. Architect Santiago Calatrava was given the almost impossible task of building a new station on the site of the former WTC, next to the National September 11 Memorial and Museum. The station was, and still is, one of Manhattan's most important rail hubs. What do we see? A canopy of white curved rafters that work against the surrounding rectangular skyscrapers. It is a train station, but does it stand for something more than that? More

than just a place for transport? What does it look like? A pigeon escaping? And what does it mean: transport as a flight; freedom from terrorism? These questions, prompted by the way the building looks, is exactly what creating the visuals of performances is about: it is always about content, about creating meaning.

Scenography

The fact that theatre design is, above all, about meaning is also reflected in the debate on what terminology should be used: design; stage design; or décor? The Czech theatre director, set and lighting designer, Josef Svoboda (1920-2002) was dissatisfied with this terminology. He stressed that the words '*Ausstattung*' in German, 'stage design' in English, and '*décor*' in French reduce the designers' task to the framework of a dramatic work, rather than participating in the entire creative process. Because this 'framing', as Svoboda calls it, means that it would involve providing a 'finished and ready' product with a (and the French word says it all) decorative environment. Svoboda found the Greek word '*scenografika*' (the writing of the theatre space) more appropriate. He therefore introduced the term 'scenographer' for someone who is responsible for the entire stage image: 'the interplay of space, time, movement and light onstage.'[16] Dramaturg Marianne van Kerkhoven expanded upon this in her article, "A Journey into Space/a World without a Centre" as follows:

> [T]oday, words such as set and set designer are increasingly being replaced by scenography and scenographer. The stage image no longer seems to be an illustrative, subordinate, added-but not a vital element in the performance; today – so the word scenography says –- space is written, it is filled with meanings; it is a fully fledged means of expression for what the theatre maker wants to say.[17]

Whereas Svoboda included all aspects of the stage image in his scenography, the aforementioned Pamela Howard makes a distinction between scenography and lighting. This, it appears, reveals a difference of opinion between theatre in the Anglo-Saxon countries and that of continental Europe. Hans-Thies Lehmann does not see visual dramaturgy as an exclusively visually organised dramaturgy, but rather as one that is not subordinate to the text and can, therefore, develop its own logic.

But since the expression 'visual dramaturgy' in Anglo-Saxon literature often refers to dramaturgy of puppet theatre or object theatre, we use 'visual

aspects of dramaturgy' in order to avoid confusion. By this, we mean the space as well as the different parts of the stage image, and the visual elements that are connected to the actor (costume, hairdressing and make-up, props). In this section, however, we concentrate on space, set design, and lighting.

Scenography 'writes' meaning in space. Scenographers do not just come up with a beautiful image as a background for what is happening on stage, rather they are responsible for the total design of the performance. Van Kerkhoven calls this 'the sense of space created by a stage image and the relationship it establishes with the globality of the performance.'[18] The scenography is part of the entire dramaturgical thought process. The work of a scenographer is therefore not very different from that of a dramaturg and a director. All are concerned with analysing and determining the meaning, and the aesthetic and dramatic potential of a text, libretto, piece of music, and/or concept. This process involves discovering and investigating what is needed to turn this into live theatre and applying it in such a way that the dramaturgy of the performance is made accessible to the audience.

If we look at the theatre history, scenography has evolved from pure decoration into a discipline that adds something essential to the vision or interpretation of the theatre maker. In other words, scenography creates a space where the individual parts may not represent and/or mean much, but rather where the whole of the assembled parts, and the way the space is filled and used by actors, dancers, singers, and performers generates a deeper meaning. The scenography thus creates a space that only makes sense, and more importantly, acquires meaning and therefore effect, when the actors, singers, and dancers occupy it. A good scenography mainly raises questions. Questions that can be answered by including the performance as a whole in the answer. *The Cambridge Introduction to Scenography* describes it as follows: 'Scenography is not simply concerned with creating and presenting images to an audience; it is concerned with audience reception and engagement. It is a sensory as well as an intellectual experience, emotional as well as rational.'[19]

Many theatre makers have influenced the role that scenography plays in the dramaturgy of performance. In the context of this chapter, two names are of particular importance: the Swiss Adolphe Appia (1862-1928) and the Englishman Edward Gordon Craig (1872-1966). It was Appia in particular who, with his publications, changed thinking about scenography; he wanted to move away from the illustrative two-dimensional painted canvases as decor and instead advocated three-dimensional structures that through the intensity, colour, and direction of light, could change shape. Appia saw light as 'visual music'. Through the interaction between light and music,

changes in emotion and action could be shown. For Craig too, shape, light, and colour were the means to convey atmosphere. He argued that moving, illuminated decors (canvases) could create an emotional reaction in the audience.

Appia and Craig were often viewed by their contemporaries as impractical people who knew little of daily theatre practice, and, as such, their ideas would not be useful. However, their ideas forced their contemporaries to think about the nature of theatre as an art form. Together, they influenced the trend towards a simplified set, towards three-dimensional decors, towards plasticity, and towards an active light: a scenography with added value rather than a literal representation of what the text prescribes. Arnold Aronson therefore calls Appia and Craig the founders of modern scenography:

> In response to the scientific realism that typified the naturalistic drama of the 1870's and 1880's and the two-dimensional but detailed realism of painted sets typical of nineteenth-century romantic realism, Appia and Craig called for a theatricality characterized by simplicity, suggestion, abstraction and grandeur within the context of a three-dimensional sculptural setting that would unify the performer and the stage space.[20]

The space and the audience

The way in which the scenography works determines how the public perceives and experiences the designed space. This is not only about what is concretely visible, but also what is not there, what we do not see. What does the space suggest, in addition to what we 'really' see? It is a space that we as an audience fill with meaning, based on what we have seen, but also what we think we have seen. Van Kerkhoven:

> The space in which a performance takes place is elusive, difficult to describe [...]. No matter how accurately and intensely we will retrieve theatrical spaces that we once saw or experienced from our memories [...] there will always be doubt about the truthfulness of our perception. Questions such as "have we seen what we have seen?" or "have we seen what there was to see?" will always be present.[21]

And this is precisely the difference with the design we encounter in our daily lives. The design of a supermarket is, of course, fundamentally different from that of a clothing shop. Each design is aimed at enticing a certain target

group to buy. But it means nothing and demands nothing from the public other than spending money.

We are talking not only about the visual aspects of dramaturgy as part of the creative process and the performance (see also the text box on *Extremalism*), but also about its effect on today's audiences.[22] But a warning is in order. In today's theatre practice, there are no fixed rules. Every performance creates its own rules and has its own method. Every collaboration between the various artists – designers, directors, and actors, each responsible for a contribution to the dramaturgy – makes the performance unique.

When we talk about theatre, we often talk about a performance in which two elements are important: the performer and the spectator. But this ignores an important aspect of theatre-making, namely the 'where'; the physical place where this event takes place. And this is essential. That space to a large extent determines where and how the audience views and experiences the performance and thus the dramaturgy of that performance. We must not forget that, for centuries, theatre architecture, the way in which theatres were built, determined the stage image, and, in turn, determines the way in which people experience performances. There were no specially designed sets or lighting for a show. Elements from the architecture of the theatre building physically formed the set. The design of the performance was, as it were, embedded in the architecture of the building. Think of the Roman theatres we still come across all over southern Europe, with their richly ornamented façade as the back wall of the stage. Whatever was performed, that wall was always present and formed the stage image of the performance that was put on.

The position from which the audience sees the performance is also largely determined by that self-same architecture. Is the audience sitting directly opposite the stage or, for example, in a circle around it? How far away is the audience from the stage? Are there ten, or ten thousand spectators? Can the spectators see each other and each other's reactions? These are questions that have almost always been answered by the architect, and therefore by the building. Van Kerkhoven says about this:

> [T]he relationship that exists in a theatre between the spectator space and the stage is largely determined by the views of the world and society [...] In the Renaissance, for example, the way of looking was influenced by the perspective as can be seen in Palladio's Teatro Olimpico. It was a reflection of the conviction that the world had a centre: in the universe it was the sun; in society it was the monarch. These beliefs, in their purest form present in Palladio's model, live on in the 19th-century or older theatre buildings that are still being played today.[23]

Arnold Aronson takes this one step further and argues that the development of the theatre building itself leads to a standstill in the development of the theatre; that the development of the Greek drama stopped when the stone theatres were built; that with the construction of the Comédie-Française in seventeenth-century Paris, the theatre of the famous French playwright and theatre maker Molière came to a standstill. In other words, the architecture determines the type of theatre that is made, and then preserves and conserves it.

We still see theatre buildings in everyday theatre practice that are essentially based on the perspective that Van Kerkhoven refers to. In all the major cities in the Netherlands and Flanders we come across theatres that are based on that perspective. Theatres in which it is almost impossible for the audience to see a performance as a whole from the side balconies, in which *where* you sit has a major influence on *what* you see and therefore on *what* you experience. Theatre innovators from the second half of the twentieth century such as Jerzy Grotowski, Richard Schechner, Eugenio Barba, Ariane Mnouchkine, and, in the Netherlands, Johan Simons and Paul Koek, tinkered with this established relationship between performance and audience. Their starting point was to share the space together, to no longer distinguish between public space and performance space. For the Polish director and theatre innovator Grotowski (1933-1999), this was the core of theatre: actors who co-create the performance together with the audience in a shared space.[24] Richard Schechner (writer, professor, and director and founder of The Performance Group) took this one step further:

> The spectator can choose his own mode of involving himself within the performance, or remaining detached from it. [...] [He or she] can change his perspective (high, low, near, far); his relationship to the performance (on top of it, in it, a middle distance from it); his relationship to other spectators (alone, with a few others, with a bunch of others); whether to be in an open space or in an enclosed space.[25]

Writing the space

How and with what do scenographers fill the theatre space? Visual art is generally perceived with the eyes. Visitors to an exhibition often admire the beauty of what is on display. How beautiful they find something determines to a large extent on how good they think it is. In theatre, this works in a slightly different way. Of course, there are beautiful theatrical images, but the scenography of a performance shapes a theatrical reality. An empty

space is transformed into an environment in which the performance can take place. The designers create a world in which the play can exist, can live. Whether a performance is dominated by images or text, the function of the scenography is to place the action in such an environment that the dramaturgy of the piece can be shown.

No matter how realistic or abstract a performance may be, it always takes place somewhere. Designers respond to this by using the various elements at their disposal in such a way that a visual unity is created. The sets and the lights are essential in this regard. These elements create an atmosphere and/or very clearly emphasise the directors view, the 'theme' of the performance. In this way, the empty space is filled with images; images that are motivated by the demands of the performance, by the text, by the choreography, and by the context of the production. Filling the space brings the stage to life. Filling the space with sets and lights influences how that space is used by the performers and how the performers, in turn, give meaning to what is on stage. Scenography acts as a designer of emotions, of conflicts, and of steering the action: sets and lights influence the placement of the performers on stage.

The scenography helps to capture the audience's attention and, where necessary, to direct and influence it. The designer must therefore also be able to speak the same language as the audience. Emotions and experiences play an important role in this because a performance always refers to a recognisable reality, no matter how abstract the images may be. In a play, very often the text gives information about the fictional world, but above all it is the scenography that refers to the time or place in which the characters find themselves. They can conjure up an illusion of reality, but they can also deliberately break through that illusion, or, on the contrary, emphasise it. Bear in mind that, generally, the audience sees and experiences the stage image sooner than it sees the performance itself. Dennis Kennedy wrote in, *Looking at Shakespeare:* 'there is a clear relationship between what a production looks like and what its spectators accept as its statement and value [...]. the visual signs the performance generates are not only the guide to its social and cultural meaning but often constitute the meaning itself.'[26]

Theatre technique also plays an essential role in this. You could argue that Appia and Craig's ideas about how to convey atmosphere and emotion are only now being realised on our stages. In the theatre we show moving images to the audience. And that audience today is encountering this more on a level of experience than on a level of direct meaning; more on the level of feeling and emotion than as a direct reference to reality. In addition to sound,

the influence of light as a visual medium, as a carrier of the atmospheric image of the performance, is particularly important.

Light

The ultimate source of light in our daily lives is the sun. It provides almost all the heat, all the light, and all the energy needed to make life on our planet possible. Although the sun is only a star of limited size in the Universe, its presence is vital to all life on Earth. But the sun is also dangerous. The sun's light is so strong that it can blind us and set the earth on fire. In other ways, too, the influence of light on us should not be underestimated. Our eyes, for example, depend on light to see. Light makes the difference between seeing and not seeing. Light, as stated above, is a creator of atmosphere.

We know, too, that light tans and has a healing effect on some skin diseases. And that a lack of light can lead to forms of depression (Seasonal Affective Disorder). In the autumn, when it starts to get dark earlier, some people notice it immediately: gloomy feelings and tiredness arise. To prevent this, in the winter of 2013, Rjukan, a village in Norway situated in a valley, placed mirrors on the mountainsides to reflect the sunlight so that the village was bathed in light for longer in the day.

Light can connect us with each other and with ourselves. We seek shelter in the warmth of light. It gives insight and clarity. We sacrifice with and for the light; we do so at feasts as a sign of solidarity, but also to share grief and seek comfort. We make light in our houses, with fire or with electricity. We celebrate each new year with explosions of light. At concerts we light ourselves and the room with lighters and telephones, to express a sense of togetherness. We light candles to make a wish or to commemorate the dead.

The contrast between light and darkness is often used as a metaphor. Darkness stands for evil, light for good. The path from dark to light is used to describe the development of man as positive, the path from light to dark as negative. The Dutch poet Van Randwijk wrote in tribute to those who perished in the resistance during the Second World War: 'a people who give in to tyrants will lose more than body and good, then the light will extinguish.'[27]

This light/dark contrast also lies at the basis of much of the subjective interpretation that the public gives to light. In thinking about visual aspects of dramaturgy, the contrast between light and dark is therefore an important element that can be used in scenography. Visual artists make frequent use of the contrast between light and darkness. M.C. Escher shows the darkness, in which the fish light up and turn into birds. The yin-yang sign symbolises

that in the light exists the seed of darkness, and in the darkness the light germinates. Vermeer shows in his paintings that light gives sharpness, and darkness softness. In art, light and dark are inseparable. We can illustrate this contradiction by means of two installations in the colossal Turbine Hall of the Tate Modern in London. These two works of art clearly show how we experience light and space, and the influence it has on us.

The first work is *The Weather Project* (2003-2004) by Olafur Eliasson. Eliasson took public obsession with the weather as his starting point. The installation made us aware of how we let light influence our thoughts and feelings. The entire ceiling of the Turbine Hall was covered with a mirror. A fine mist spread through the space. Sometimes as clouds, sometimes as dense fog, changing the perception of the space. At the end of the hall there was a gigantic semi-circular shape, consisting of hundreds of mono-frequency lamps. Mono-frequency lamps emit light with a limited range of the light spectrum, so that the spectators saw all colours as yellow and black, just like the yellow sodium lighting along our highways. Due to the reflection of the mirrored ceiling, the semi-circle became a round, sunny object. The fog and the mirrored ceiling provided a dazzling light.

Visitors to the installation sometimes spent hours in the Turbine Hall. Why did they do that? What did the installation evoke? The rising sun, the setting sun? The feeling of lying on the beach? People described that they experienced the feeling of bathing in warm sunlight. But the mono-frequency lamps emit little or no heat. Were they talking about inner warmth? There was an interaction between what was shown and what was happening in the visitors' memory, all kinds of memories of 'beautiful' moments associated with the sun must have played a role in this.

Eliasson shows us where the world comes from. He wants to connect what we see and therefore think we know in a creative way. 'Knowing' and 'seeing' are part of an experience created by the viewer. As Eliasson articulates it: 'seeing yourself sensing.' Being able to experience your own 'seeing' as 'conscious seeing' makes you aware that you are reacting to the environment you are in, consciously, not unconsciously. You can only influence what you are aware of. Visual awareness not only influences our perception, it can also influence our feelings: seeing with your heart, feeling with your eyes.

Just as *The Weather Project* is an almost perfect representation of how we are obsessed with the sun and the weather, *How It Is* (2009-2010) by Polish artist Miroslav Balka shows our fear of darkness. *How It Is* refers to recent Polish history. Balka created an enormous metal black box in the Turbine Hall. On the outside, the box was reminiscent of the train carriages and

trucks that transported Jews to the camps of Treblinka and Auschwitz. The enormous construction filled the entire space of the Turbine Hall.

On the inside, it was painted with the darkest black paint available. By entering the dark space, visitors underwent a strictly personal, sensory, and emotional experience. The absence of light hindered their perception; we can only see because objects are illuminated. Without every possible perception, we lose our grip. But in *How It Is* it is not only the absence of light that causes the feeling of being adrift. The fact that you could not see but rather feel the presence of others combined with the lack of sound experienced in the box caused feelings of excitement and even fear.

These examples illustrate the power of light and its influence on our perception, conscious or unconscious. This is certainly also true in the theatre. When you become 'aware of seeing', as Eliasson calls it, you also make connections between the light images and the dramaturgy of the performance.[28] Light can then be used as a guiding principle in the performance. This goes for the maker as well as for the spectator. The performance *Extremalism* by Greco and Scholten is a good example of this (see the text box).

In the theatre we strive for total control over the scenography, over the light. We do this to dispel the dark or to create that dark again. Since we started building theatres with a roof, we have been working on ways of bringing the light inside and controlling it. From the soft yellow lighting of wax candles to today's HMI and LED lighting. The light we work with in the theatre has evolved over the centuries from 'making visible' to 'lighting'. It is not only aesthetic, it shapes the space, it directs our gaze and guides us through the image, it influences how we experience the space, the image. Light, of course, has its own beauty, its own dramatic impact, but it is also an important part of the visual and auditory elements that contribute to the dramaturgy of the theatrical image.

The visual experience

Because spectators give meaning to what they see in the theatre based on their own experiences, the theatrical image is more than just visual: it is an experience you undergo. It is not only about what it *looks* like, but rather more about what it *does* to us; how it draws us into the image and allows us to experience it; how the light, for example, imposes itself on us; how the image is hidden or slowly becomes visible; how it creates space and movement and thus evokes new associations and emotions. How does this work? Maria Shevtsova wondered what the audience actually sees in

the theatre, what it perceives: 'At the most there is the habit of Western spectators, when questioned about a production, usually to mention the acting first, and then, in decreasing order, sets, costumes, lighting, pace, spatial configuration, choreography, music and atmosphere.'[29]

Apparently, spectators look first at something that is human, and only then at the other elements, such as the set and the costumes. Light plays a crucial role in this, it is the scenographic part that connects all visual elements on stage (space, set, costume, actor), and gives them a certain character. According to Dennis Kennedy '[...] the visual [...] is an essential part of theatre, even when not particularly delightful, or luxurious; what an audience sees is at least as important as what it hears.'[30] According to Aronson, man is a spatial being, a being that reacts instinctively to space and so it is debateable whether what we see on stage can be read.[31] As Van Kerkhoven rightly argues as early as 2002:

> In modern scenography, as space is *written* more and more, the viewer is increasingly asked to *read* the signs applied; fixed points of reference are hardly offered to them; their looking is a journey; they are invited to map out their own route in a world without beacons.[32]

Extremalism – ICK & Ballet National de Marseille (2015)

In 2015, Pieter C. Scholten and Emio Greco celebrated their twentieth anniversary as theatre makers. Their first collaboration, *Bianco*, dates back to 1995. Greco and Scholten have been working together since 1995 and founded ICK in 2009. Between 2014 and 2019, they were also artistic directors of Ballet National de Marseille. *Extremalism*, a fusion of the extreme with the minimal, is the first major co-production between these two companies and the fourth performance of Scholten/Greco with the theme 'Body in Rebellion'. With the series 'The Body in Rebellion'. Greco and Scholten use the body to map out a changing society. The tired body of the hurried man is the most important frame of reference. According to Greco and Scholten, people have lost contact with their own bodies and sensations. They wonder about the ways that the body can revolt against this. In the performance *Extremalism*, this theme is incorporated in both form and theme. They take stock of the present with a glimpse into the past, and a cautious helping hand towards the future. Together with thirty dancers, twenty-four from Marseille and six from Amsterdam, the artistic team went in search of the extreme and the minimal.

The basis for all movement material in their work is the body of Emio Greco. Their collaboration began with solos performed by Emio. They later began working on duets, then pieces with up to six dancers. The scale of their perfor-

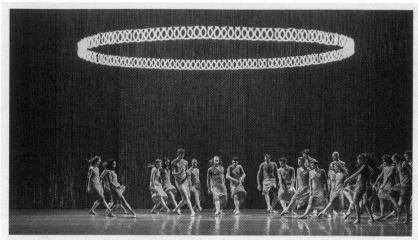

Extremalism, staged by Emio Greco and Pieter C. Scholten / ICK & Ballet National de Marseille (2015). Photo: Alwin Poiana.

mances continued to grow over time; with *Extremalism* they came to work with a group of thirty dancers. The performance *Extremalism* has three parts, IERI, OGGI, and DOMANI. In IERI, past material from previous performances returns, and is reinterpreted by a new generation of dancers. The concept of 'tribal' is also worked on: a group of dancers trained in Marseille and one in Amsterdam, with their own rituals, come together and share the recognisable movement material of Emio Greco and Pieter Scholten with the audience. In the second part, OGGI, the present, the central question during the creative process is where to start talking about our current society. The starting point was the Millennium Development Goals formulated by the UN in 2000. These goals can all be traced back to the body (hunger, mortality, disease, technology, etc.). These research questions are not directly reflected in the performance and are therefore invisible to the audience. Instead, they were a guideline for the creators in the creation and structuring of material. The third part, DOMANI, introduces the future through a farewell to a new beginning. It becomes a moment of hope with an open mind to that future. The performance ends with dancers, exhausted, sweaty, and almost naked, standing together and looking expectantly at the audience.

In the philosophy of Greco and Scholten, dance is not approached as a succession of movements in time, but as synchronous movement and breathing at the same time and in the same space. Together with the three formulated parts, this formed the starting point for the design of the performance. Whereas in most of Greco and Scholten's performances the scenography develops during the creative process, during *Extremalism* several starting points were formulated,

in addition to the thematic three-part division, such as a reference to the design of earlier performances, but especially the introduction of a 'strange new element' into the world of *Extremalism*.

Crucial for the scenography was the introduction of a strange, new penetrating object into the performance. The light sculpture with the name Chain Reaction, designed by Henk Stallinga, became not only the starting point for the scenography, but also the anchor for the whole creation of the performance. Chain Reaction consisted of a chain of 144 connected round fluorescent tubes and was a symbol of eternity. The intensity of the tubes could change per lamp from a subtle glow to an intense bright light. As a light object, the installation not only enters the stage, but through the movements it made, rising and falling and fast or slow revolutions, it becomes part of the choreography and thus, as it were, an extra dancer. During the creative process, the dancers interacted with the object and searched for a way in which they could react to each other, strengthen each other, or confront each other.

Because of its shape and size (eight metres in diameter), the Chain Reaction also became decisive for the rest of the scenography. The colour contrast with the fluorescent tubes played an important role in the choice of the dance floor (brown) and the chain curtains (red copper). The chain curtains creates a box set (a reference to the earlier sets in performances by Greco and Scholten), which, due to the colour of the lamps in the Chain Reaction, in cooperation with the other lighting, changes colour and atmosphere. Because of the different colour qualities of the light, the chain curtains change from warm red/bronze in IERI to cold silver-grey in DOMANI. The costumes reinforce this development. In the IERI part, the dancers wear the iconic black dresses that had already appeared in the earlier work of Greco and Scholten; in DOMANI, the dancers wear only skin-coloured underwear. Here, the body must speak as much as possible. Every muscle and every breath has to be shown.

Music always plays an important role in the work of Emio Greco and Pieter Scholten. There is constant research into how music and dance work together without merging completely. For *Extremalism*, the Icelandic musician, composer, and producer Valgeir Sigurðsson was asked to capture the universe that Greco and Scholten create with their dancers, in music, alongside the soundscapes composed by Scholten. Sigurðsson combines contemporary classical and esoteric electronic music, sometimes to a point where one is indistinguishable from the other. The dialogue between his music and Scholten's soundscapes was mainly expressed in relation to the Chain Reaction. Sigurðsson's composition strengthens the movements of the object and thus the rhythm and tempo of the choreography.

3.4 Auditory aspects of dramaturgy

In recent years, sound in theatre has received significant scholarly atten-
tion. This is partially in reaction to a changed theatre practice exploiting
the technical possibilities of sound design. It is additionally the result of
an academic turn to sound, and concerns traditional opera and musical
theatre as much as experiments within theatre. When we speak of auditory
aspects of dramaturgy we collect different instances and examples, similar
to Mladen Ovadija's 'dramaturgy of sound' in his book with the same name.
However, Ovadija focuses on examples throughout history that revolve
around sound or take sound as a starting point. He assembles observations
from avant-garde to postdrama:

> '[...] the dramaturgy of sound has become constitutive of a theatre that
> places more emphasis on performance, mise en scène, and the audio-visual
> architecture of the stage than it does on dramatic text.'[33]

With postdrama the emancipation of theatre elements in terms of sound
means, as Ovadija observes, that sound is no longer subordinate to the
theatre text, as is the case in musical soundtracks or background sounds
and sound effects.

In the Netherlands, elaborate 'sound décors' (*klankdecor*) are a common
way of using sound in a merely supporting role and historically were used
in performances of the Nederlandse Comedie from the 1950s on, and later
by Publiekstheater and Toneelgroep Baal.

These 'sound decors' often consist of composed music alternating (to a
lesser extent) with sound effects and atmospheric sounds, which give space
to its auditory characteristics.

> What is the musical space of a performance? If the script says that a
> scene takes place outside, you can make use of strategies from musique
> concrète, with church bells, birds and rain. A bedroom sounds different
> than a dining room. Those are things which you can design with music
> and sound.[34]

In the sound archives of the former Dutch Theater Museum you can find
sound recordings of performances from the 1960s that are based on texts
known internationally for their radiogenic qualities, such as *Under Milk
Wood* by Dylan Thomas or *Telemachus Clay* by Lewis John Carlino.

In this chapter, we choose to talk about the auditory aspects of dramaturgy as opposed to 'dramaturgies of sound', as Ovadija calls it. We prefer to focus, in line with earlier chapters, less on observations on specific performances per se, and more on the underlying knowledge and principles handled and how to inquire into them. When focusing on the auditory dimension of performance (making), we focus on what becomes audible, and how sounds are composed to move, undermine, contrast, etc., in relation to the rest of the theatrical material. On which level does the auditory material communicate? How does the auditory dimension relate to the other theatrical elements? What vocabulary describes the auditory aspects? Will I rely on metaphors, do I tend to describe its effect? What function does sound have in the overall dramaturgy of the performance? How and why does the auditory dimension become a crucial factor for the analysis of a performance? At what point does the auditory become more than a part and maybe the central paradigm of the performance? In which medium is the auditory dimension presented?

In their 2015 production *The Encounter*, Complicité and director/ performer Simon McBurney make use of a binaural microphone on stage, which allows the audience to perceive the live produced sounds spatially through their headphones. The performance explores the (technologically at the time) newest ways of listening, but finds its reason to do so in the story being told. As McBurney elaborates: "The Encounter is at its heart a story about "listening", not "hearing" but listening; to other, older narratives which, at the deepest level, form who we are, and if we do, we can imagine how we can "begin" again.'[35] In contrast to the rich story world in the headphones, switching location between the Amazon rainforest and a family home in Britain, the visible stage remains unchanged and emphatically empty, which amplifies the focus on the auditory dimension and the 'space' given to imagination.

In another example, *The World-Fixer* (*Der Weltverbesserer*) from 2017/2018, based on a play by Thomas Bernhard, Toneelschuur Producties and director Erik Whien present a deliberately dimly lit stage, with actor Sanne den Hartogh delivering a haunting solo performance. In the twilight of the stage, the story comes to life, and, in terms of sound, the focus shifts to the performer's voice.

Voice

We will now zoom in on voice, and in particular on its performative use and function in the creative process. Voice is the transitory medium of text

and song. In addition to transmitting content, it also has a certain pitch and tone, which contribute to the sensory experience; an experience of atmosphere and physicality that is situated much less clearly on a spectrum between aesthetics and meaning. Any signature of directing is carried out at the level of the body.

As a performative instrument for text, it operates in between text and audience, it carries meaning and colours simultaneously. We almost never hear voice without its emotive movement, which underlies the spoken words. This complex makes the position of voice interesting. Voice is rarely discussed in performance reviews unless it has had a special place in the dramaturgy of a performance. How, then, can we talk about voice? And how can voice be perceived to figure so centrally in the dramaturgy of a performance, as mentioned in *The World-Fixer*?

To distinguish amongst all the different perspectives on voice, let us focus on at least three categories, each of which have drawn interest in different fields of study:

a) *Sound:* what seems to be a basic level turns out to be quite complicated to discuss. How can you speak about the sound of a voice? Most people find it quite difficult to express exactly what they hear. Yet, borrowing from music studies, for example, might bring us closer to determining the interplay with other theatrical means and lets us pay attention to the singing voice, rhythm, pitch, intonation, conduct of voice, silence and breaks, breath. This way we can speak about one specific voice, but we can also zoom in on the level of the auditory: What else is *audible*? How do the different voices of the actors sound together? Do they contrast? Do they form a choir? When focusing on sound, voice appears alongside music and other auditory means. Moreover, our perception of voice might belong in this category of paying attention to sound. How do we listen? To analyse this, we can make use of the findings in the interdisciplinary field of sound studies, but also borrow from philosophy, or, more specifically, from phenomenology.

b) *Technique/ technology ('techniek'):* The Dutch word 'techniek' designates both the technique or (voice) training as well as (audio)technology. The former largely concerns what an actor learns in acting school and, as such, draws on a specific body of literature. For the latter, we pay attention to innovations in audio technology. However, in practice, we might find that performances, like *The Encounter* that tasks itself with a specific dramaturgy of projection of voice and story, refine both of these 'technical' modulations of voice. However, to analyse aspects of technique/ technology we must rely on different fields. In one case, we

might be interested in, for example, an actor's voice training; in another case, we might ask about the use of microphones, the technological innovations of loudspeakers, or sound design in relation to the soundscape.

c) *Language/ speech:* to summarise a field of language might be a problematic suggestion, as it unites interests from semiotics, linguistics, philosophy of language, and various interests from theatre and performance studies under a single header. However, what might justify a categorical distinction from the above-mentioned categories, is that, on this level, we look at voice specifically in terms of the act of reciting text.[36]

The division into the categories above is meant to raise questions and to lay out some of the fields that, historically, have taken an interest in the study of voice. When working on or analysing a performance, a specific interest in voice come to the fore.

For decennia, the live performances of Laurie Anderson have been often-mentioned examples of the experimental use of voice and voice filters and as integral part of her music. Another famous example is the opera *Einstein on the Beach* by composer Philip Glass and director Robert Wilson. High-pitched voices, which count down a series of numbers, are a catchy and memorable part of the performance. In both examples, voices are employed in different ways as instruments and part of the music, and can hardly be said to serve the conveying of information.

A few historical examples of voice in theatre

In her article "Shakespeare hören" (2008), the German theatre scholar and voice expert Doris Kolesch looks at the history of the experimental use of voice. She focuses in particular on the conduct of voice and the auditory dimension in Greek antiquity and Elizabethan theatre. She remarks on the importance of the acoustics of theatre buildings.[37] In Greek antiquity, the agora, the central meeting spot for citizens, was a place of rhetorical declamation. As we know from Greek tragedies, the chorus held a central place as dramatic expression, while solo actors were introduced only later.[38]

For Shakespeare's time, Kolesch takes note of the communicative aspect of the architecture of the *public theatres*, for which Shakespeare wrote. Peter Brook notes that seventeenth-century stage design was not detailed, but that the dialogues spoken by actors had the task of speaking to the collective imagination, to 'furnish' the interior stage, so to say. Text, voice, and music might be said to play important roles on the stages of the time.

Beyond meaning

Someone who is known for his use of voice, without doing so in the context of music or theatre text recital, is Antonin Artaud (1896-1948). He is known for his Theatre of Cruelty, for which he reclaims the immediate and direct force of theatre. He explores the most extreme expressions. In pushing the limits, theatre becomes a physical sensory experience, with voice and language becoming the instruments of a particular transgression:

> But this tangible, objective theatre language captivates and bewitches our senses by using a truly oriental concept of expression. It runs through our sensibility. Abandoning our Western ideas of speech, it turns words into incantation. It expands the voice. It uses vocal vibrations and qualities, wildly trampling them underfoot. It piledrives sounds. It aims to exalt, to benumb, to bewitch, to arrest our sensibility. It liberates a new lyricism of gestures which, because it is distilled and spatially amplified, ends by surpassing the lyricism of words.[39]

An extreme example of his use of voice is *Pour en finir avec le jugement de Dieu* (1947). Artaud himself performs this work for the radio. Alongside a wide and intense range of voices with particularly haunting screaming and screeching, there is a striking fluidity between spoken language and unarticulated sounds. The touching intensity of Artaud's voice is strongly alienating. Susan Sontag comments in her article "Approaching Artaud" on how his theatre works through an intended 'mutilation of language and the transcendence of language in the actor's scream.'[40]

It is not easy to identify any traces of Artaud's influence in current Dutch-speaking theatre practice. Naomi Velissariou is perhaps an exception. She experiments with intensity and the sound of voice in her concert trilogy. The violence, even if, ultimately, somewhat ironically presented as marketable, with merchandise at the door and with the allure of a diva, resonates in the name of the concert series *Permanent Destruction*. It continues in the style of a textual adaptation, such as that of Sarah Kane and Heiner Müller, and, in so doing, it arguably achieves Artaudian ambition in its performance at times. Velissariou's choice to voice the text is matched by the overpowering sound and beats of the music.

A theatre form not often practiced in the Dutch-speaking field, at least in comparison with the rest of Europe, is the voice performance of actors speaking in chorus. In German-speaking countries, *Chorisches Sprechen* is even taught in acting schools and, in recent decades, it has manifested

in the practice of numerous theatre makers, ranging from Einar Schleef to René Pollesch; internationally, the Polish director Marta Górnicka has been praised for her *Chorus of Women*.

A chorus requires musical direction and, dramaturgically, raises questions that fall into the reach of composition. Artistically, it requires a sense of collectivity. Both the 'compositional approach to the creation and structure of performance,' as Mladen Ovadija calls it,[41] as well as operating as a collective is familiar territory in the Dutch-speaking theatre world, as we have mentioned before (such as De Veenfabriek or its predecessor Hollandia). Recent initiatives, such as DIEHELEDING, research rap as mode of storytelling and theatre making. Voice becomes one of the instruments and is equal to all other theatrical elements. Principles of musicality are not, after all, limited to the acoustic dimension but concern the play with tempo, repetition, and rhythm, which can then also be applied to visual elements such as light.

Performances of De Veenfabriek are regularly site-specific. As theatre scholar Marijn de Langen argues, even in performances on location, the material on site becomes an instrument, or what she calls for their performances on farmland 'drumming the countryside.'[42] This access to theatre is fundamentally sensory; using sound centrally but also interacting with senses of orientation, taste, and tactility. Time is often organised musically, and the dramaturgy of the montages is composed musically as well. In the case of De Veenfabriek, the conduct of voice can often be observed as the starting from musical principles.

The examples from current Dutch-speaking theatre practice stem from postdramatic or experimental theatre forms. Narrative or classical forms of musical theatre or opera know their own more or less standardised code for using voice. Within those conventions, the audience accepts that voice is both carrying out text as well as melody, which can mean that a character who is dying is still going to finish their aria. Brecht takes an interest in this paradox when laying out the foundations of his epic theatre (as described in Chapter 2): 'A dying man is real. If at the same time he sings, we are translated into the sphere of the irrational. (If the audience sang at the sight of him the case would be different.'[43]

Accents, dialect, play with language, and sound of voice

Another way in which voice can become a dramaturgical tool is the play with regional dialects, accents, or languages. The use of such language variations goes back to Greek antiquity. When Dutch writer Herman Heijermans

(1864-1924) seeks to portray the local farmers' dilemmas, he makes use of regional ways of speaking to highlight the regional problem authentically. Since 1965, the Frisian theatre company Tryater has usually performed in at least two languages, standard Dutch and Frisian or its local varieties, in order to promote the regional languages.

Voice in the Dutch-speaking theatre landscape can still be heard in its particular sound, technicality, and voice training. There are sound recordings in the archives of the actor Louis Bouwmeester (1842-1925), who portrayed Shylock in *The Merchant of Venice* in a peculiar singing voice. A particular female voice from recent Dutch theatre history that can be heard over the course of time on recordings from the archive is that of Ank van der Moer (1912-1983), who had a characteristic low and increasingly raspy voice. Another actor vividly remembered for his use of voice was Jeroen Willems (1962-2012). As well as being an actor, Willems was also a singer. He regularly played (and sang) in performances by Hollandia.

It is striking how the voices of the above-mentioned actors are detailed in popular writing such as reviews, jury rapports, and journalistic pieces as magical and an indescribable force that remains in the ear of the listener. Such mystification is clearly of no use to a methodological sound approach, yet it is symptomatic of the lack of vocabulary that exists for analysing the voice, and the experience of a grey area between meaning and aesthetic dimensions.

For a dramaturg, sound analysis requires an openness to sensory registers, which, within the creative process, relates to the bigger picture of conceptual framing and the envisioned whole. How does a depressed Ivanov sound, and what does it mean for atmosphere, music, and use of voice? How does time get stretched in *Einstein on the Beach*? What makes Artaud's screeching transgressive? How does it change over the course of time? Which elements of Naomi Velissariou's concerts support the theme of the death drive in Sarah Kane's texts? How are motives translated to an experienceable level? How does the use of a microphone promote intimacy and intensity and when does it disturb it?

At the beginning of this chapter, we wondered whether a dramaturg needs to speak all (disciplinary and linguistic) languages. The elements detailed on voice in particular, and on sound more generally, prompt some different dialogues that can be had with the different makers on an artistic team. In addition to watching a lot of performances and being open to them with all the senses, dramaturgs are in a position to test vocabulary on their (auditory) experiences, in order to have a starting position from which to speak with other makers involved in a process.

4. Audience

4.1 The first spectator

'I can take any empty space and call it a bare stage. A man walks across this empty space whilst someone else is watching him, and this is all that is needed for an act of theatre to be engaged.'[1] This is the opening sentence of Peter Brook's famous 1968 book *The Empty Space*. The presence of at least one spectator is a condition for theatre. The word 'spectator' suggests that such a person does little more than looking, a predominantly passive attitude towards the performance. But that is seldom the case. The spectator not only watches, they feel, empathise, think, actively construct meanings, and try to relate to the performance in one way or another. In almost all cases, the spectator is also aware of the fact that they are simultaneously watching an actor and the character that the actor is portraying. Actors have a similar kind of dual consciousness. They are immersed in the character they are portraying while at the same time being aware of the artistic process itself, including the audience they are addressing. The spectator is therefore not only an essential component of the performance, but also an actor themself in the interaction between stage and auditorium.

Thus, without spectators, there is no theatre. The audience is therefore a key part of dramaturgy and of the dramaturg's work. An important task that is often assigned to dramaturgs is that of first spectator at rehearsals. For this task, they try to empathise with the future spectator and their aesthetic experience. The dramaturg not only gives artistic and content-related advice to the director, actors, and other creators, but also predicts how (part of) the audience will experience and appreciate the performance. On the basis of this, the dramaturg is also capable of predicting what a spectator might need or find interesting. At that moment, the dramaturg represents the virtual audience that the makers wish to relate to and enter into dialogue with. In the theatre, this is usually an imaginary dialogue, but the dialogue with the dramaturg in the creative process is real. The Dutch scholar Bart Dieho assigned the title *Een voortdurend gesprek. De dialoog van de theaterdramaturg* (An ongoing conversation. The theatre dramaturg's dialogue) to his book on theatre dramaturgy. He states: 'The theatre dramaturg not only enters into a dialogue with the makers, but also acts as an intermediary between the "inner world" of the makers and the "outer world" of the audience and other interested parties, such as theatre programmers and journalists.'[2]

The question is, however, which spectator we are talking about when the dramaturg tries to empathise with the role of the spectator. After all, spectators are individuals. And individuals can be quite different from each other. Of course, we also use the term 'audience'. All the individual spectators of a performance together form that audience. When we talk about spectators, we are able to distinguish between each individual experience of the performance. When we talk about the audience, we are talking about a more or less anonymous group to which the creators of the performance are trying to relate. This distinction is also identified in academia. Reception research is research into the theatrical experience of the individual spectator. It takes a psychological approach and looks at what a spectator actually experiences in the theatre, how they may empathise and identify with a certain character, how meanings are constructed and what stimuli cause a spectator to become aroused or, conversely, bored. Audience research on the other hand, is research into the behaviour of groups of people. It has a sociological approach, in which groups of spectators are defined in terms of cultural background, gender, age and level of education. This type of research provides statistical data on audience reach for different types of performances, and on which people visit the theatre and why. This kind of information is not only important to scholars, but also to policymakers and the marketeers of companies and venues.

During rehearsals, theatre makers, including the dramaturg, also take a future audience into account, i.e. a group(s) of spectators for whom the performance is intended. In policy and marketing terminology, such a group is called a target group or a target audience. For example, youth theatre performances may be targeting children of a certain age group. At the same time, however, the makers must take into account the wishes of the teachers and parents who accompany the young audience. When a company includes a Greek tragedy in its repertoire, it will usually be aware that such a performance attracts an audience of theatre connoisseurs, but classical language teachers will also find it attractive to attend such a performance with their students. The more strictly these target groups are determined, the more strongly the performance will respond to the expectations of these specific target groups. If you want your performance to convey a political message or address a specific social issue, you will most likely find it important that the audience for whom that message or issue is intended attends the performance. Sometimes, such performances are not even open to the general public and take place in venues where only the intended target groups come to see them. This is the case, for example, with certain educational performances, theatre pieces that are exclusively

performed in schools and that are intended to make students aware of a specific social issue that concerns them, for instance performances and projects about bullying, racism, gender inequality, etc.

In addition to a specific target audience, theatre makers may also wish to address the general public. The word 'public' has a broader meaning than a group of spectators to which the makers relate. We encounter this in expressions such as 'the public debate' and 'the public cause'. Public has the connotation of general importance on the one hand and of openness on the other, as in 'public transport' or 'public interest'. In this respect, the public can be much more than a group of spectators and theatre itself can therefore be more than the dialogue between the makers and the spectators who have bought a ticket and are present in the theatre at a specific moment in time. In this respect, as mentioned in Chapter 1, the Flemish dramaturg Marianne van Kerkhoven makes a distinction between minor and major dramaturgy. According to her, minor dramaturgy is the dramaturgic craftsmanship surrounding one specific performance. Major dramaturgy is about how theatre relates to the world. It is the kind of dramaturgy in which the theatre fulfils its social function. In her *state of the union* for the opening of the Flemish Theatre Festival in 1994, Van Kerkhoven put it like this:

> We could define the minor dramaturgy as that zone, that structural circle, which lies in and around a production. But a production comes alive through its interaction, through its audience, and through what is going on outside its own orbit. And around the production lies the theatre and around the theatre lies the city and around the city, as far as we can see, lies the whole world and even the sky and all its stars. The walls that link all these circles together are made of skin, they have pores, they breathe. This is sometimes forgotten.[3]

So, who or what is this first spectator? Does the dramaturg indeed empathise with the experience of an individual spectator, do they try to represent the audience in terms of a predefined target group or do they look at the performance in its significance for society as a whole and in its contribution to the public debate? And is it even useful to make such a distinction? In this chapter, we will examine this distinction between the spectator, the audience and the public: between the individual; the group; and society. Moreover, we look at the consequences of such a distinction for dramaturgy in general and in particular for the work of the dramaturg themself.

After this introduction, the second section of this chapter looks at the changing role of the spectators in the performance, and the consequences

this has for the position of the dramaturg and their tasks. The third section focuses on the way in which performances and other theatre projects try to reach certain groups in our society and encourage them to participate in theatre. It also discusses the financing of theatre, for instance in the Netherlands, in which reaching a diverse audience nowadays is an important criterion. The fourth section deals with the question of how political theatre can make spectators conscious of their socio-economic position and how, according to Augusto Boal, self-activity is the key to accomplish this. The fifth section deals with the organisation of the theatrical space and the spatial division between performance and audience. This determines, to a large extent, how spectators experience the performance. This section also deals with site-specific theatre and immersive theatre as special forms of theatre in which the spatial relationship plays an important role. Finally, the sixth section of this chapter explains how children and youngsters come into contact with theatre. In doing so, we look at Dutch youth theatre, or theatre for young audiences, on the one hand, and at the position of drama and dance within the educational system on the other.

4.2 The position and the role of the audience in the performance: the spectator as/is dramaturg

There is no theatre without an audience, that much is certain. But how the audience participates in the performance and how the spectators relate to the performance mentally and physically can differ immensely. How that relationship is organised is also part of dramaturgy. Should the spectator empathise with the characters on stage and be immersed in the story or should they critically view what is shown? Or, is a different kind of experience intended? Is that experience a collective or an individual one? And to what extent can this experience actually be determined in advance? After all, an important characteristic of theatre as an art form is that it is short-lived. The performance is limited to a certain time and place. There may be several performances of the same show, but the theatrical performance cannot be reproduced exactly. Each performance is unique and transitory. Therefore, the urgency and emotion of the moment, the physicality of the actors and spectators, and the spatial relationships largely determine the theatrical experience. Closely linked to this transitoriness is the simultaneity of production and reception. The audience is present while the work of art is being produced. The makers not only produce the performance at that particular moment, they also use their own bodies as the main medium.

Konstantin Stanislavski[4] was a Russian actor and director of the Moscow Art Theatre. Stanislavski not only wanted the actor to familiarise himself with the emotional world of his character, he also wanted the spectator to empathise with the characters, to see the world, as it were, through their eyes. However, in the physical space of the theatre, Stanislavski maintains a strict separation between the world of the spectators and that of the performance. From their seat in the dark, the spectator looks through the so-called fourth wall into a world they must experience as 'real', but of which they can only be mentally part of. This 'fourth wall' is the imaginary wall between the stage and the auditorium. By erecting this imaginary wall through stage design and acting, and by denying a direct connection between the world on stage and that of the spectators in the auditorium, the theatre makers want to give the audience the illusion that another, fictitious world is being presented on stage. This differs from the world that the audience members are part of, but they can still empathise with the characters and their emotions.

Bertolt Brecht, on the other hand, did not want the spectators to empathise too much with the events on stage or identify with the characters. This would risk them losing their ability to think critically. That is why Brecht, in his epic theatre, broke down the fourth wall and had the actors address the audience directly at certain points in the performance. He also used other alienation or distancing techniques (*Verfremdungseffekte*) to prevent the audience from getting too carried away by the story and the characters. This could be achieved by singing a song, using masks, or projecting texts during the performance. Brecht's aim was to get the audience to relate critically to what was shown and to reflect on its social position. After all, in Brecht's Marxist vision, the characters were primarily a product of the historical and social circumstances. But even though Brecht wanted his audience to think rather than empathise, in most of his productions the physical separation between performance and audience was maintained.

The French philosopher Jacques Rancière argues that this classic separation between performance and audience has put the spectator in a bad light. According to him, the spectator is regarded as ignorant and passive. They are deprived of knowledge about what is shown and of the capacity to act. According to Rancière, history has responded to the ignorant and lethargic state of the spectator in two ways. The Greek philosopher Plato and his followers considered the theatre to be fundamentally wrong because it was a false imitation (mimesis) of an already illusory world (an illusion of an illusion). In this way, the spectator became increasingly distanced from knowledge of the real world. Others did not blame the theatre itself, but

rather aimed their arrows at the passivity and ignorance of the audience. The spectators had to become active instead of passively watching the performance.

The urge to break through the spectator's passivity is one of the most important ingredients of the theatre reforms of the twentieth century. With Brecht, the audience was forced out of the illusion and confronted with a world that could not be real, because the actors themselves denied its authenticity. Thus, the artificiality of the theatre was emphasised and the audience was invited to relate critically to what was shown on stage. On the other hand, Antonin Artaud (1896-1948), with his theatre of cruelty, wanted to get rid of this critical distance. Instead of distancing themselves, the spectators had to be absorbed in the action and become part of a theatrical ritual, with the aim of abolishing the separation between performance and audience.

According to Rancière, both Plato and the aforementioned twentieth-century theatre innovators ultimately judge the attitude of the audience negatively. For Plato, theatre is wrong; for Brecht and Artaud, theatre is a way to free the audience from their inactivity and make them socially aware (Brecht) or to include them in a spiritual and energetic circle and bring them into contact with their subconscious (Artaud). Thus, the theatre of these twentieth-century revolutionaries confirms the fundamental inequality in the relationship between performance and audience. True emancipation begins, declares Rancière, when, following the example of the teacher-pupil relationship, we ourselves question the opposition between acting and looking. According to Rancière, the spectator is not passive at all, and the theatre maker should therefore not try to convince or change the spectator, but respect their dignity and role as a spectator:

> Emancipation begins when we challenge the opposition between viewing and acting; when we understand that the self-evident facts that structure the relations between saying, seeing and doing belong to the structure of domination and subjection. It begins when we understand that viewing is also an action that confirms or transforms this distribution of positions. The spectator also acts, like the pupil or scholar. She observes, selects, compares, interprets.[5]

This vision by Rancière is also a good starting point for a postdramatic view of spectatorship. After all, in postdramatic theatre, the spectator becomes the producer of coherence and meaning. Instead of the makers trying to seduce the spectator to sympathise with the main characters, as in classical

theatre, or to encourage them to overcome their lethargic state, as with Brecht and Artaud, in postdramatic theatre, the primacy of meaning lies not with the makers, but with the spectator themself. There is no explicit story and the various signs do not reinforce each other's meaning. Instead, the spectator is invited to make their own coherence and meaning. Each spectator becomes, as it were, their own dramaturg. This also implies a change in experience: from a collective experience (where the aim is for all spectators to experience more or less the same thing) to an individual experience (in which each spectator constructs their own story).

The dramaturg as intermediary between performance and audience

The role and status of the audience is therefore less unambiguous than it used to be, which also implies that the dramaturg can relate to the audience in different ways. In all cases, however, the dramaturg acts as an intermediary between the artistic core, the artistic mission and/or the (political) message the company/organisation/performance wishes to convey on the one hand, and the audience on the other. For example, the dramaturg provides all kinds of background information about the performance to inform the spectators. The main functions of this information are to reduce the information gap between the makers and the audience and to bridge the worlds of the makers and the spectators. Such an informative function can take many forms. One of these is the classic booklet with explanations about the play, the makers, the themes, the artistic mission, and all the other things the dramaturg wants to draw attention to. Nowadays, the websites of companies and venues also offer extensive information. In addition to these written and digital sources of information, many performances or series of performances are nowadays accompanied by various other activities, such as an introductory talk before the performance or a discussion, meeting or debate afterwards.

In *De taal van de toeschouwer* (The Language of the Spectator) Marieke Dijkwel, Simone van Hulst, and Tobias Kokkelmans conclude that, nowadays, the spectator is the centre of attention. Relatively new concepts such as 'audience development', 'relational aesthetics' (Bourriaud), and even 'relational dramaturgy' (Boenisch) confirm this. However, following Rancière, Dijkwel *et al.* argue that the relationship between professionals and audience is still an unequal one. In context programmes, the professionals try to inform the audience, introduce them to the makers of the performance, or encourage them to engage in critical reflection, but the result is seldom a truly equal exchange. Even in popular concepts such as 'participation' and 'co-creation', in which the audience not only watches and listens, but also contributes

physically to the performance, it is usually the professionals who determine the conditions under which the audience may participate or co-create.

The terms participation, co-creation, and outreach suggest that a theatrical event may incorporate more than the performance itself. They also suggest that the relationship between creators and spectators is more equal and based on an exchange. Moreover, these performances usually have a socio-artistic component, which can include participation, co-creation and cooperation with social partners. Youth theatre company BonteHond from Almere is one of the companies in the Netherlands that explicitly includes participation and co-creation in their youth performances under the direction of Judith Faas. A successful example is the diptych *Broek Uit!* (Take off your pants!) and *Schoppen* (Kicking), two site-specific performances about the world of football, which, in Faas' view, turns out to be mainly a man's world. The small-scale *Broek Uit!* (2016) was both literally and figuratively set in the football locker room and addressed the macho behaviour and physical shame of football boys in a light-hearted way. *Schoppen* (2018), in collaboration with dancers from the Utrecht based DOX, an organisation for talent development in the urban arts, is a much larger event that is literally set on the football field and in which the battle between two teams is captured in a stylised choreography with text, song, and music. The performance addresses several sensitive issues in sports and in society at large, such as racism and xenophobia. Moreover, by putting on a supporter's scarf, the spectators are given the role of supporters of one of the teams and are invited to cheer on their team throughout the performance. Halfway through the performance, however, they are asked to step onto the field themselves and reflect on how they relate to the other.

In this slowly changing theatre landscape, in which traditional forms of theatre coexist with participatory events and other performance concepts, the dramaturg continues to play a key role in the relationship between makers and spectators, between performance and audience. In their role of first spectator, the dramaturg must be able to place themselves in the shoes of the various spectators, each with their own individual experience. They must additionally consider how to relate to the audience at large. Do the makers want to draw the audience into their story? Do they want the audience to reflect on what is shown? Do they want to appeal to the individual (sensory) experiences of the spectators? Do they see themselves as transmitters and the audience as receivers, or do they want the audience to participate in the performance on an equal footing? Similar questions can also be asked about what is organised around a performance: workshops; introductions; after talks; debates; discussions; and exhibitions. Since the dramaturg is at

the centre of this process, close coordination is necessary, not only with the director and the other creators, but also with the marketing and education department. Is the aim to reach as large an audience as possible, is the performance aimed at a specific target group, or even at a group of people that would normally not be so eager to attend a performance?

4.3 Audience reach

The above-mentioned forms of outreach, participation, and co-creation are often intended to attract groups to the theatre that are not the 'traditional' theatre audience. Audience reach has been a tricky issue for cultural institutions, including the theatre, for some time. In the Netherlands, only a small percentage of the population regularly visits the professional theatre. This limited reach is not new. Since the rise of television and other forms of popular culture, the reach of the theatre in particular and of the professional arts in general has been a cause of concern for the arts sector and for the government, which, after all, is the main funding body of the arts. This is why the distribution of art and culture has been central to Dutch cultural policy since the 1950s. On the one hand, this involves the so-called geographical or horizontal distribution of art. In the case of the performing arts, this means that there is a finely meshed network of theatres and playhouses in the Netherlands and that the theatre companies in the *'Basisinfrastructuur'* (basic cultural infrastructure – BIS)[6] are spread across the country so that theatre is accessible to everyone in the Netherlands. Accessibility also applies in a social sense, the so-called vertical distribution. This implies that theatre must be accessible, affordable, and available to people from all social strata. The idea of distribution has ensured, for example, that the major companies not only perform in their own city, but that they also 'travel' with most of their shows; and that the prices of theatre tickets are kept relatively low compared to other countries.

Unfortunately, this policy has not led to an even distribution of cultural participation across the population. The average theatregoer is still white and highly educated. Women visit the theatre significantly more often than men. And the theatre's reach among people of another ethnic or cultural background is distinctly low. These are a few important conclusions that can be drawn from research conducted by the Netherlands Sociaal en Cultureel Planbureau (Netherlands Institute for Social Research – SCP), which has been monitoring the cultural behaviour of the Dutch population for decades. Their research shows, among other things, that the average Dutchman is

more interested in popular culture than in canonical art. By canon we mean
a collection of works (literature, plays, paintings, pieces of music, etc.) with
which a community identifies culturally, and which is passed on from one
generation to the next.[7] In theatre, for example, the Greek tragedies, the
works of Shakespeare, but also plays by more modern playwrights such as
Ibsen, Chekhov, Brecht, Beckett, and Albee may be considered part of the
canon. However, the canon is increasingly subject to critique. After all, the
writers mentioned above are all white men and represent the hegemony of
Western culture. In his book *Interculturele intoxicaties. Over kunst, cultuur
en verschil* the Flemish dramaturg Erwin Jans defines the canon as follows:

> The canon is the point where politics, power, education, institutionalisa-
> tion and aesthetic quality intersect. Hence the importance attached to
> it. The canon is usually the guideline for the curriculum in education:
> the canon says no more or no less than which books are important for
> cultural education. The canon largely determines the purchasing policy
> of libraries, museums and publishers. The canon also guides the history
> of literature and art.[8]

The SCP studies partially confirm the analysis of the French art sociologist
Pierre Bourdieu, that social inequalities are not only determined by dif-
ferences in economic capital (property and income), but that it is precisely
the differences in cultural capital and cultural behaviour, in particular
the mastering of the so-called high culture, which contribute to the divi-
sion in our society. According to Bourdieu, this cultural capital and the
corresponding behavioural patterns are mainly determined by family
background and education. Although Bourdieu's analysis focused mainly
on France in the 1960s and 1970s and the distinction between high and low
culture is increasingly blurred in our time, the dichotomy he identified
still applies to some extent. The well-educated arts consumer today is a
cultural omnivore.[9] They move effortlessly between different genres and
between canonical and popular culture, while the uneducated cultural
univore hardly visits art and culture outside the home environment and
limits themself to only a few forms of popular culture at home. These
differences in cultural behaviour are large and it is an important task
for cultural institutions to include as many groups as possible in their
programmes. This requires theatre companies to pursue a policy that does
not focus exclusively on fans of canonical art, but that actually tries to reach
groups for whom these cultural visits are not self-evident. A complicating
factor is that the contrasts observed are not unambiguous. Differences in

educational level seem to be the main determining factor, but differences in place of residence, income, religion, and ethnic origin should also be taken into consideration.

One of the greatest challenges facing the cultural sector is therefore how to reach out to different social groups in society. This aspiration is often summarised as striving for diversity and inclusion. By cultural diversity, we mean the variety of cultures within a city, region, or organisation. In 2011, the Dutch cultural sector established the Cultural Diversity Code, an updated version of which was published in 2019. It distinguishes four pillars of diversity: audience; programme; staff; and partners. Thus, cultural diversity is not only visible in the audience and on stage, it should also be taken into account in the content of performances and in the organisations to collaborate with. For many institutions, it is still a major challenge to take all four pillars into account. After all, the cultural sector is part of a society in which diversity is still far from self-evident. If, for example, the schools mainly deliver white graduates of native origin, it becomes very difficult for an organisation to achieve staff diversity. But theatre schools, in turn, depend on diversity among students entering secondary education and the various talent development programmes. In addition to diversity, there is also an increasing demand for inclusion. Whereas diversity is mainly about proportions, inclusion, on the other hand, is about how you deal with differences, how you take everyone seriously and give them a voice. Here, too, the cultural sector is often expected to be a pioneer.

Dramaturgs may have to deal with issues of diversity and inclusion in various ways. When making a selection for the repertoire, for example, to what extent should they take the dramatical canon as their point of departure? Or should they look for pieces by female authors or authors who do not represent the Western canon? Another possibility is to cast a completely different light on the 'classics' by means of a critical interpretation or radical adaptation of well-known plays. Through such an adaptation, well-known Shakespearean plays such as *Othello* or *The Taming of the Shrew* can highlight themes such as racism and the male-female relationship in a completely different way from that which is obvious upon a first reading. In Dutch youth theatre, too, well-known classics by Euripides or Shakespeare, for example, are often taken as the starting point for an adaptation in which the children or young people who have a secondary role in the original plays suddenly receive full attention. For example, in *Ifigeneia Koningskind* (Iphigenia, King's Child), an adaptation of Euripides' *Iphigenia in Aulis* by Pauline Mol from 1989, which was taken back on the repertoire by NTjong in 2017. Or in *De Storm*, an adaptation of Shakespeare's *The Tempest*, which

was performed by de Toneelmakerij and Firma Rieks Swarte in 2010. Youth theatre will be dealt with later in this chapter.

The funding of the performing arts

In the Netherlands, the equal distribution of art has been part of the government's arts policy for some time. Since the Dutch performing arts are funded primarily by the government, that same government – both central, municipal, and local – can determine what conditions apply in spending that money. Thus, also in a financial sense, theatre (and therefore dramaturgy) is always connected to the wider world. Theatre is a relatively expensive art form. Each performance requires a theatre building with staff and technical facilities, but also professionals who perform the show: actors; dancers; musicians; and technicians. Without government subsidies, theatre could not exist in the quality and variety to which we are accustomed.

Historically, there have been three political convictions in the Netherlands that have largely determined, and continue to determine, government art policy. The first conviction is that art must be able to develop freely. According to this principle, the government should interfere as little as possible with art. This idea goes back to the famous statement in 1862 by the liberal prime minister Rudolph Thorbecke (1798-1872) that art is no business of the government and that the government should not be the judge of arts and sciences. This so-called Thorbecke Adage still plays an important role in the subsidisation of art. The minister of culture, or other responsible member of government, is given advice by an independent council of experts. For the national government this is the Raad voor Cultuur (Council for Culture), which, every four years, advises the minister on long-term subsidies for institutions that are part of the national cultural basic infrastructure (BIS). In most cases, the minister will follow that advice. For smaller subsidy awards, central government has set up various funds that receive a sum of money from government and divide it among all kinds of smaller initiatives.

The downside of the liberal conviction, as outlined above, is that the government may become somewhat indifferent towards the intrinsic value of art and culture because it has little substantive involvement in their development. This makes the cultural sector vulnerable in times of budget cuts and to populist ideas that art is exclusively for the elite or a left-wing hobby, and that it is therefore better not to spend any money on art at all. The second historically grown conviction is that art and heritage are vulnerable and in need of protection by the government. This belief, too, goes back to the second half of the nineteenth century, when the Roman Catholic politician Victor de Stuers (1843-1916) made a case for managing and protecting historical buildings, monuments and

works of art. He had a completely different view than Thorbecke and saw art as a possibility to educate the people. Therefore, De Stuers took a stand against the indifferent attitude of the government and against the neglect of historical buildings and works of art. He was also closely involved in the construction of the Rijksmuseum in Amsterdam, which opened in 1885.

The third conviction is most clearly expressed in Dutch history by Emanuel Boekman (1889-1940). Boekman was a prominent member of the Social Democratic Workers' Party (SDAP). In that capacity, he was a member of the Amsterdam city council and twice a councillor for education and art in the Amsterdam city government in the 1930s. Like De Stuers, Boekman was a great advocate of art and culture and of an active cultural policy. He especially believed that art should be accessible and available to everyone. This idea became leading in the organisation of the Dutch theatre system after the Second World War, which was based on geographical (horizontal) and social (vertical) distribution.

As outlined above, audience reach and distribution of the arts are important components of Dutch cultural policy and this is reflected today in the efforts to bring different social groups into contact with art and culture and to give cultural institutions, including theatre companies and venues, a big task in education and participation. Quality is still the most important criterion for granting subsidies and in this sense, according to Thorbecke's Adage, artistic freedom still comes first. But policy goals in the field of outreach, education, participation, diversity and fair practice now largely determine the conditions under which subsidies are granted to art institutions. This holds true not only for the Netherlands. One could say that in the art policies of most European countries today, an artistic and a social emancipatory perspective are combined. In addition, a third perspective has developed in recent decades: the economic perspective. This perspective does not look so much at artistic and social values, but rather at economic value. Cultural entrepreneurship is an important criterion in this perspective. Theatre companies should be as self-sufficient as possible or at least generate the largest possible amount of their own income. That is why sponsorship and other ways of raising funds such as crowdfunding have become increasingly important in the cultural sector in recent years. The economic perspective also looks at the added value that art and cultural institutions have within the national and metropolitan infrastructure. Art and culture can boost urban economies by attracting tourists and increasing the attractiveness for entrepreneurs and professionals to settle there. The same applies here: around the performance is the theatre, around the theatre is the city, and around the city is the whole world. They are all connected.

Dramaturgs are expected to play an important role in this network as representatives and intermediaries between the company, financiers and political

forces. This may involve contacts with different funding bodies: governments; sponsors; and private benefactors. Dramaturgs, for example, help write applications, subsidy statements, evaluations, annual reports, etc., but they are also closely involved in the recruitment of financiers other than the government. Each subsidy-providing organisation has its own conditions for applying and accounting for subsidies. For example, companies may receive a subsidy from the national government, while another part may be financed by the municipal government, each of which has its own conditions for granting and accounting, that are sometimes even contradictory. The dramaturg helps to put all the pieces of the puzzle together. Excellent communication and drafting skills are therefore important qualities of a good and versatile dramaturg.

4.4 Theatre and politics: The heritage of Brecht and Boal

The theatre is in the city and the city is in the world. In her article on major and minor dramaturgy, Marianne van Kerkhoven wrote that her heart lies with minor dramaturgy, the dramaturgical craftsmanship around a specific performance, but that major dramaturgy should never be forgotten. It seems that contemporary theatre makers are increasingly aware of the importance of major dramaturgy. According to the Brazilian theatre maker and theoretician Augusto Boal, this close connection between theatre and society means that theatre and politics cannot be separated. According to Boal, even a performance that is exclusively aimed at amusement or that makes you empathise with a specific character confirms and legitimises the political power relations of the society in which that performance is produced. Boal directed theatre performances in Brazil in the 1950s and 1960s under a political regime that was becoming increasingly repressive. At the time, he worked as a director and writer for the Arena Theatre, which derived its name from the fact that it produced performances in arena style, with the audience sitting around the performance. Because Arena made performances about and directed to the oppressed population in this way, the military regime tried to make it harder and harder for him to work until he was finally expelled from Brazil in 1971.

During his exile, Boal started making theatre for a literacy campaign in Peru called ALFIN (Operación Alfabetización Integral). ALFIN's methods were strongly influenced by the Brazilian educationalist Paulo Freire. His pedagogy was aimed at awareness and emancipation. Translated into theatre this meant that the participants should not have to watch a theatre performance by professionals, but had to make theatre themselves and learn

the language of theatre by active participation. Instead of theatre aimed at and about the oppressed, it had to become theatre of the oppressed. From this starting point, Boal developed his Theatre of the Oppressed. The book of the same name appeared in Spanish and Portuguese in 1974 and was translated into English in 1979. The book emphasises the repressive nature of theatre throughout the centuries. Boal wanted to transform the theatre from an instrument of social control into a path to liberation. According to Boal, the first person who seriously tried this was Brecht. In Brecht's case, the actions of the characters on stage are to a large extent determined by their socio-economic position and the audience is encouraged to reflect on this critically. But with Brecht, according to Boal, the characters on stage still speak in the name of the audience. The next step should be for the spectators to become active themselves. The spectator had to start thinking and acting for himself. He had to become a 'spectactor': an observer and a participant at the same time.

Boal was, of course, not unique in his exploration of the political roots and revolutionary potential of theatre, but he was the first to put participation at the heart of this process and to propose a practical methodology for achieving participation. He based his methods on the experiences he gained in the ALFIN project. The best-known of these methods is undoubtedly Forum theatre. In this, the company first performs a scene or a play in full. After that, the spectators are given the opportunity to intervene and take over roles in order to change the course of the play, for example from injustice to justice. The so-called Joker plays a facilitating role. He invites the spectators to jump in and guides the transition from spectator to 'spectactor'.

Since Boal developed his Theatre of the Oppressed in exile, he initially had little opportunity to put it into practice. But when he obtained a teaching position at the prestigious Sorbonne University in Paris in 1978, his fame grew. In Europe, more and more people started using his methods. Although these were developed to combat oppression in developing countries, they were mainly being put into practice in Europe at the time. Boal developed a workshop called *Le Flic dans la Tête* (The cop in the head), in which op-pression was not so much caused by a (military) dictatorship but was, as it were, internalised by the people themselves: the cop in the head. This gave his methods a more therapeutic character and they gained in popularity.

Nowadays, Boal's methods remain as popular as ever, but more often in the form of workshops or therapy sessions than in professional theatre itself. Nevertheless, based on the idea that you should not only make theatre aimed at the people but also in cooperation with the people, concepts such as participation and co-creation have gained popularity in recent years, as

observed earlier in this chapter. These are usually participatory projects in which professional theatre makers work with people from a specific community or neighbourhood in the creation of the performance. In the Netherlands, one could name, for example, directors such as Eric de Vroedt (Het Nationale Theater) in The Hague and Adelheid Roosen (Adelheid+Zina) in Amsterdam and other Dutch cities.

4.5 The auditorium and the stage

Previously (in 3.4 and 4.2), we read that theatre innovators such as Artaud and his followers wanted the audience to be part of a ritual theatrical event. And Boal, as described in the above section, wanted the spectators to become actors themselves. If the spectator is to relate differently to the performance, the spatial relationship between the performance and the audience will also have to change, and thus the spectators will have to occupy a different position in the theatrical space. The classic proscenium theatre prescribes a strict, architectural separation between the world of the show and that of the spectators. After all, the stage is raised, and a large part of the stage area is hidden from view by the proscenium arch. Over the course of the twentieth century, many directors, stage designers, and architects tried to change this dominant architecture and the corresponding relationship between audience and performance. Richard Schechner, for example, became famous in the sixties and seventies with the performances of his Performance Group (later renamed the Wooster Group, which is still active). Schechner and his group produced performances in The Performance Garage in New York, in which the spectators were not separated from the actors. Schechner called this environmental theatre. In *Dionysus in 69*, for example, a very free adaptation of Euripides' Bacchae, there were no chairs. The audience and actors sat on the stage floor and on platforms and scaffolding that filled the space of The Performance Garage. Thus, Schechner wanted to break down both the material and mental barriers between actors and audience. In 1967, he elaborated his idea of environmental theatre in six axioms.[10]

Schechner's notion of environmental theatre was later elaborated theoretically by Aronson and by Eversmann. Eversmann used the axioms about theatrical space and the audience's line of sight as the starting point for a new, more formal definition of environmental theatre. According to Eversmann, there is a continuum between frontal theatre, in which the spectator finds themself outside the theatrical world and does not need to turn their head more than 45 degrees in any direction in order to fully

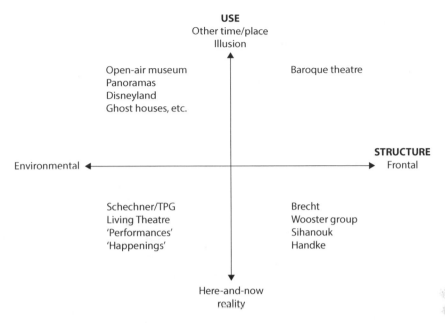

USE
Other time/place
Illusion

Open-air museum
Panoramas
Disneyland
Ghost houses, etc.

Baroque theatre

STRUCTURE
Environmental ← → Frontal

Schechner/TPG
Living Theatre
'Performances'
'Happenings'

Brecht
Wooster group
Sihanouk
Handke

Here-and-now
reality

The structural dimension and the dimension of use combined: a classification model for theatre spaces in accordance with Eversmann (1996).

absorb it, and environmental theatre, in which the spectator is part of the theatrical world, meaning that the play can be performed in front of, behind and sometimes even above or below them.[11] What is interesting about his theory is that he separates the spatial distribution from the experience itself. For example, a frontal performance does not necessarily mean that the spectator is immersed in the virtual world, and an environmental performance can, in some cases, achieve just that. So, there is a distinction between the structural dimension of the spatial relationship (frontal versus environmental) on the one hand, and the usage dimension (illusion versus here-and-now) on the other. He has captured these two dimensions in a system of axes as shown at the top of this page.[12]

The examples that Eversmann includes in the diagram are examples from the sixties, seventies, and eighties. In the upper right quadrant, he places the classic proscenium theatre, where another time and place is suggested in a frontal situation. The top left quadrant contains, for example, open air museums, where the visitor goes back in time, as it were, and becomes part of the illusion. In the lower left quadrant, Eversmann mentions Schechner with his Performance Group and The Living Theatre as examples from the sixties and seventies, but one could also include contemporary site-specific and immersive theatre performances. In the lower right quadrant,

Eversmann positions examples from the seventies and eighties alongside Brecht's performances, but numerous contemporary theatre groups could be added here.

Site-specific and immersive theatre

A special form of theatre in which the spatial relationships are crucial for the spectator's experience, is *site-specific theatre*. This is theatre that takes place in locations that are not originally intended for the stage. In the 1980s and 1990s, the Dutch directors Johan Simons and Paul Koek, together with dramaturg Tom Blokdijk and their company Hollandia, became famous with their site-specific performances in unusual locations: farms; greenhouses; factories; churches; car scrapyards, etc. The sites were not necessarily chosen to represent the action itself, but rather to give a certain atmosphere to the performance. Sometimes, the spectators had to be transported in buses to an otherwise inaccessible place, which had been specially selected and transformed for the performance. Instead of sitting down comfortably in the red plush chairs of a playhouse, the spectators sat on wooden benches or on a gallery made of piled-up car wrecks, wrapped in blankets against the cold. This was the case, for example, in the previously mentioned production of Aeschylus' *Persians* (1994) in a former car breakers yard in Zaandam.[13]

Many other Dutch theatre makers and companies create site-specific performances. These may even take place in public spaces or in open air. The Oerol Festival takes place every year in June on the small island of Terschelling. Many site-specific performances are set here in the dunes or on the beach. Some of the makers who each year put on performances at Oerol can also be counted among another category that has been gaining ground over the past two decades: *immersive theatre*. Immersive theatre is a bit of an unfortunate term, because it rather suggests that immersion is absent in regular theatre. That, of course, is not the case. Although the expression is used frequently, it is not always clear what is meant by this umbrella term 'immersive theatre' in each specific context. But in general, one could say that immersive theatre performances are not set in regular theatres and that the focus is on the individual, intimate, and sensory experience of the spectator in the here and now. Sometimes, this means that the spectator participates in the performance, but it may also be the case that a performance is different for each individual spectator or even that the spectator does not get to see the other spectators. In that case, their experience becomes a purely individual one, that is not shared with others.

In 2007, theatre maker Dries Verhoeven created the experiential theatre installation *U bevindt zich hier* (*You are here*). The space was nothing like a theatre. It consisted of a labyrinth of corridors and numbered rooms. In each small room there was only a bed. The ceiling was a mirror. The spectators were all given a room key and each occupied a room for by themselves, like in a hotel. They could sit or lie on the bed. Thus, in the end, in each room a solitary spectator lay staring at her own reflection and listening to sounds or voices from elsewhere. But at a certain point in the performance, the reflecting ceiling was raised very slowly, almost imperceptibly, and turned out to be one big mirror of 400 square metres. The higher the mirror was raised, the more the spectators were able to see the other rooms and thus the other spectators. It was like a camera that slowly zooms out from a close-up to a wide angle. The individual, unshared, almost anonymous experience changed into a game of watching and being watched. This performance set the individual experience against the collective one and thematised this opposition. That is why it is still an important performance in the development of immersive theatre, not only in the Netherlands but also worldwide, and it was performed on several international festivals.[14]

4.6 Youth in/and theatre

Earlier in this chapter (4.3), a connection between canon, education and existing power structures was mentioned. In a way, this connection confirms the popular saying that the future belongs to the young. Cultural education largely determines the art forms with which children come into contact, but also how they will relate to art, canonical or not, in later life. Together with literature, theatre is one of the few art forms that may be specifically aimed at children and young people, called youth theatre or Theatre for Young Audiences (TYA). Dutch and Flemish TYA has set an international example in the past twenty-five years. There are now nine youth theatre companies in the Dutch basic cultural infrastructure, which are each time subsidised by the central government for a period of four years. But this has not always been the case. Up until the 1990s, there was relatively little interest in TYA in the Netherlands, and it was hardly seen as a full-grown artistic discipline. For many directors and actors, theatre for children was mainly a stepping stone to more serious work, theatre for adults. Nevertheless, Dutch TYA went through a major development in the 1970s and 1980s. A generation of makers and writers stood up to make their mark on the development of youth theatre and initiate its current flowering. Because TYA was not yet

taken very seriously as an artistic genre, this generation was able to develop in relative seclusion. They could experiment a lot without constantly having to be accountable to subsidisers and critics. The educational theatre of the 1970s, which primarily had a social and political content and was often aimed at schoolchildren, made way for theatre that focused not on the political message, but on the experiences of the children themselves.

Nowadays, youth theatre makers often disagree with parents and teachers about what children of a certain age can handle. This is partly due to the dominant concept of childhood in our society. According to this concept, children are regarded as vulnerable creatures who need to be protected from harmful external influences. In parenting and education, there is an increasing tendency to exclude risks as much as possible. We prefer not to let children play outside alone, climb trees, cycle to school or sit alone at the computer. And we want to be able to reach our children via mobile phone at all times and in all circumstances. Whether we are really doing these children a favour is, of course, questionable. Children develop and learn by falling, by making mistakes, but also by coming into contact with things that some parents or teachers would rather they did not see or hear, such as violence, trauma, foul language, or sex.

It is important to recognise that our view of children as vulnerable beings who need to be protected is to a large extent historically and culturally determined. If we go back in time a few centuries, we see that as soon as children could move around on their own and no longer needed to be nurtured, they had to help out around the house or be put to work. They were used to deal with family members and people close to them falling ill and dying. War and other forms of violence were never far away. Corporal punishment was common. Children also received limited or no education. In short, there was little difference between the world of adults and that of children.

The image of children as we know it today dates back to the Enlightenment and is therefore no more than two centuries old. Since then, children have been seen as pure and unspoilt, on the one hand, and as beings who still need to develop and receive education in order to eventually go through life as independent adults, on the other. Influenced by these ideas, more and more children went to school in the nineteenth century, but it was only in 1900 that through legislation compulsory education became general practice in the Netherlands. Whether we consider children to be pure or imperfect beings, in both cases it is necessary that they are protected against all kinds of undesirable external influences. Because of these dominant concepts of childhood, we have come to regard certain subjects as unsuitable for

children. Books, films, but also theatre performances about 'nasty' things such as war, drugs, violence, and death, but also sex, sexuality, and coarse language are generally considered unsuitable for young children. Many people also feel that things that they think children might not understand are best avoided.

The minimum age level from which children can 'handle' a performance is sometimes difficult to determine. Nevertheless, that choice often has to be made long beforehand. Frequently, there appears to be a discrepancy between what theatre-makers produce or want to produce for a particular age group and what some parents and especially teachers think is suitable. It is remarkable how theatre makers in general want to challenge and confront children, while teachers and parents think that children are not yet ready for that confrontation. However, it is important to realise that parents and teachers almost always act as gatekeepers. After all, children seldom choose for themselves which theatre performances to visit. Theatre makers therefore not only have to deal with their young audiences, but also with the adults who decide what the children may or may not see. Since schools are important customers, youth theatre makers usually cannot afford to ignore the protective attitude of teachers and parents. The dramaturgy of youth theatre performances has to take this into account and can therefore be quite complex.

Dutch Theatre for Young Audiences

In 1989, the play *Ifigeneia Koningskind* (Iphigenia King's Child) by Pauline Mol premiered in Nijmegen by Tejater Teneeter, directed by Liesbeth Coltof. The performance is generally considered to mark the coming of age of Dutch youth theatre. *Ifigeneia Koningskind* was an adaptation of Euripides' classic play *Iphigenia in Aulis* from the fifth century BC. The original tragedy revolves around the Greek king and army commander Agamemnon. Agamemnon wants to sail from Aulis with the Greek fleet to Troy to avenge the abduction of Helena, the wife of his brother Menelaus. However, a lack of wind prevents the fleet from sailing. After consulting a seer, it appears that the goddess Artemis is responsible, because Agamemnon has offended her. Agamemnon must appease her by sacrificing his own daughter Iphigenia, so that the wind will start to blow again and the fleet can set sail for Troy. Despite considerable hesitations, Agamemnon, under pressure from his brother Menelaus, decides to allow Iphigenia to come to Aulis on the false pretext that she will marry Achilles. However, eventually the true reason comes to light, and Agamemnon finds himself at odds not

only with Achilles, but also with his wife Clytamnestra. Achilles wants to protect Iphigenia, but the girl ultimately decides to follow her father's will. At the end of the tragedy, a messenger reports that Iphigenia is saved by Artemis at the ultimate moment of sacrifice. A doe has taken the place of Iphigenia.

In Pauline Mol's adaptation, it is not Agamemnon but his daughter Iphigenia who plays the main role. In the original play, Iphigenia's decision to sacrifice herself is rather unexpected, but in this adaptation her coming of age is the focal point and is revealed in successive scenes. To this end, Pauline Mol introduced a second character, Child, who hangs out with Iphigenia for much of the play. At the beginning, Iphigenia and Child are united and inseparable, but this changes when it becomes clear that Iphigenia's sacrifice can help the Greek army to gain a favourable wind. Slowly but surely, Iphigenia is drawn into the world of the adults, until she finally decides not to resist her fate any longer but to voluntarily sacrifice herself. Child, however, does not want Iphigenia to be sacrificed at all and denounces her decision as a false act of heroism and patriotism. In her eyes, death is never heroic. Child thus symbolises both the youth that Iphigenia wants to say goodbye to and the youth that is the victim of the violence adults are guilty of, but at the same time want to keep hidden from their children.

Violence is one of the delicate subjects that youth theatre makers do not shy away from, but which parents and teachers often find unsuitable for young audiences. In *Ifigeneia Koningskind*, violence is often mentioned, but it is not so much the subject of the play. A few years later, playwright and director Ad de Bont tackled a similar theme in *Mirad, een jongen uit Bosnië* (Mirad, a boy from Bosnia, 1993). Instead of a classical tragedy, De Bont uses the then current violence in former Yugoslavia as a source of inspiration. It is remarkable that the main character Mirad is physically absent from the play. Mirad's story is told by Djuka and Fazila, his uncle and aunt, who came to the Netherlands as refugees. They tell the story using Mirad's letters and their own memories. At the time, writer and director De Bont was artistic leader of theatre group Wederzijds, one of the few companies that exclusively performed school plays. The two actors performed the play in the classroom, standing behind a reading desk. So, the setting was very simple, but the impact of the play was huge. It has been translated into at least fourteen languages and performed all over the world. In a poll of readers of the Dutch theatre magazine *TM* in 2009, the play was named the fourth best play of all time. It has therefore become part of the canon, the collection of plays from the past that connoisseurs consider to be of special value and which, for that reason, are usually performed with some regularity.

In both *Ifigeneia Koningskind* and in *Mirad, een jongen uit Bosnië*, children or youngsters collide with the violent world of adults. The plays show that we may want to protect children from the evil in the outside world where adults are in charge, but that this is ultimately an impossible mission; if only because those children will eventually become adults themselves, and because of all kinds of influences over which we have little or no control, this may happen faster than we would like. That is why the two examples cited are not only drama texts and performances about (war) violence that children encounter, but in a certain sense they are also coming-of-age dramas. Both Iphigenia and Mirad are catapulted into the world of adults.

With Mol's adaptations of classical tragedies and De Bont's account of the civil war in Bosnia, the fame of Dutch youth theatre was established, also internationally. The confrontation of children with, and their inauguration into, the adult world is a subject that is still central to many TYA performances today, but it is no longer necessarily expressed through a pre-written stage text. Just as in postdramatic theatre for adults, in TYA today the drama text has lost its importance as an element that gives meaning and structure to the performance at all levels. Many current productions no longer have a text as their starting point, but rather a central idea, an image, or even a piece of music. These performances are characterised by a physical way of acting, and this ultimately extends to the ideas a number of contemporary youth theatre practitioners have developed about education. They believe that learning is a physical process and that theatre and dance can therefore make an important contribution to education. In doing so, they are in fact formulating their own view on education and sometimes come into conflict with representatives of the majority of schools and other educational institutions, in which learning by head is still dominant and educational success is measured against international rankings of national levels of mathematics and language skills.

The Story of the Story (Het Verhaal van het verhaal) – Theater Artemis & Het Zuidelijk Toneel (2018)
Jetse Batelaan is the artistic director of Theater Artemis in Den Bosch, one of the nine youth theatre companies in the Dutch cultural Basic Infrastructure (BIS). The company is known for its anarchistic performances, in which hardly any through lines can be discerned and which disregard all the rules that usually guide the audience in the theatre. The website of Artemis states:

Theater Artemis like to seek out and experiment with new forms of theatre. They create work that offers children and young people challenging experiences that teach them

Het Verhaal van het verhaal (*The Story of the Story*), directed by Jetse Batelaan / Theater Artemis
& Het Zuidelijk Toneel (2018). Photo: Kurt Van der Elst.

> to have confidence in the unknown, and in themselves. Their work is brave, anarchic,
> interactive and often hilarious. The company also creates innovative, independent art
> projects in which artists and young people collaborate.[15]

You would probably expect this kind of theatre in a small venue, but Batelaan
chooses to stage some of his performances in the larger playhouses in co-
operation with the company Het Zuidelijk Toneel. This has also brought him
considerable international success. He was the first Dutch theatre maker ever to
receive the Silver Lion for theatre at the Venice Biennale in 2019. *The Story of the
Story* was also the opening performance of the Biennale in that year, a show for
children aged eight and up and adults. In the performance, Batelaan creates a
universe of his own, in which partly the same rules apply as in 'ordinary' theatre,
but in which some of those rules are also deliberately disobeyed. One could also
call his work metatheatrical, because he not only disregards some of the rules
that normally apply in theatre, but also makes their violation one of the themes
of his performances. The units of time, place, and action are absent, as are fully
developed characters. Whereas in youth theatre there is the general belief that
the first thing you have to do is make children familiar with the specific conven-
tions that apply, Batelaan emphatically and somewhat provocatively sets them
aside.

In *The Story of the Story*, at least four layers or 'story' lines intertwine, none of
which, however, establish a story with a clear beginning, middle and end. Firstly,
the almost empty stage is populated by a group of silent creatures, halfway be-

tween prehistoric people and plastic-clad post-apocalyptic tramps. They experiment with all kinds of materials that they collect on or behind the stage or take from the audience. The creatures hardly react to each other, nor to the spectators in the auditorium or the other events on the stage. The second layer is made up of abstract, coloured, and sometimes luminous objects, which occasionally move slowly from one side of the stage to the other to the sound of an equally abstract audio landscape. The third layer is a simple dialogue between the members of a young family: father; mother; and son. This dialogue is depicted as one between three enormous cardboard puppets, which are as high as the proscenium arch and in which we immediately recognise the footballer Ronaldo (son Sander), Beyoncé (mother Ria), and Donald Trump (father Hans). This is perhaps the most blatant and provocative violation of theatre conventions. After all, there is no way we can connect the dialogue, a kind of child's play, with the world-famous cardboard figures that are so emphatically present on stage and are reminiscent of the giant puppets in religious processions. The three layers seem to exist more or less independently of each other. Only the boy (Sander/Ronaldo) speaks to the other figures on the stage, but they do not respond to his questions in any way. Sander also breaks through the fourth wall by looking over the 'edge' and addressing the spectators in the auditorium. Finally, the fourth layer consists of a voice-over that tells the actual 'story of the story', a story that takes a long time to get going and has an unclear ending. This voice-over could have brought the other layers together. There seem to be even some signs of that, but in the end it does not happen. The performance ends as confusingly as it started. The dialogue between the enormous billboard figures degenerates into a slow but well-timed slapstick, in which a fourth billboard figure appears on stage as Ria's lover, in whom we recognise the North Korean dictator, Kim Jong-un. Precisely at that moment, however, the dialogue suddenly breaks off again. The actors who operate the puppets and speak the texts appear. 'I don't have a script anymore,' one says to the other. This breaks down the last bit of tension built up. The technicians finally push all the puppets off the stage. Only the group of tramps remains.

The performance can be considered a musical composition rather than one determined by classical dramaturgical conventions, to which the development of storylines and characters is central. The different layers alternate, but are sometimes also present at the same time, influencing each other's course and together adding rhythm and movement to the performance. Such a description might give the impression that this performance remains completely abstract and incomprehensible for both children and adults. But that is not the case. The audience quickly accepts the incongruities between text and image that occur when the giant cardboard puppets appear on stage: Beyoncé is the mother; Trump is the father; and Ronaldo is their son. The performance was not only

well-received by the audience, the critics were also full of praise. Anita Twaalf-
hoven wrote in the Dutch newspaper *Trouw*:' "The Story of the Story" is full of
clever jokes, asides, double meanings, well-known media images and bizarre
events. In a theatrical language that one has never seen before, but which nev-
ertheless seems familiar.'[16]

Theatre education for children and youngsters

Earlier in this chapter we have briefly discussed art education in the context
of participation, co-creation, and outreach. Educational activities of cultural
institutions can, of course, target many other groups than youth. But in this
section we will limit ourselves to schoolchildren, which is also the group
most often targeted by youth theatre companies. The common belief is that
it is good for children to come into contact with art – and therefore also
with theatre – at a young age, to become acquainted with it, and to learn the
language and conventions of the different art forms. Various studies have
also shown that active arts practice and regular visits to cultural events
during childhood are important predictors of cultural participation during
adulthood. But coming into contact with art is not natural to everyone.
The parents and the environment in which the child grows up play an
important role in this. Thus, the level of cultural participation in childhood
may confirm or even reinforce existing differences in our society – those
between the low-educated and the highly educated and those between
people of different cultural and ethnic backgrounds. Schools are therefore
an important and perhaps the only place to introduce art to all children,
regardless of the environment in which they grow up. After all, each child
attends school, and by performing in schools theatre companies can reach
a large proportion of those children. Dutch youth theatre companies put on
most of their performances for and at schools, and therefore reach a much
more diverse audience than most 'regular' companies.

Within art education, a distinction is often made between active, receptive
and reflective education. Active or productive art education involves making
art yourself, receptive art education involves looking at and listening to art
made by others, and reflective art education involves reflecting on the other
two forms. It is generally accepted that all three forms must be present and
of high quality for art education to be most effective. For theatre, this means
that children must learn to play and dance themselves, but also watch
(professional) performances and reflect on their own play and dance, that
of their peers, and on the professional performances they have visited in
the theatre or at school. Besides the intrinsic value that theatre education

has, it can also be used as a pedagogical or didactic tool. Particularly in primary education, children can improve their language skills, social skills, and spatial skills through active theatre education (drama and dance). In the meta-analysis *Art for Art's Sake. The Impact of Arts Education* from the OECD (2013), the effects of active arts education on cognitive, creative, and social skills were investigated, i.e. skills that are partly external to the arts themselves. Although there has been performed less research into the effects of theatre education compared to the visual arts and music, there is relatively strong evidence of the effects of drama lessons on verbal skills and social skills such as empathy, perspective taking, and emotion regulation. By putting themselves in another person's shoes, children learn to play with the possibilities of language, but also to imagine what other people think and feel. Practising these skills and training physical and verbal expression may also be useful in everyday life. Theatre education therefore lends itself perfectly to the development of the so-called twenty-first-century skills, which in addition to digital literacy and media literacy, also include communication, cooperation and other social and cultural skills

In most education systems worldwide there are four art subjects: art; music; drama; and dance. Although two of these four subjects (drama and dance) can be classified under theatre, visual art education, and music education are offered far more often than drama and dance. This is a worldwide phenomenon. Just as the art subjects are at the bottom of the educational hierarchy, since language, mathematics, and other traditional subjects are considered more important, so visual arts and music are dominant over drama and dance. In the Netherlands, drama and dance were integrated in the standard curriculum of secondary schools in the 1990s. Although this has made it possible to choose drama and dance as electives and examination subjects in the second part of secondary schools, only a small minority of schools in the Netherlands actually offer this possibility. Furthermore, in research programmes more attention is also paid to (the effects of) visual arts education and music education than to theatre education.

In the Netherlands, Cultural and Artistic Education (CKV)[17] was introduced as a subject in 1999. CKV is an interdisciplinary art subject in the senior years of secondary education, which is obligatory for all students. Internationally, CKV is unique because of the emphasis on receptive rather than active education and the introduction to different kinds of professional art, which often takes place outside the school environment. Theatre performances in particular have proven to be popular within CKV and students therefore regularly visit performances by professional theatre companies. Performance visits of this kind also take place in primary education, either

at school or in the theatre. It is, of course, extremely important that these performance visits do not take place in a void, but are embedded in an educational context and part of an educational trajectory. Education officers and dramaturgs of the companies must ensure this in consultation with the schools. Unfortunately, in some schools, a visit to the theatre is considered a fun excursion or a means to address a particular social or societal problem rather than as a serious introduction to the art form. Expertise in drama and dance is not readily available at all schools. In secondary education, drama and dance teachers are scarce. Teachers in primary education are trained broadly, also to teach art subjects, but their knowledge and experience usually stay inadequate. Within theatre companies there is more extensive expertise which may be used to support the schools in this. That is why intensive cooperation between schools and companies is so important. Both youth theatre companies and regular companies, are expected by their funding institutions to play an active role in this. Every company now has an educational department or staff member to organise educational programmes connected to the performances, but also to work with schools in their region.

Since the introduction of CKV, youth theatre companies and regular companies in the Netherlands have grown somewhat closer together in terms of the age groups they want to reach. In the past, youth theatre companies mainly focused on children of primary school age, while regular companies produced theatre for adults. Initially, the regular companies tried to serve CKV students by developing educational programmes aimed at narrowing the gap between the students' limited theatre experience and the performances of the company. They did this, for instance, by developing workshops in which the students were actively introduced to the play text. Such a workshop not only taught them what the play was about, but also how difficult it is for an actor to memorise the text and present it convincingly. These workshops ensured that the students would recognise the texts during the performance itself and show respect for the actors' skills. However, for many adolescents, the performances remained a long sit and an intellectual challenge, to say the least. Because it proved to be not so easy to bridge the afore mentioned gap in a short time, both regular companies and youth theatre companies started to develop a range of performances that suited the perception of teenagers and young adults. Nowadays, youth theatre companies are increasingly producing performances for 12+, while regular companies are also developing performances for this age group. Toneelgroep Oostpool from Arnhem, for example, collaborates with youth theatre company Sonnevanck from the same region, in producing so-called trailer

performances. These are plays written especially for young people, which are performed in the schoolyard in a truck trailer that has been converted into a theatre. The pupils sit right on top of the performance and experience the actors from close by. Classroom performances, in which the actors perform in the classroom itself, are also becoming part of the repertoire of regular theatre companies. In this manner, these companies contribute to a receptive curriculum in which pupils more easily get acquainted with all the characteristics of theatre, so that they may ultimately end up at a performance from the canon, such as a classical tragedy or a Shakespeare play.

The last spectator

Especially in these youth theatre performances and their education programmes, it becomes clear how important dramaturgy is in the translation of a substantive topic and an artistic signature to a specific audience, but also to an educational context in which theatre has an increasingly important role to play. The dramaturgical tasks do not stop at the end of a production process either. Theatre and dramaturgy follow not only a linear, but also a circular movement: each performance and each educational process produces new material for the next. The dramaturg has an important role to play in this process. How is the performance described, documented and archived and how does it remain retrievable and usable for education, for future scholars and dramaturgs? The dramaturg is thus not only the first, but in a certain sense also the last spectator and is responsible for the 'afterlife' of a performance, for what remains of a performance that can again serve as material for research and for new artistic expressions.

Epilogue

Where we came to a stop, the dramaturgical process does not end. Theatre is not simply a linear process, aiming at the performance as an end result and at an intended audience. Both process and performance re-occur as material and thus feed the ongoing development of theatre makers and theatre as an art form. Consequently, we, too, are looking for a follow-up. There is an interesting parallel to be drawn between the writing of this book and dramaturgical practice. Every creative process is different and therefore requires substantial discussions in order to clarify what we are actually talking about. This applies both to a dramaturgical creative process and to writing this book. It is not so much a question of coming to a common understanding, but rather of developing a common language and a common vocabulary in which we can exchange ideas. For us, that is the basis of dramaturgy, whether that process takes place with or without the presence of a dramaturg.

In the course of our discussions, we not only sought a common language, but also found a common objective in mapping out the dramaturgical process. The fact that every process is different does not mean that processes are non-committal and that dramaturgy is just about talking and communicating. Dramaturgic preliminary work, in which the dramaturg or others involved do extensive research before the actual creative process begins, is an essential starting point. This applies as much to the staging of a classic theatre text as to a performance that is based on a subject matter or an idea rather than a theatre text. We believe that research and analysis, as well as openness and curiosity, are the basis of dramaturgical thinking and communication. And that was our basis for this book as well.

The first meeting in which we discussed the plan for an introduction to dramaturgy took place in the spring of 2015. In an optimistic email, the target date for publication was planned for 1 September 2016. That turned out to be too ambitious. Due to the growing workload, time for research and writing is limited in today's academic world. And there are always urgent matters that need attention, not least because we always put our teaching responsibilities first. Here, too, a parallel can be discerned to dramaturgical practice. The work pressure in the arts, just like in the academic world, has increased. Dramaturgs in the field seldom have a permanent position, but usually work as freelancers. As a result, dramaturgy is also organised more often in terms of projects, which in turn impedes the circular effect of dramaturgy. Our impression is that a large part of the theatre field tends

to work more under production and performance pressure than before and is more concerned with marketing and financial accountability. The slowness of practice with attention to artistic development and sustainable cooperation is in jeopardy. There is little time to stand still, literally and figuratively. This applies equally to science and academic education. In that sense too, we depict a common field.

In 2017, the project gained momentum. We started looking more explicitly at the 'market': at what theatre students and lecturers at universities and theatre schools would expect from a book like the one we were planning and how we could meet that expectation. With this in mind, Joy Jeunink interviewed dramaturgy lecturers in higher education about their working methods, the sources they use and their requests for a Dutch-language introductory book on dramaturgy that would be suitable for their courses. In June 2017, we also organised a workshop with dramaturgy lecturers, students, and practising dramaturgs in which we made an inventory of subject matters that could or even should be dealt with in the various chapters. We asked the participants to categorise what they considered to be the most important topics into different chapters. In this way, we were able to clarify the concepts in more detail. Based on the input of the workshop participants we further developed our book proposal and attuned the synopsis of chapters. In early 2018, we contacted the Amsterdam University Press and then the writing process really took off.

There were therefore almost five years between the first ideas and their actual realisation. However, we regard taking time as a necessary feature of dramaturgical and academic practice. None of us considered ourselves capable of writing such an introductory book on her or his own. Many books on dramaturgy are structured into individual chapters, with one author responsible for his or her own contribution. We felt that this was not a particularly satisfactory starting point for a book that was to be used primarily in the field of education. A variety of perspectives would illuminate different aspects of and views on dramaturgy, with the result that students might quickly lose sight of the whole picture. That is why we wanted to write a book with a coherent structure as the result of a joint effort. This also involved us taking joint responsibility for the book's overall content.

This publication hardly would have been realised without dramaturgy being an important part of our teaching practice. The professional Master's programme in dramaturgy at the University of Amsterdam now exists for a decade and a half. In that time, dramaturgical practice has changed. Both the theatre field and the educational system had to respond to the global developments in recent years. Consequently, our Master's curriculum has

also shifted in that direction. The teaching language is now partly in English and the programme no longer trains dramaturgs only for the Dutch-speaking field, but also for a broader international context. To this end, the Master's programme cooperates with a group of partner universities, both within and outside Europe. When for the first group of Master's students internships had to be found in the Dutch and Flemish theatre world, there was still much hesitation in the field. Although the university had been training theatre scholars for decades and the study programme had always tried to connect theory and practice, a good deal of scepticism prevailed about what dramaturgy students and graduates had to offer the field. Over the years, however, the contribution they can actually provide has become increasingly clear. For us, it has become much easier to organise internships, and for graduates to find their way in the theatre practice. Both the Master's programme in dramaturgy and the Bachelor's programme in Theatre Studies are now closely linked to the Dutch-language theatre field, and meanwhile also to the international field.

Theatre practice changes and education changes accordingly. By working with students, we are constantly concerned with the future. In a sense, we are already part of that future, even though none of us knows what it will be like yet. At the same time, education – and academic education is certainly no exception – tends to historicise and perhaps even to preserve. We cannot illustrate where theatre practices will take us, but we can explain where they have come from. What we have outlined in this book can be seen as the basis for understanding where developments in theatre practices come from and their current state. However, this does not mean that they are or will be universally applicable.

After writing the book, though, we have to ask ourselves which things are missing. Our choice has been to describe the process from material to performance primarily in the light of the research into text material. For this reason, there is probably less focus on, for example, issues of interculturality, or on musicals, dance, opera, and installation art. According to Marianne van Kerkhoven, however, there is no essential difference between text dramaturgy and dance dramaturgy, as already indicated in Chapter 1. In both instances, it is a matter of how to relate to material, process, audience, politics, and society; in other words, it is a matter of dramaturgical thinking. In the present book, we have set out what this dramaturgical thinking is about and how it manifests itself in theatre practice, but also how dramaturgy and dramaturgical thinking relate to the academic field. We hope that this book will provide points of access, that it will help lecturers and that it will provide guidance for students. We, too, are heading for a

follow-up. Dramaturgy and theatre are circular movements. This book is again an input for a follow-up. The world is never done. Theatre is never done. This book is never done.

Glossary

absolute drama – The term absolute drama was introduced by Peter Szondi in 1956 and refers to the dominant form of theatre from the Renaissance onwards. Absolute drama takes place in a fictional and closed world, in which there are no references to the world of the reader or the spectator. We only get to know this world through the dialogue of the characters. The underlying conflict between characters determines the action of the play. According to Szondi, drama entered a crisis at the end of the nineteenth century when playwrights such as Chekhov, Ibsen, and Maeterlinck broke through this absolute universe by, for example, focusing not on the present but on the past, not on a dialogue between people but on inner dialogue, not on a development but on a situation. See Chapter 2.

action – Action or course of action refers to changes in the situation of the play, usually brought about by the characters. These actions by the characters are concrete, but in theatre, action as a dramaturgical term is more of an overarching, abstract concept. In Aristotle's *Poetics*, action or plot (muthos) is the most important element of tragedy. The emphasis is on unity of action, which means that there must be a clear beginning, middle and end, and that events must follow each other according to the rules of necessity and probability. No unnecessary side plots should be part of the play. See Chapter 2.

adaptation – When a play text or other source is adjusted to a specific performance, we call this an adaptation. Adapting and editing are important aspects of the dramaturgical process. Because a play text often contains directions for the future performance, either explicitly in the stage directions or implicitly in the primary text, dramaturgical choices have to be made as to whether and how those directions are to be followed. When performing a play from another language, the translation itself is also part of this process. How the text is translated has consequences for the interpretation of the text and for the final performance. Adaptation takes this one step further, in the sense of actually changing the text. For example, classical plays are often shortened by omitting characters or parts of the text. There are all kinds of practical reasons for this, for example because the performance would otherwise be too long for the taste of today's audiences or because there are not enough actors available to play all the roles. But it is also possible that one wants to convey a certain interpretation and vision of the

play through the adaptation. An adaptation may also be based on a source other than a play text. Nowadays, many novels are adapted into a drama text. Film scenarios, newspaper reports, or interviews can also be used as sources. See Chapter 3.

aesthetics – Aesthetics is the part of philosophy that deals with the beauty of art, and in particular how we as readers, spectators, or listeners perceive that beauty. When we use the word aesthetic, we often mean that we find something beautiful, harmonious, or in balance. But the question is of course *why* we find something beautiful. Is it inherent in the object or is it determined by our perception and therefore also by the social conventions of the world we live in? In other words, is there a standard for beauty? When we talk about the aesthetics of a performance, we actually mean how that performance appeals to our perception and how that relates to the implicit or explicit standards that exist about art and beauty. See Chapters 2 and 3.

alienation effect – see *epic theatre*

antagonist – In classical plays, there is almost always a central conflict between a protagonist and an antagonist. The protagonist is usually the hero, the good guy, the one the reader or spectator identifies with. The antagonist is their opponent, the enemy, the villain, the bad guy. Typically the protagonist wants something or strives for something, which we as reader or spectator have sympathy for. The antagonist tries their best to prevent the protagonist from succeeding in their mission. In Shakespeare's work, there are famous protagonist-antagonist pairs, such as Othello and Iago. Many Hollywood films are based on this kind of opposition, for example, the relationship between Luke Skywalker and Darth Vader in *Star Wars*. See Chapter 2.

aside – In an aside, a character addresses the audience, on the understanding that the other characters cannot hear them. This creates a form of dramatic irony, i.e. the audience knows more than certain characters on the stage. In an aside, the fourth wall is broken through, but without violating the conventions of absolute drama. See also *absolute drama*, *dramatic irony* and *fourth wall*.

audience participation – Audience participation occurs when the audience is an active part of the performance, for example when a spectator is invited on stage or when the separation between the audience area and the

performance area is completely eliminated and the audience is integrated into the performance itself. Participation also refers to the aspiration for art and culture to be inclusive by reaching out and allowing as many groups and individuals as possible to participate.

audience research – Audience research analyses the origin and behaviour of audiences. This type of research yields statistical data on audience reach for different types of performances as well as on the question of who goes to the theatre and why. It is information that is not only of interest to scholars, but also to policymakers and the marketing departments of companies and venues. See Chapter 4. See also *reception research*.

black box – Black box theatre stands for a neutral (usually painted black) and flexible theatre space that can be set up as desired. In many cases, even the positioning of the audience is flexible. Thus, there is no architectural separation between the audience space and the performance space. Spectators and actors share the same space. Black box theatres are usually smaller theatres with a capacity of up to 400 spectators and are the counterpart to the classical playhouse with its raised proscenium stage, which can usually accommodate many more spectators. The emergence of the black box theatre in the second half of the twentieth century has ensured that, in addition to the larger proscenium theatres, a second circuit of smaller flexible theatres has emerged in the Netherlands and Flanders. See Chapter 4. See also *proscenium theatre*.

canon – The canon is the collection of works (literature, plays, paintings, music, etc.) and (historical) events with which members of a community identify and which is passed on from generation to generation. In the theatre, for example, the Greek tragedies and the works of Shakespeare are part of the canon, but plays by more modern playwrights such as Ibsen, Chekhov, Brecht, Beckett, and Albee can also be considered part of the canon. The canon steers the curriculum on all educational levels. It is static and conservative and changes very slowly. Because of its static character, the canon is also increasingly criticised. After all, the authors mentioned are all white, well-educated men, and represent the domination of Western culture in society. See Chapter 4. See also *repertoire*.

catharsis – Catharsis means purification. According to Aristotle, tragedy evokes fear and pity, and causes a catharsis of such emotions. Because Aristotle does not explain what he means by catharsis, the question of

how exactly this should be interpreted has been debated for centuries. Is it about controlling or balancing one's own emotions? Or does it have a more therapeutic effect: by sympathising with the tragic hero, the spectators are freed from their own negative emotions? See Chapter 2.

character – Characters are the fictional figures who appear in a play. The actors portray these fictional persons, i.e. they play a role. In twentieth-century theatre, the boundaries between actor and character started to shift. Stanislavski argued that an actor had to empathise as much as possible with their role so that the audience would experience the character as real. Brecht wanted to break through such an illusion. He therefore made his actors step out of their roles. Nowadays, we distinguish between *representation* and *presentation*, between playing a role and the physical presence of the actor who 'shows' the audience something. In this process, actor and character can seamlessly merge and comment on each other. See Chapters 1 and 2.

choreographer – see *choreography*

choreography – Choreography generally means the design and structuring of a performance by means of moving bodies, as in dance. This is usually done on the basis of existing or newly composed music. It concerns the structuring of (the succession of) movements into a whole, for example in terms of form, direction, space, and rhythm. The final structure itself is also called a choreography. Most often, choreography refers to dance and ballet, in which various dance notation systems may be used. But the word can also refer to, for example, gymnastics, figure skating, and fashion shows. The person who designs a choreography is called the choreographer.

climax –In a well-made play, the climax is the moment when the tension is at its highest point and the central conflict is resolved. This moment is usually close to the end of the play. The climax is followed by a quick resolution. See Chapter 2.

co-creation – The term co-creation can be used in many different ways and refers to processes in which the consumer (in this case the spectator) becomes a co-creator. Theatre makers create all kinds of performances in cooperation with artistic partners, but also with people from the neighbour-hood, with businesspeople, with scientists, and with representatives of social or political institutions. Co-creation usually takes place with the intention of allowing specific target groups to participate by involving them

in the creative process and thus suggests a high level of equality between the participants, but it is important to keep in mind that it is usually the theatre makers themselves who decide in advance which rules or conditions apply. See Chapter 4.

comedy – A comedy is a play that aims to entertain spectators and make them laugh. Comedies often deal with human shortcomings, misunderstandings, cheating, and adultery. The characters in a comedy are usually stock characters, i.e. one character trait prevails. Whereas in tragedy, the *climax* foreshadows the downfall of the tragic hero, in a comedy, the climax leads to a solution. Unlike in *tragedy*, a comedy always ends well. Aristotle already made a clear distinction between tragedy and comedy in his *Poetics*, but his definition of comedy has been lost. In the course of the nineteenth and twentieth centuries, the boundaries between tragedy and comedy became blurred. See Chapter 2.

configuration of characters – Configuration of characters is the combination of the characters present on stage at the same time. The configuration changes with every entrance and exit. By studying the configuration of characters you can find out which characters are often on stage together and which characters avoid each other. See Chapter 2. See also *dramatic irony*.

conflict – In traditional dramatic theatre, conflict is a confrontation between two forces that must inevitably lead to a climax. Often, the conflict is between a character and another character (protagonist and antagonist), but it can also be an inner conflict or a conflict between the main character and the forces of nature. The conflict is the driving force of the drama and creates increasing tension in the play. In modern and postdramatic theatre, contrasts and conflicts still play an important role, but they no longer determine the structure of the entire play. See Chapter 2.

cultural capital – Cultural capital is a term used in (cultural) sociology to refer to the knowledge and skills people acquire during processes of primary socialisation (upbringing) and secondary socialisation (education). They are partly formalised in the form of titles and diplomas. The term was used by cultural sociologist Pierre Bourdieu, among others, to indicate that inequality in society is not only caused by differences in economic capital (money and possessions), but also by differences in cultural and social capital. For example, a certain amount of cultural capital is necessary to be able to understand and appreciate art. Someone who has never been taken to the

theatre by their parents and has not been introduced to it through school, will have difficulty understanding and appreciating a theatre performance. See Chapter 4.

cultural omnivore – A cultural omnivore is someone who breaks with traditional cultural behaviour, that includes either consumption of popular cultural forms of expression or high cultural forms of expression (including most forms of theatre). The cultural omnivore does not limit themself to high or popular culture, but combines, for example, visits to pop concerts with visits to opera; visits to the theatre with watching a blockbuster film or musical. See Chapter 4.

curator – In the museum world, especially that of contemporary art, a curator is someone who is responsible for the organisation of a specific exhibition. They select works of art that fit within the theme of the exhibition, but personal taste may also play a role. In theatre, a similar (dramaturgical and artistic) function is emerging in the programming of festivals and other events. See Chapter 1.

desk dramaturgy – All dramaturgical tasks that can literally be carried out from behind a desk, such as reading, analysing, translating, and editing (theatre) texts; collecting background information about the play and earlier performances; writing policy documents and subsidy applications, but also texts for the programme booklet and for publicity and educational purposes. See Chapter 1. See also *production dramaturgy*.

dialogue – Dialogue occurs when two or more characters in a play talk to each other. Dialogue is contrasted with monologue, in which a character does not address other characters. In traditional dramatic theatre, dialogue is the author's main means of introducing the world of the play and presenting the course of action to the reader or the audience. The dialogues between the characters make the central conflict visible and determine to a large extent the build-up of tension during the play. See Chapter 2. See also *monologue*.

director – The director is usually the person in charge of a theatre production. They direct the artistic process from text (or other source material) to performance and are ultimately responsible for the artistic choices made in that process. The director is the one who, during the rehearsal process, guides the actors in rehearsing and shaping their roles and the mise-en-scène. Because of the broad scope of the task, a good relationship between director

and actors, but also between director and other artistic staff, including the dramaturg, is very important. This does not mean that a director is necessarily a prerequisite for the realisation of a theatre production. In theatre history, it is only in the nineteenth century that we see the director emerge as a separate function in the production process. Even today, there are still quite a few companies in the Netherlands and Flanders, mostly collectives of actors, that work without a director.

diversity – Diversity literally means variety. By cultural diversity, we mean the variety of cultures within a city, region, or organisation. Diversity is an important objective of Dutch cultural policy because cultural visitors are not very diverse. That is to say: they are mostly women, white, and highly educated. In 2011, the Dutch culture sector established the Cultural Diversity Code. It includes four pillars of diversity: audience; programme; personnel; and partners. So, it is not only focused on cultural diversity in the audience, but also on diversity among creators and partners, operating in the field of theatre and performance. If you want to reach other target groups, it is also important to choose themes and art forms that appeal to different audiences. See Chapter 4. See also *inclusiveness*.

drama – The word drama can refer both to the play or the play text, and to the school subject of the same name in which pupils in primary and secondary education come into contact with (text based) theatre both actively and receptively. Drama as a written text has determined the form and content of most theatre performances for many years, but it has lost importance in recent decades. In the so-called postdrama or postdramatic theatre, text is no longer the starting point, but rather one of the many elements in the theatre performance and therefore not necessarily more important than other aural and visual components. See Chapter 2. See also *postdramatic theatre*.

dramatic irony – Dramatic irony occurs when the reader or spectator knows more than (one of) the characters in the play. It is one of the most important narrative techniques for creating tension. The knowledge advantage creates tension because the reader or spectator sees the character acting in ignorance, which often results in a fatal outcome. An iconic example of dramatic irony can be seen in Shakespeare's *Othello*. Iago convinces Othello that Othello's wife Desdemona has been unfaithful to him, whereupon Othello decides to kill her. However, the audience knows that Othello is wrong and that the culprit is not Desdemona but Iago himself.

dramaturgical concept – A dramaturgical concept reflects the principles by which theatre makers transform a play or other material into a performance. Such a concept expresses, for example, why you want to perform a certain play text, what the starting points of the interpretation are, and what message you want to convey to the audience. It is important to keep in mind that a dramaturgical concept is not a blueprint for the final performance. What the performance will ultimately look like is always the outcome of a process and can never be exactly determined in advance. It is possible that the dramaturgical concept is actually written down by the dramaturg, but in most cases it is not. The concept often remains implicit and may change in the course of the creation process and even retrospectively. See Chapter 3.

engagement – Engagement in art usually refers to the social involvement of the artist and the extent to which they try to express this in their work of art. Most theatre performances are based on mimesis (imitation) and are therefore directly related to (social) reality. Moreover, theatre always takes place in the here and now, which means direct communication between performers and audience. That is why engagement in theatre is perhaps even more prominent than in other art forms. Marianne van Kerkhoven distinguishes between minor and major dramaturgy. Minor dramaturgy, she says, is the dramaturgical craftsmanship connected to one specific performance. Major dramaturgy is concerned with how theatre relates to the world at large. It is the kind of dramaturgy in which the theatre fulfils its social function. See Chapter 4.

environmental theatre – The term environmental theatre was introduced in 1967 by Richard Schechner, referring to the performances of his Performance Group, in which the intention was to eliminate the conventional separation between spectators and performers. Aronson and later Eversmann built on Schechner's idea of environmental theatre and came to a more formal definition. According to Eversmann, one can define a continuum between frontal theatre, in which the spectator finds himself outside the theatrical world and does not need to turn his head more than 45 degrees in any direction in order to fully absorb it, and environmental theatre, in which the spectator is completely surrounded by the performance and becomes part of the staging itself. Actors may perform in front of, behind and sometimes even above or below the spectators. As a consequence they are no longer able to overlook the entire performance. See Chapter 4.

epic theatre – Epic theatre is a narrative and political form of theatre in which the unity of action, time, and place is abandoned, and the distinction between the actor and their role is made visible. The term was introduced by Erwin Piscator, but was made famous by the German theatre reformer Bertolt Brecht (1898-1956). According to Brecht, the audience should not get carried away by the performance or empathise with the feelings of the characters. Instead, they should think for themselves and relate critically to what was shown on stage. This is why Brecht uses so-called alienation effects, such as addressing the audience directly, using masks, or singing a song. See Chapters 1, 2, and 4.

exposition – In theatre, exposition means the unfolding of the history and circumstances at the beginning of a play. Through the exposition, readers and/or spectators get to know the world of the play and its inhabitants (the characters). The exposition may take place in the form of a prologue, but in absolute drama, the dialogue between the characters is the main means by which the exposition is brought about. This can be accomplished in a short period of time, but sometimes the playwright gives the reader/ spectator only sporadic information. This generates curiosity and tension.

forum theatre – Forum theatre is a kind of participatory theatre developed by Augusto Boal. In forum theatre, the company first performs a scene or a play in full. Subsequently, the audience is invited to replace or add characters to change the course of the performance and thus solve a social or political problem raised in the play. The so-called Joker plays a facilitating role. They invite the spectators to intervene and guide the transition from 'spectator' to 'spectactor'. See Chapter 4. See also *Theatre of the Oppressed*.

fourth wall – The fourth wall is an imaginary wall of separation between audience and performance. By erecting this imaginary wall between the stage and the audience in the stage design and acting, and by denying, as it were, that the world on stage and that of the audience in the auditorium are connected, theatre makers want to give the audience the illusion that another fictitious world is presented on stage. The fourth wall is especially applicable in traditional theatre, where the architecture reinforces the separation between audience and stage. The fourth wall can be consciously 'broken through' by an actor by taking an aside or by addressing the audience in another way. See Chapter 4. See also *absolute drama*, *proscenium theatre*, and *aside*.

frontal theatre – Classical form of theatre in which the spectator does not have to turn their head more than 45 degrees to be able to perceive the entire performance. See Chapter 4. See also *environmental theatre*.

hermeneutics – Hermeneutics is a broad philosophical movement that focuses on the study and interpretation of texts, but it is also a more concrete method for reading, interpreting, and understanding texts. The so-called hermeneutic circle is a process in which we try to interpret and understand the constituent parts of a text from an understanding of the whole. This study of the parts also leads to new insights about the whole and thus to a constant back and forth movement from general to specific knowledge. When studying and interpreting drama texts, dramaturgs often make implicit or explicit use of such a hermeneutic methodology. See Chapter 3.

immersive theatre – Immersive theatre is a broad term, generally implying that the audience is immersed in the performance itself. This may, for example, be accomplished by eliminating the spatial separation between spectators and performance, by using a specific location, or by physical interaction between actors and spectators. These performances therefore rarely take place in regular theatre venues. In the Netherlands and Flanders the term '*ervaringstheater*' is used to describe a specific type of performance at the beginning of the twenty-first century. It refers to a form of theatre in which the individual, sensory experience of the spectator in the here and now is the core element. Sometimes, this means that the spectator participates in the performance, in other cases the performance may be different for each individual spectator, sometimes the spectator does not even get to see the other audience members, so their experience becomes purely individual. See Chapter 4.

improvisation – Improvisation is an acting technique in which the text, the course of action, and the mise-en-scène are not predetermined, but are invented by the actors as they go along. Usually a specific situation, location, or theme is given as a starting point. Improvisation can be part of a rehearsal process, but fully improvised performances are rare. However, improvisational theatre is popular as a form of entertainment, sometimes even in a competitive format (theatre sports).

inclusiveness – In addition to diversity, inclusiveness has gained importance as a principle in cultural policy. Diversity is directed towards reaching audience groups from different cultural backgrounds and making this

visible on stage and in human resources. Inclusiveness goes one step further. It is not only about numbers, but also about how you deal with diversity, to what extent you know how to involve everyone and give them a voice. This process is called inclusion. Inclusiveness is the outcome of that process. See also *diversity*. See Chapter 4.

interpretation – Interpretation is a well-founded judgement about the meaning of a work, in theatre referring to either a play text or a performance. The interpretation of play texts is an important component of a dramaturg's activities. This involves questions such as: what do we think this play is about? And: why do we want to perform this play at this moment in time and in this location? These questions are particularly relevant to performing texts that are part of the repertoire, i.e. the body of theatre texts that are performed on a regular basis and in which each new production is not only an enactment of the play in question, but is also part of an ongoing discourse on the meaning of that play. See Chapter 3. See also *repertoire*.

intertextuality – By intertextuality we mean that texts can quote each other in content as well as form, can react to each other, and can absorb and transform each other. The term originates from literary theory, but can also be applied to other art forms in a more comprehensive understanding of 'text'. Because of its multidisciplinary character, intertextuality plays a major role in theatre. This applies in particular to postdramatic theatre. Because the play text has lost its importance as a guiding source, the material that forms the basis of a performance is already diverse by definition. See also *postdramatic theatre*.

libretto – The libretto is the text of an opera, operetta or musical, i.e. the play or other text that forms the basis of a music theatre performance. See also *opera* and *musical*.

major dramaturgy – see *engagement*

metatheatricality – Metatheatricality occurs when performances not only reflect on the world around us, but also on theatre itself as an art form. In other words, theatre about theatre. This can be created through text, characters, acting, scenery, or other mediums. An important question here is why the makers use such a dramaturgical strategy and how this helps to determine the relationship between stage and audience. See Chapter 2.

mime – Mime is a form of theatre with a strong focus on the actor's body. Mime is related to *pantomime* and is sometimes called movement theatre, but that does not mean that mime performances are always silent. The main difference with regular theatre is that in mime, the starting point is not a text, but the actor's body and its movements as a means of expression. Dutch mime is multifaceted and difficult to classify under a single heading, but it can nevertheless be distinguished as a theatre form with its own history, development, and vocabulary. In Amsterdam, there is even a separate mime programme at the Academy for Theatre and Dance. The Dutch mime tradition, with its focus on the actor's body in relation to the environment, was the basis for typical Dutch theatre forms such as site-specific theatre and immersive theatre. Mime has also had a great influence on Dutch youth theatre. See Chapter 1. See also *site-specific theatre* and *immersive theatre*.

mimesis – The Greek word mimesis means imitation and is central to Aristotle's definition of tragedy. Since theatre is essentially about actors playing a role, i.e. people pretending to be other people, one could say that all theatre is essentially mimetic, but there are some disputable issues with this, especially in the era of postdramatic theatre. See Chapters 1 and 2.

minor dramaturgy – According to Marianne van Kerkhoven, minor dramaturgy is the dramaturgical work relating to a specific performance. See Chapter 1. See also *engagement*.

mise-en-scène – see *staging*.

monologue – In monologues, an actor does not address other characters but speaks to themselves or to the audience. According to Marianne van Kerkhoven, there is an abundance of 'monological material' in today's theatre. She explains this by, among other things, a shift from something that takes place between people to something that takes place within people, i.e. a reflection of individuals on themselves. She therefore considers the monologue to be a symbol for the social isolation and extreme individualisation of modern man. See also *dialogue*. See Chapter 2.

montage – Montage refers to the sequence and connection of various elements of a performance. Just as in film, different scenes, images, and sounds are assembled one after the other, in the montage of a theatre production, fragments, storylines, and theatrical means can be forged into a whole. The

sequencing and linking of several disparate elements that do not together form a continuous storyline is sometimes referred to as 'montage theatre'. See Chapter 2.

musical – Musical is a popular, usually large-scale form of music theatre, in which spoken text, music, singing, and dancing are combined.

naturalism – see *realism*

opera – Opera is a form of music theatre, which originated in the sixteenth century and is related to drama, but in which the dialogues and monologues are not spoken but sung in so-called arias. Many classical plays have been adapted into operas, such as *Le nozze di Figaro, Il Barbiere di Siviglia, Faust, Otello, Don Carlos, Pelléas et Mélisande*, and *Wozzeck*.

outreach – In theatre, we usually speak of outreach when an effort is made to attract more people, and audiences that performance don't usually reach. See Chapter 4.

performance art – Performance art is a form of visual art that is closely related to theatre because the artist explicitly uses their own body to become part of the work of art. The physical limits of the body are often explored in the process. Performance art has its origins in the historical avant-garde movements, but flourished mainly in the 1960s and 1970s. An important characteristic of performance art is that it is a one-time event and cannot be repeated. Well-known performance artists include Marina Abramowic, Joseph Beuys, Hermann Nitsch, and Jan Fabre.

peripeteia – Aristotle defined peripeteia as 'a sudden change whereby the situation is reversed.' According to Aristotle, peripeteia comes directly from the course of action and normally involves a turn from happiness to unhappiness. In the best tragedies, according to Aristotle, peripeteia coincides with *anagnorisis* (recognition, insight). A famous example is Oedipus who comes to realise that he has killed his father and married his mother. See Chapter 2.

phenomenology – Phenomenology is a movement in twentieth century philosophy that focuses on direct, sensory perception. For the theatre, this means a focus on perception and experience, rather than on interpretation and meaning.

physical theatre – see *mime*

playhouse – By playhouse, we usually mean a large theatre with a traditional architecture. This means that the audience area is separated from the performance area by a raised stage and a proscenium arch. The space behind the proscenium arch is much wider and higher than the arch itself, allowing all sorts of things to be kept out of sight from the audience. A playhouse is always easily recognised from the outside by the fly tower that rises above the rest of the building. See Chapters 3 and 4. See also *black box* and *proscenium stage*.

plot – Plot is a word that can be used in different ways. It can be applied as a synonym for course of action, but more precisely, the plot of a play is the concrete organisation of what is meant to be shown on stage. The story is the whole narrative presented in the play, in chronological order, while the plot is the concrete organisation of a story, i.e. what we as spectators hear and see on stage. Thus, in most cases, the plot is much more compressed than the story, which also contains the entire before-and-after history. Through the *exposition*, we, the audience, can learn about that pre-history. The moment in the story when the plot begins is called the *point of attack*. Besides the distinction between story and plot, we can also distinguish between closed and open plots. In the case of a closed plot, there is usually a unity of time, place, and action. In the case of an open plot, there may be several story lines, changes in location, and time jumps. See Chapter 2.

point of attack – see *plot*

postdramatic theatre – Postdramatic theatre literally means the theatre that comes after dramatic theatre or the theatre of the written word. It is a collective term for all theatre in the second half of the twentieth and the beginning of the twenty-first century in which the play text as the structuring element of the performance has made way for a series of texts, images, and sounds that generate meaning in a more associative manner. See Chapter 1.

primary text – Primary text is the text spoken by the characters in the play through monologues and dialogues. Secondary text is all other text, including names and descriptions of the appearance and mental state of characters, layout of the stage area, stage directions, descriptions of the scenography, etc. See Chapter 2.

production dramaturgy – Production dramaturgy is concerned with the dramaturgical work that takes place during the production process itself

and for which the dramaturg needs to get out from behind their desk. For example, the dramaturg can be of assistance to the director and the actors during the rehearsal process, and can take on the role of the first spectator. See Chapters 1 and 4. See also *desk dramaturgy.*

props – Props are objects used by the actors during their performance that are not considered to be part of the costume or set. These may include weapons, telephones, cameras, etc. In large-scale productions where many props are used, a separate props manager sometimes ensures that all props are ready behind the scenes or that they are handed to the actors.

proscenium stage – Proscenium stage refers to a traditional raised stage that is framed by a proscenium arch through which the audience watches the performance. The audience space and the performance space are separated by the raised stage and by the proscenium arch, which offers the spectators a glimpse, as it were, into another, fictitious world that is depicted on stage. Since the space behind the proscenium arch is much higher and wider than we, the audience, can see, it also serves to keep everything that creates this fictitious world out of sight, 'behind the scenes'. This includes stage machinery, lighting equipment, but also actors who are not on but off stage. See also *black box, playhouse* and *fourth wall.*

protagonist – The main character. See also *antagonist.*

realism – In theatre, realism refers to a style of acting and design that attempts to imitate reality as closely as possible and allows the audience to experience what happens on stage as 'real'. Realism is also the name of a cultural movement that emerged in the second half of the nineteenth century in literature, the visual arts, and theatre. It was a reaction to Romanticism. The idea was to depict (social) reality as well as possible. Plays by the Dutch playwright Herman Heijermans (1864-1924), for example, are considered to be naturalistic. Naturalism is a form of far-reaching realism. In naturalism, everything on stage not only had to seem real, but preferably also had to be real.

reception research – Reception research looks into the experiences of individual spectators in the theatre. It focuses on what a spectator encounters in the theatre, how they empathise and identify with a character, how meanings are constructed, and how a spectator becomes fascinated or bored. See Chapter 4. See also *audience research.*

repertoire – By repertoire, we usually mean the collection of theatre texts that are performed on a regular basis. In other words, it refers to plays that were written at some point in the past and are regularly performed again thereafter. These may be texts from distant theatre history, such as plays by the Greek tragedy poets or by Shakespeare, or more recent plays by writers such as Beckett, Pinter, Jelinek, or Kane. The concept is somewhat broader than canon, which rather refers to the collection of texts that we consider to be the most important of our national or Western culture. Repertoire can also refer to the productions that are performed over and over again by a particular company. Only companies with a permanent ensemble of actors can afford this. See also *canon*.

representation – see *character*.

review – A review is a descriptive and evaluative article about a theatre performance (or another artistic expression). Reviews are published in newspapers and magazines, but nowadays increasingly online as well. The person who writes a review is the reviewer or critic. Many reviews nowadays are accompanied by a rating based on the number of stars a reviewer assigns to a performance, almost always from one to five stars.

secondary text – see *primary text*

scenography – By scenography, we mean all aspects of dramaturgy that are part of the stage design, so not only scenery, but also space, lighting, costumes, etc. Scenography has developed from mere decoration to an essential part of the dramaturgy of a performance. See Chapter 3.

semiotics – Semiotics is concerned with the study of signs, sign systems, and the creation of meaning. The semiotic approach originated in linguistics, but it has also been used extensively in theatre. In addition to language, the theatre has many other sign systems that are to a large extent linked to the actor. But space, scenery, light, music, and sound can also be analysed as sign systems. See Chapter 1.

site-specific theatre – Site specific theatre is theatre in places not originally intended for this purpose. These might be sheds, farmhouses, empty factory buildings, or open-air sites. The Netherlands has a rich tradition of site-specific theatre. *Oerol* is a well-known site-specific theatre festival that takes place on the island of Terschelling every year in June. See Chapter 4.

stage design – By stage design, we mean all aspects of the visual appearance of a performance, including the set, lighting, costumes, etc. When it comes to the dramaturgical, meaning-creating aspects of the stage design, we rather speak of scenography. See Chapter 3. See also *scenography*.

staging – Staging or mise-en-scène means the way in which an existing (play) text is put on stage. Staging refers to both the acting and the scenography. Mise-en-scène usually refers only to the acting.

stock character A stock character or type is a character that does not undergo any development and is dominated by one characteristic or a certain combination of characteristics. Stock characters often occur in comedies, but Brecht also uses them to indicate characters with a certain social status, such as the farmer or the servant. See Chapter 2. See also *character*.

story – see *plot*

subtext – Subtext is the implicit meaning of the written or spoken text. For the actor, subtext is an important input for the interpretation of their role. After all, what the character says is laid down in the dialogue or monologue, but what the character actually means by that (the subtext) depends on the interpretation the makers (director, dramaturg, actors) assign to it. Through the subtext, the actor can give colour and direction to their.

theatre of cruelty – The Theatre of Cruelty is a concept of theatre that was laid down by the French actor and theatre maker Antonin Artaud in a series of writings that were collected in 1938 in 'Le Théâtre et son Double' (The Theatre and its Double). Artaud distanced himself from the psychologically oriented approach of Western theatre and advocated a ritual form of total theatre, in which the spectator is absorbed in a shocking, cruel, total experience that appeals to their subconscious and must ultimately lead to healing (catharsis). See Chapters 3 and 4. See also *catharsis*.

theatre of the oppressed – The term Theatre of the Oppressed was coined by Brazilian theatre-maker Augusto Boal. It is also the title of his 1974 book, in which he emphasises the repressive nature of theatre throughout history. According to Boal, the goal of political theatre is not to make theatre for or about the oppressed, but to make it become theatre of the oppressed. To this end, theatre had to be transformed from an instrument of political oppression ino a path to social liberation. To achieve this, he developed

various methods of participatory theatre, including forum theatre. See Chapter 4. See also *forum theatre*.

tragedy – In tragedy, serious and often fateful events are at the very centre of the play. In his *Poetics*, Aristotle gives a detailed definition of tragedy, describes what a good tragedy should contain, and what effects the tragedy has on the audience. Nowadays, we simply mean a tragedy as a play that ends badly. In everyday life, too, we often call a sad event that ends badly a 'tragedy'. See Chapter 2.

well-made play – The guidelines for a well-made play or *pièce bien faite* were developed in the nineteenth century by the French playwright Eugène Scribe and strongly influenced the theatre of his day. The play usually has a rather artificial plot, which is constructed according to strict rules. It includes a late point of attack, so that the complications unfold at a dizzying pace after extensive exposition. Because some characters have an information gap compared to others and to the audience, the tension is heightened. The audience empathises with the *protagonist* who faces a clear opponent (*antagonist*). The complications lead to a late climax in which the protagonist is victorious, followed by a quick resolution in which all remaining problems and ambiguities are resolved. See also *point of attack, antagonist,* and *climax.*

Notes

Chapter 1: What is dramaturgy?

1. Cathy Turner and Synne K. Behrndt, *Dramaturgy and Performance* (Basingstoke: Palgrave Macmillan, 2008), 18.
2. Marianne van Kerkhoven, "Looking without a Pencil in the Hand", *Theaterschrift. On Dramaturgy* 5-6 (1994), 140-142 (emphasis M.v.K.).
3. Aristotle et al. *Poetics*. New edition, revised by Donald A. Russell. Cambridge, MA: Harvard University Press, 1995, 47.
4. For a more extensive treatment of *Poetics*, see Chapter 2.
5. French Classicism was a literary movement at the end of the seventeenth and the beginning of the eighteenth century that had a great influence on the playwriting of the time.
6. See also Chapter 2.
7. For a more extensive treatment of Brecht's epic theatre, see Chapter 2.
8. This paragraph is partly based on the lectures on dramaturgy that Tom Blokdijk gave to theatre studies students in 2007 and 2008.
9. Marianne van Kerkhoven, "Van de kleine en de grote dramaturgie", in *Van het kijken en van het schrijven. Teksten over theater*, samenstelling en red. Peter Anthonissen *et al.* (Leuven: Van Halewyck, 2002), 197. English translation by the authors.
10. 'Emio Greco | Pieter C. Scholten' https://www.ickamsterdam.com/en/company/choreographers/emio-greco-pieter-c-scholten-1; accessed 2 December 2019.
11. Van Kerkhoven, "Looking without a Pencil in the Hand", 142.
12. *Ibid.*, 146 (emphasis M.v.K.).

Chapter 2: Material

1. See also Chapter 3.
2. Marianne van Kerkhoven, "Samenvallen met wat je denkt", in *Van het kijken en van het schrijven. Teksten over theater*, comp. and ed. by Peter Anthonissen et al. (Leuven: Van Halewyck, 2002), 187. (transl. by authors)
3. *Ibid.* (transl. by authors).
4. See *The Hamburg Dramaturgy by G. E. Lessing*. A New and Complete Annotated English Translation. Eds. Wendy Arons, Sara Figal & Natalya Baldyga (London: Routledge, 2018).
5. John Jones, *On Aristotle and Greek Tragedy* (London: Chatto & Windus, 1962), 13.

6. Aristotle, *Poetics*, 47. In fact, all core concepts of this definition are difficult
 to translate and have a long history of philological, philosophical, literary,
 and theatrical dispute. From a dramaturgical point of view, a critical reflec-
 tion on these concepts is important because they indicate, among other
 things, the relationship between art and the social-political sphere; but we
 would like to emphasise that the following considerations are not about
 'correct' or 'incorrect' translations/interpretations of these concepts.

7. Aristotle, *Poetics*, 53.

8. *Ibid.*, 61.

9. *Ibid.*, 51.

10. See also Chapter 1.

11. Aristotle, *Poetics*, 53.

12. *Ibid.*, 47.

13. *Ibid.*, 65.

14. *Ibid.*, 71.

15. See text box *Oedipus*, Chapter 1.

16. Aristotle, *Poetics*, 69.

17. If there is a term in the *Poetics* that refers to dramatic figures/characters, it
 is the term *prattontes*, which could be translated as 'actants', acting perso-
 nas or those who act/do.

18. These remarks are mainly intended to reflect on the 'contemporary
 viewpoint' through which we read theatre texts. Concepts that now seem
 self-evident (such as dramatic figures as the centre of dramatic texts) do not
 necessarily correspond to Ancient Greek or Roman theatre conventions.

19. Elsbeth Etty, "De namen der gevallenen" [The names of the fallen], *NRC*,
 4 May 2010, 7. (transl. by authors).

20. *The Hamburg Dramaturgy by G. E. Lessing.* A New and Complete Annotated
 English Translation. Ed. Natalya Baldyga, transl. by Wendy Arons and Sara
 Figal (London: Routledge, 2018), 251.

21. Stefan Hulfeld (ed.), *Scenari più scelti d'istrioni. Italienisch-Deutsche Edition
 der einhundert Commedia all'improvviso-Szenarien aus der Sammlung Cors-
 iniana* (Göttingen: Vienna University Press bei V&R unipress, 2014).

22. Stefan Hulfeld, "Einführung in die Lektüre der Scenari più scelti d'istrioni", in
 *Scenari più scelti d'istrioni. Italienisch-Deutsche Edition der einhundert Commedia
 all'improvviso-Szenarien aus der Sammlung Corsiniana*, ed. Stefan Hulfeld (Göt-
 tingen: Vienna University Press bei V&R unipress, 2014), 102 (transl. by authors).

23. For example, certain stock characters are recognisable in Bredero's comic
 play *Spaanschen Brabander* (*The Spanish Brabanter*), written in 1617, includ-
 ing Jerolimo (Capitonio), Robbeknol (Zanni), Byateris (La Ruffiana), and
 Gierighe Geeraart (Pantalone, but without his characteristic libido).

24. Peter Szondi, *Theory of Modern Drama* (Cambridge: Polity, 1987), 8.

25. *Ibid.*, 9.

26. See also Chapter 2.5, Dramatic characters.

27. Ödön van Horváth, "Hin und her", in Ödön von Horváth, *Prosa und Stücke*
 (Frankfurt am Main: Suhrkamp, 2008), 920 (transl. by authors).

28. Lodewijk de Boer, "De herinnering", in Lodewijk de Boer, *De herinnering. Drie toneelstukken* (Amsterdam: De Bezige Bij, 2005), 214 (transl. by authors).

29. E.M. Foster, *Aspects of the Novel* (New York: Penguin Books, 1962), 87.

30. See text box in Chapter 1.

31. Pfister prefers the term 'dramatic figure', see Manfred Pfister. *The Theory and Analysis of Drama* (Cambridge: Cambridge University Press, 1991), 160-163.

32. William Shakespeare, *King Richard III*, red. James E. Siemon (London: Methuen Drama, 2009), 134 (vs. 1.1.14-1.1.23).

33. For a study on dramatic characters in contemporary, anglophone dramatic literature and theatre performances, see Cristina Delgado-García, *Rethinking Character in Contemporary British Theatre: Aesthetics, Politics, Subjectivity* (Berlin/Boston, MA: De Gruyter, 2015).

34. Marianne van Kerkhoven, "De drager van het verhaal. Over monologen", in *Van het kijken en van het schrijven. Teksten over theater*, comp. and ed. by Peter Anthonissen et al. (Leuven: Van Halewyck, 2002), 171-172 (transl. by authors).

35. Erwin Jans, "Drama na het drama? Een overzicht van postdramatische theaterteksten in Vlaanderen", in *Het statuut van de tekst in het postdramatische theater*, eds. Claire Swyzen and Kurt Vanhoutte (Brussel: PA/Research Centre for Visual Poetics, 2011), 64 (transl. by authors).

36. See box text *Grensgeval* (directed by Guy Cassiers; the performance is based on Jelinek's play).

37. BOG. is a Dutch-Flemish collection of theatre makers founded in 2013.

38. Gerda Poschmann, *Der nicht mehr dramatische Theatertext. Aktuelle Bühnenstücke und ihre dramaturgische Analyse* (Tübingen: Niemeyer, 1997), 312.

39. Marianne van Kerkhoven, "Van de kleine en de grote dramaturgie", in *Van het kijken en van het schrijven. Teksten over theater*, comp. and ed. by Peter Anthonissen et al. (Leuven: Van Halewyck, 2002), 197.

40. Bertolt Brecht, "The Modern Theatre is the Epic Theatre (Notes to the opera *Aufstieg und Fall der Stadt Mahagonny*)", in *Brecht on Theatre. The Development of an Aesthetic*, ed. & transl. by John Willett (London: Eyre Methuen, 1974), 37.

41. Walter Benjamin, "What is Epic Theatre? [Second Version]", in Walter Benjamin, *Understanding Brecht*. Transl. by Anna Bostock (London, New York: Verso 1983), 16, 18.

42. *Ibid.*, 18-19.

43. Szondi, *Theory of Modern Drama*, 73.

44. Arnon Grunberg, "Scherp als een stanleymes, alledaags als zeepsop" ["Sharp as a Stanley knife, as ordinary as soapsuds"], *De Groene Amsterdammer*, 21 November 2018 (transl. by authors).

45. Judith Herzberg, "The Wedding Party", in Della Couling (ed.): *Dutch and Flemish plays* (London: Hern 1997), 119.

46. In the Dutch version, each character of the play is provided with a year of birth; the English version refrains from providing this remarkable information.

47. William Shakespeare, *Hamlet*, eds. Ann Thompson and Neil Taylor (London: Arden Shakespeare, Bloomsbury, 2006), 272-273 (vs. 2.2.61-63).

48. Elinor Fuchs, *The Death of Character: Perspectives on Theater after Modernism* (Bloomington, IN: Indiana University Press, 1996), 34.

49. "The Drama of the Drama" was also the title of a research project at the AP University of Applied Sciences in Antwerp (supervisor Liese Stuer, co-investigator Erwin Jans).

50. Jans, "Drama na het drama?", 60 (transl. by authors).

51. The title of the musical is a playful variation on the proverb "Eerlijk duurt het langst", which more or less coincides with the English proverb "Honesty lasts longest".

52. This is also the title of the volume *Het statuut van de tekst in het postdramatische theater* [*The State of the Text in Post-Dramatic Theatre*] edited by Claire Swyzen and Kurt Vanhoutte (Brussel: UPA/Research Centre for Visual Poetics, 2011).

53. Jans, "Drama na het drama?", 66. (Transl. by authors).

54. Heiner Müller, "The Hamletmachine", transl. by Carl Weber, *Performing Arts Journal* 4, No. 3 (1980): 141.

55. *Ibid.* The italicised lines are English phrases in the original text by Müller.

56. AH THE WHOLE GLOBE FOR A REAL SORROW: the line is a variation on King Richard's famous exclamation: 'A horse! A horse! My kingdom for a horse!'(vs. 4.7 & 13); 'Globe' can also be read as a reference to the Globe theatre in London, where Shakespeare's plays were performed.
RICHARD THE THIRD I THE PRINCE-KILLING KING: reference to Shakespeare's play *King Richard III*, overlap of Hamlet character (in line 1 of quote) and Richard III.
OH MY PEOPLE WHAT HAVE I DONE UNTO THEE: Quote from the Bible, Micah 6:3-4: 'O my people, what have I done to you? / In what have I wearied you? Answer me!' This line also functions as a refrain in the poem 'Ash Wednesday' by T.S. Eliot: 'If the lost word is lost, if the spent word is spent / If the unheard, unspoken / Word is unspoken, unheard; / Still is the unspoken word, the Word unheard, / The Word without a word, the Word within / The world and for the world; / And the light shone in darkness and / Against the Word the unstilled world still whirled / About the centre of the silent Word. // O my people, what have I done unto thee.' It is not the only reference to T.S. Eliot in *Hamletmachine*; in Part 4 he quotes the poem 'Journey of the Magi' ('A cold coming we had of it, / Just the worst time of the year / For a journey, and such a long journey').
CLOWN NUMBER TWO IN THE SPRING OF COMMUNISM: reference to the so-called Communist Spring, a brief period of political liberalisation in Czechoslovakia in 1968, which was violently suppressed by the Soviet army after a few months.
SOMETHING IS ROTTEN IN THIS AGE OF HOPE: adaptation of one of the most famous sentences from *Hamlet*, 'Something is rotten in the state of Denmark' (vs. 1.4.90); Müller gives it a temporal twist, that is, not in Den-

mark, but in 'this age of hope'. Probably also a reference to the philosopher Ernst Bloch and his magnum opus *The Principle of Hope*.

LET'S DELVE IN EARTH AND BLOW HER AT THE MOON: adapted quote from *Hamlet*: 'But I will delve one yard below their mines/ And blow them at the moon' (3.4.210-1). This sentence can also be read as a reference to the American and Soviet-Russian space programmes.

57. Heiner Müller, *Gesammelte Irrtümer. Interviews und Gespräche* (Frankfurt am Main: Verlag der Autoren, 1986), 20, 36.

58. Jac Heijer, "Stijl. Theater met feilloos gevoel voor schoonheid. Stijl door Onafhankelijk Toneel [NRC Handelsblad, 18 maart 1980]", in Jac Heijer. *Een keuze uit zijn artikelen*, selected by Judith Herzberg, Gerrit Korthals Altes, Michael Matthews, and Jan Ritsema (Amsterdam: International Theatre & Film Books, 1994), 350 (transl. by authors).

59. Simon van den Berg, "Dertig jaar Discordia. 'We hebben natuurlijk wel het een en ander uitgevonden'", *Theatermaker* (April 2012), 12.

60. Marianne van Kerkhoven, "Over kritiek," in *Van het kijken en van het schrijven. Teksten over theater,* comp. and ed. by Peter Anthonissen et al. (Leuven: Van Halewyck, 2002), 83 (emphasis M.v.K.; transl. by authors).

61. Automatic writing is writing without a predetermined idea or plan. This 'technique' was first applied by the Dadaists and the surrealists.

62. Fuchs, *The Death of Character*, 74. Fuchs recalls Brecht's reflections on the use of scene titles, songs, and slogans in *The Threepenny Opera* published under the title "The Literarization of the Theatre".

63. Quoted by Poschmann, *Der nicht mehr dramatische Theatertext*, 195 (transl. by authors).

64. Like the Kaprun disaster in 2000 (*Das Werk*), the murder of 200 Jewish forced labourers at the end of the Second World War (*Rechnitz* [*The Exterminating Angel*]), the economic crisis in 2009 (*The Merchant's Contracts*) or the so-called refugee crisis in 2015 (*Charges* [*The Supplicants*]; *Coda; Appendix*).

65. Elfriede Jelinek, *Charges (The Supplicants)*. Transl. by Gitta Honegger. London, New York, Calcutta: Seagull Books, 2016, 86.

66. The German terms are Nadelkissen and Nadelwald, which provoke a more direct stream of associations and dissociations

67. Jans, "Drama na het drama?", 62 (transl. by authors).

68. *Ibid.*, 56-57 (transl. by authors; emphasis E.J.).

69. Van Kerkhoven, "Vervaging aller grenzen," in *Van het kijken en van het schrijven. Teksten over theater,* comp. and ed. by Peter Anthonissen et al. (Leuven: Van Halewyck, 2002), 29-30.

70. Gertrude Stein, "Plays", in Gertrude Stein, *Writings and Lectures 1911-1945*, ed. Patricia Meyerowitz (London: Peter Owen, 1967), 58.

71. Van Kerkhoven, "Vervaging aller grenzen", 30 (emphasis M.v.K.; transl. by authors).

72. See Chantal Mouffe, "Art and Democracy. Art as an Agonistic Intervention in Public Space", *Open! Platform for Art, Culture & the Public Domain*,

1 January 2007, https://www.onlineopen.org/art-and-democracy, accessed 3 February 2021.

Chapter 3: Process: From material to performance

1. Note that we avoid the catchy phrase 'from page to stage' at this point, as we would consciously like to account for sources other than text.
2. Konstantina Georgelou, Efrosini Protopapa and Dana Theodoridou, ed., *The Practice of Dramaturgy. Actions in Performance* (Amsterdam: Valiz, 2017).
3. An exception to this is, for example: Annemarie Matzke, *Arbeit am Theater. Eine Diskursgeschichte der Probe* (Bielefeld: Transcript, 2012).
4. For example: Shomit Mitter, *Systems of Rehearsal: Stanislavsky, Brecht, Grotowski and Brook* (London: Routledge, 2015).
5. Duška Radosavljević, *Theatre-Making. Interplay between Text and Performance in the 21st Century* (Basingstoke: Palgrave Macmillan 2013), 29.
6. On the question of travelling, see also Chapter 4.
7. Margherita Laera, *Theatre and Adaptation: Return, Rewrite, Repeat* (London: Bloomsbury, 2014), 2.
8. See also text box Kings of War.
9. We think of, for example, the version of Ivanov, directed by Nina Spijkers (2016) at Toneelschuur, Haarlem. The scenography not only expresses the claustrophobia and lack of safe spaces, but also determines how the characters will relate to one another. It has a direct consequence for the acting.
10. Rafael Spregelburd, "Life, of Course", *Theatre Journal 59, No. 3* (2007): 373.
11. One of the examples: "*Night School's* aunts are two very dignified ladies living in the greatest of poverty with a nephew who spends most of his time in jail. The aunts have a very simple, very ingenious way of speaking, typical of British working-class English. But onstage they take tea! This is very hard to translate for Argentines. What local slang or quasi criminal dialect rich in ingenuity is compatible with such a bourgeois British activity that it doesn't become totally absurd? England's tea-drinking ceremony has no equivalent here. Replacing it with the ceremony of our local mate and our local *lunfardo* slang would be totally merciless: it would make spectators feel even further away from the original. I chose to subject them to a simple and exotic fiction according to which, in other countries, these impoverished women take tea as if it were the most normal thing in the world." Spregelburd, "Life, of Course", 375.
12. Re: Heijermans, a recent example at the time of writing is "Flight 49" (2020), an adaptation of "Op Hoop van Zegen", directed by Simon Stone with the ensemble of International Theater Amsterdam.
13. Original: "Hoe kan het theater, dat bestaat bij de gratie van het ogenblik, van het hier en nu, de complexiteit en de meerduidigheid van het moment vatten? Hoe kan de kunstenaar een antwoord geven op het leven dat hij

ervaart als een chaotische opeenstapeling van sensaties, die elkaar opvolgen in grote snelheid en in ontelbare, zich steeds wijzigende combinaties?"

Marianne van Kerkhoven, "Het gewicht van de tijd", in *Van het kijken en van het schrijven. Teksten over theater*, ed. Peter Anthonissen *et al.* (Leuven: Van Halewyck, 2002), 50. (transl. by authors).

14. Original: Het onder controle krijgen van de stijgende, zelfopgelegde complexiteit in het kunstwerk geeft blijkbaar minder aanleiding tot het gebruik van noties als inhoud, analyse van betekenis, psychologie, verhaal. Deze zijn vaak te concreet, te eenduidig, te anekdotisch. Door hun inhoudelijke consequentie of samenhang dwingen ze te zeer tot lineariteit; het is moeilijk om hen een steeds andere plaats te geven binnen een groter geheel. Er ontstaan bijgevolg andere werkmethoden binnen het repetitieproces, die meer en meer steunen op het hanteren van abstracties en die bijna als 'muzikaal' omschreven worden. [...] Dankzij de abstrahering krijgen de dingen een toegevoegde waarde én een andere natuur: door de afstand die wordt toegevoegd, zijn wij in staat ze anders te bekijken en eventueel hun complexiteit te onderkennen.

Ibid., 51. (transl. by authors).

15. Pamela Howard "What is Scenography? Or what's in a name" in: *Theatre Design and Technology* Vol. 37 No. 3, 2001, 16.

16. Jarka M. Burian, *Leading Creators of Twentieth Century Czech Theatre*, (London: Routledge, 2013), 123.

17. Marianne van Kerkhoven, "Een reis in de ruimte/een wereld zonder middelpunt" in: *Van het kijken en van het schrijven. Teksten over theater*, (Leuven: Van Halewyck, 2002), 65. (transl. by authors).

18. *Ibid.*, 65.

19. Joslin McKinnney and Philip Butterworth, *The Cambridge Introduction to Scenography*, (Cambridge: Cambridge University Press 2009), 4.

20. Arnold Aronson "Post Modern Design", *Theatre Journal* Vol. 43 No 1, 1991, 3.

21. Kerkhoven, "Een reis in de ruimte", 65.

22. See also 4.5: The auditorium and the stage

23. Van Kerkhoven, "Een reis in de ruimte", 76.

24. Jerzy Grotowski, *Towards a Poor Theatre*, (London: Routledge, 2002)

25. Schechner, as quoted in: Peter Eversmann, *De Ruimte van Theater*, Universiteit van Amsterdam, 1996, 138.

For more information on Schechner and The Performance Group, see paragraph 4.5: The auditorium and the stage.

26. Dennis Kennedy, *Looking at Shakespeare*, (Cambridge: Cambridge University Press, 2001), 5.

27. The text is the last line in Van Randwijks poem 'Bericht aan de levenden' (Message to the living) from 1953. Translation by the authors.

28. Kwinter, Sanford. "The Reenchantment of the Interior, Olafur Eliasson's Weather Project" in: *Harvard Design Magazine* Harvard University School of Design, No. 29, F/W 2008, 72.

29. Maria Shevtsova, as quoted in: Patrice Pavis, *Analyzing Performance*, (Ann Arbor, MI: University of Michigan Press 2006), 171.

30. Kennedy, *Looking at Shakespeare*, 6.

31. Arnold Aronson, *Looking into the Abyss*, (Ann Arbor, MI: University of Michigan Press, 2005).

32. Kerkhoven, "Een reis in de ruimte", 78.

33. Mladen Ovadija, *Dramaturgy of Sound in the Avant-Garde and Postdramatic Theatre* (Montreal: McGill-Queens University Press, 2013).

34. Paul Koek in: Van de Haterd: "Muziektheatermaker Paul Koek: Theater vanuit de wetten van de muziek", p. 131. (transl. by authors).

35. http://www.complicite.org/productions/TheEncounter.

36. For a systematic categorisation in terms of interdisciplinary methodology, see: Doris Kolesch and Sybille Krämer, "Stimmen im Konzert der Disziplinen", in *Stimme. Annäherung an ein Phänomen*, ed. Doris Kolesch and Sybille Krämer (Frankfurt am Main: Suhrkamp, 2006), 7-15.

37. Doris Kolesch, "Shakespeare hören: Theatrale Klangwelten in der griechischen Antike, zu Zeiten Shakespeares und in gegenwärtigen Shakespeare-Inszenierungen", *Shakespeare Jahrbuch* (*Shakespeares Klangwelten*) 144 (2008): 11-27.

38. Benjamin Hunningher, who in 1964 introduced the first department dedicated to theatre studies in the Netherlands at the University of Amsterdam under the name 'Dramaturgie en de geschiedenis van de dramatische kunst' ('Dramaturgy and the history of the dramatic art') published a study, in 1956, which sought to reconstruct the acoustics in Athens' theatre of Dionysos Eleuthereus.

39. Antonin Artaud, "The Theatre of Cruelty" in *Theatre and Its Double*, transl. by Victor Corti, (London: Alma Classics Ltd), 64.

40. Susan Sontag. "Approaching Artaud", in *idem, Under the Sign of Saturn. Essays* (New York: First Vintage Books, 1981), 39.

41. Ovadija, *Dramaturgy of Sound*, 16.

42. Marijn de Langen, "Geräuschemacher, Klangkünstler und Musikarchitekten", *Theater der Zeit* (Holland Flandern Spezial) 9 (September 2001): 32-34.

43. Bertolt Brecht, "The Modern Theatre is the Epic Theatre," in *Brecht on Theatre*, ed. And transl. John Willet (London: Methuen, 1974), 35.

Chapter 4: Audience

1. Peter Brook, *The Empty Space* (London: Penguin Books, 1972 [1968]), 11.

2. Original: 'De theaterdramaturg gaat niet alleen in gesprek met de makers, maar is ook intermediair tussen de "binnenwereld" van de makers en de "buitenwereld" van toeschouwers en andere betrokkenen, zoals theaterprogrammeurs en -journalisten.'
Bart Dieho, *Een voortdurend gesprek. De dialoog van de theaterdramaturg*

(Amsterdam, Utrecht: International Theatre & Film Books/HKU, 2009), 12. (transl. by authors).

3. Marianne van Kerkhoven, "Het theater ligt in de stad en de stad ligt in de wereld en de wanden zijn van huid", in *Van het kijken en van het schrijven. Teksten over theater*, samenstelling en red. Peter Anthonissen *et al.* (Leuven: Van Halewyck, 2002), 137-143.
 This State of the Union address was delivered at the 1994 Theaterfestival in Brussels and was first published in Dutch in *Etcetera*. Translated from Dutch by Gregory Ball. http://sarma.be/docs/3229.

4. See also Chapters 1 and 3.

5. Jacques Rancière, "The Emancipated Spectator" in *The Emancipated Spectator*, Translated by Gregory Elliott. (London/New York: Verso, 2009), 14.

6. The Dutch Cultural Basic Infrastructure includes all performing arts institutions that are directly funded by the national government. The subsidy period is four years, after which the subsidies are redistributed.

7. Erwin Jans, *Interculturele intoxicaties. Over kunst, cultuur en verschil* (Berchem: EPO, 2006) 157.

8. Original: 'De canon is het punt waar politiek, macht, opvoeding, institutionalisering en esthetische kwaliteit elkaar kruisen. Vandaar het belang dat er aan wordt gehecht. De canon is meestal richtinggevend voor het curriculum op onderwijs: de canon zegt niet meer of niet minder dan welke boeken belangrijk zijn voor een culturele vorming. De canon bepaalt in grote mate het aankoopbeleid van bibliotheken, musea en uitgeverijen. Ook de geschiedenisoverzichten van literatuur en kunst worden door de canon gestuurd.'
 Ibid., 157-158. (transl. by authors).

9. The term cultural omnivore was introduced in 1992 by Richard A. Peterson based on research in the United States.

10. "1. The theatrical event is a set of related transactions. 2. All the space is used for the performance. 3. The theatrical event can take place either in a totally transformed space or in a "found space". 4. Focus is flexible and variable. 5. All production elements speak their own language. 6. The text need be neither the starting point nor the goal of the production. There may be no text at all." Richard Schechner, "6 Axioms for Environmental Theatre", *The Drama Review* 12, No. 3 (1968): 41-64.

11. Peter Eversmann, *De ruimte van het theater. Een studie naar de invloed van de theaterruimte op de beleving van voorstellingen door de toeschouwer* (Amsterdam: s.n., 1996), 154.

12. *Ibid.*, 154.

13. See text box *Perzen* by Hollandia, Chapter 2.

14. Dries Verhoeven. "You are here".
 https://driesverhoeven.com/en/project/u-bevindt-zich-hier/; last accessed 3 June 2021.

15. "About us", Theater Artemis, https://artemis.nl/en/company/about-us/; last accessed 12 March 2021.

16. Anita Twaalfhoven, "Hoezo is er geen verhaal? Er zijn wel vijf verhaallijnen!"
 Trouw, 18 September 2018, https://www.trouw.nl/cultuur-media/hoezo-is-er-
 geen-verhaal-er-zijn-wel-vijf-verhaallijnen~be8d9d64/ (transl. by authors).
17. CKV stands for 'Culturele en Kunstzinnige Vorming', in English best trans-
 lated as Cultural and Artistic Education.

Illustration acknowledgements

Bibliography

Aeschylus, Peter Burian, and Alan Shapiro. *The Complete Aeschylus*. Vol. II: *Persians and Other Plays*. Greek Tragedy in New Translations, 31-109. New York: Oxford University Press, 2009.

Aristoteles. *Poëtica*. Transl., introd. and annot. by Piet Gerbrandy and Casper de Jonge. Groningen: Historische Uitgeverij, 2017.

Aristoteles. *Poetik*. Transl. by Manfred Fuhrmann. Stuttgart: Reclam, 1982.

Aristotle et al. *Poetics*. New edition, revised by Donald A. Russell. Cambridge, MA: Harvard University Press, 1995.

Aronson, Arnold. "Postmodern Design". *Theatre Journal* 43, No. 1 (1991): 1-13.

Aronson, Arnold. *Looking into the Abyss. Essays on scenography*. Ann Arbor, MI: University of Michigan Press, 2005.

Artaud, Antonin. "The Theatre of Cruelty". In *Theatre and Its Double*, transl. by Victor Corti, 63-71. London: Alma Classics, 2010.

Babbage, Frances. *Augusto Boal*. London: Routledge, 2004.

Belfiore, Elizabeth. "Aristotele's Concept of Praxis in the Poetics". *The Classical Journal* 79, No. 2 (1983): 110-124.

Benjamin, Walter. "The Task of the Translator". In *Selected writings*. Vol. 1: *1913-1926*, eds. Marcus Bullock and Michael W. Jennings, 253-263. Cambridge, MA: Harvard University Press, 2004.

Benjamin, Walter. "What is Epic Theatre? [Second Version]". In Walter Benjamin. *Understanding Brecht*, transl. by Anna Bostock, 15-22. London, New York: Verso, 1983.

Berg, Simon van den. "Dertig jaar Discordia. 'We hebben natuurlijk wel het een en ander uitgevonden'". *Theatermaker* (April 2012): 10-14.

Bishop, Claire. *Artificial Hells. Participatory Art and the Politics of Spectatorship*. London, New York: Verso, 2012.

Blokdijk, Tom. *Blokboek. Blokschijf. Tom Blokdijk over theater. 1970-nu*. Amsterdam: Theaterinstituut Nederland, 2007.

Boal, Augusto. *Theatre of the Oppressed*. London: Pluto Press, 2008.

Boenisch, Peter M. "Acts of Spectating. The Dramaturgy of the Audience's Experience in Contemporary Theatre." In *New Dramaturgy. International Perspectives on Theory and Practice*, eds. Katalin Trencsényi and Bernadette Cochrane, 225-241. London: Bloomsbury, 2014.

Boer, Lodewijk de. "De herinnering". In Lodewijk de Boer. *De herinnering. Drie toneelstukken*, 213-278. Amsterdam: De Bezige Bij, 2005.

Bont, Ad de. *Mirad, een jongen uit Bosnië*. Amsterdam: De Nieuwe Toneelbibliotheek, 1993.

Bourdieu, Pierre. *The Field of Cultural Production. Essays on Art and Literature*. Cambridge: Polity Press, 1993.

Brecht, Bertolt. "The Street Scene. A Basic Model for an Epic Theatre". In *Brecht on Theatre. The Development of an Aesthetic*, ed. and transl. by John Willett, 121-129. London: Eyre Methuen, 1974.

Brecht, Bertolt, "The Modern Theatre is the Epic Theatre (Notes to the opera *Aufstieg und Fall der Stadt Mahagonny*)". In *Brecht on Theatre. The Development of an Aesthetic*, ed. and transl. by John Willett, 33-42. London: Eyre Methuen, 1974.

Broek, Andries van den. *Kunstminnend Nederland? Interesse en bezoek, drempels en ervaringen. Het culturele draagvlak, deel 12*. Den Haag: Sociaal en Cultureel Planbureau, 2013.

Brook, Peter. *The Empty Space*. London: Penguin Books, 1972 [1968].

Burian, Jarka M. *Leading Creators of Twentieth Century Czech Theatre*. London, New York: Routledge, 2013.

Chemers, Michael Mark. *Ghost Light. An Introductory Handbook for Dramaturgy*. Carbondale, IL: Southern Illinois University Press, 2010.

Cousijn, Marian. "Waarom iedereen zich tegenwoordig curator noemt (en of dat erg is of niet)". *De Correspondent*, 27 januari 2016. https://decorrespondent.nl/3941/waarom-iedereen-zich-tegenwoordig-curator-noemt-en-of-dat-erg-is-of-niet/513180381098-6f8e30ab.

Crombez, Thomas. *Het antitheater van Antonin Artaud. Een onderzoek naar de veralgemeende artistieke transgressie toegepast op het werk van Romeo Castellucci en de Societas Raffaello Sanzio*. Ghent: Academia Press, 2008.

Decroux, Étienne. *Words on mime*. Transl. by Mark Piper. Claremont: Pomona College Theatre Department for the Claremont Colleges, 1985.

Delgado-García, Cristina. *Rethinking Character in Contemporary British Theatre: Aesthetics, Politics, Subjectivity*. Berlin/Boston, MA: De Gruyter, 2015.

Detken, Anke. *Im Nebenraum des Textes. Regiebemerkungen in Dramen des 18. Jahrhunderts*. Tübingen: Niemeyer, 2009.

Diderot, Denis. *Paradox of Acting*. Transl. by Walter Herries Pollock. Createspace Independent Publishing Platform, 2015.

Dieho, Bart, ed., Sanne Thierens, Sandra Verstappen and Jeroen van Wijhe. *De Nederlandse musical. Emancipatie van een fenomeen*. Amsterdam: International Theatre & Film Books, 2018.

Dieho, Bart. *Een voortdurend gesprek. De dialoog van de theaterdramaturg*. Amsterdam, Utrecht: International Theatre & Film Books/HKU, 2009.

Dieleman, Cock, and Peter Eversmann. *Podiumkunsten in de cultureel-maatschappelijke infrastructuur*. Utrecht: Landelijk Kennisinstituut Cultuureducatie en Amateurkunst, 2018.

Dieleman, Cock, and Veronika Zangl. "Challenging Grand Narratives: Performing canonical texts in Dutch TYA". *Youth Theatre Journal* (16 april 2019): 1-12, https://doi.org/10.1080/089 29092.2019.1582443.

Dieleman, Cock. "De moeizame samenwerking tussen jeugdtheater en basisonderwijs in Nederland." *Cultuur + Educatie* 36 (2013): 26-40.

Dijkwel, Marieke, Simone van Hulst and Tobias Kokkelmans. *De taal van de toeschouwer*. Amsterdam: De Nieuwe Toneelbibliotheek, 2017.

Eén familie, acht tragedies. Aischylos. Sofokles. Euripides, transl. by Gerard Koolschijn. Amsterdam: Athenaeum/Polak & Van Gennep, 1999.

Erenstein, R. L. ed. *Een theatergeschiedenis der Nederlanden. Tien eeuwen drama en theater in Nederland en Vlaanderen.* Amsterdam: Amsterdam University Press, 1996.

Esslin, Martin. *The Field of Drama. How the signs of drama create meaning on stage and screen.* London: Methuen Drama, 1987.

Etty, Elsbeth. "De namen der gevallenen". *NRC,* 4 May 2010, 7.

Eversmann, Peter. *De ruimte van het theater. Een studie naar de invloed van de theaterruimte op de beleving van voorstellingen door de toeschouwer.* Amsterdam: s.n., 1996.

Finter, Helga. "Experimental Theatre and Semiology of Theatre: The Theatricalisation of Voice", transl. by E. A. Walker and Kathryn Grardal. *Modern Drama* 26 (1983): 501-517.

Fischer-Lichte, Erika. *The Semiotics of Theater.* Transl. by Jeremy Gaines and Doris L. Jones. Bloomington, IN: Indiana University Press, 1992.

Foster, E. M. *Aspects of the Novel.* New York: Penguin Books, 1962.

Freriks, Kester. "Tranen op het toneel; De acteur en de geloofwaardigheid van zijn emoties; Extreme gevoeligheid heeft een slechte invloed op acteerprestaties". *NRC,* 9 September 1994.

Fuchs, Elinor. *The Death of Character. Perspectives on Theater after Modernism.* Bloomington, IN: Indiana University Press, 1996.

Gadamer, Hans-Georg. *Gesammelte Werke. Hermeneutik II: Wahrheit und Methode.* Tübingen: Mohr, 1993.

Georgelou, Konstantina, Efrosini Protopapa and Danae Theodoridou, eds. *The Practice of Dramaturgy. Actions in Performance.* Amsterdam: Valiz, 2017.

Groot Nibbelink, Liesbeth. "Jan Wolkers of het wollen dekentje." In *Het ligt in uw handen. Over de rol van de toeschouwer in hedendaags theater,* eds. Sonja van der Valk and Cecile Brommer, 5-21. Amsterdam: Domein voor de Kunstkritiek/Theaterschrift Lucifer, 2008.

Grotowski, Jerzy. *Towards a Poor Theatre,* ed. Eugenio Barba. New York: Routledge, 2002.

Grunberg, Arnon. "Scherp als een stanleymes, alledaags als zeepsop". *De Groene Amsterdammer,* 21 November 2018, https://www.groene.nl/artikel/scherp-als-een-stanleymes-alledaags-als-zeepsop.

The Hamburg Dramaturgy by G. E. Lessing. A New and Complete Annotated English Translation, ed. Natalya Baldyga, transl. by Wendy Arons and Sara Figal. London: Routledge, 2018.

Heijer, Jac. "Stijl. Theater met feilloos gevoel voor schoonheid. Stijl door Onafhankelijk Toneel [*NRC Handelsblad,* 18 maart 1980]". In *Jac Heijer. Een keuze uit zijn artikelen,* selected by Judith Herzberg, Gerrit Korthals Altes, Michael Matthews and Jan Ritsema, 350-352. Amsterdam: International Theatre & Film Books, 1994.

Herzberg, Judith, "The Wedding Party". In *Dutch and Flemish plays,* ed. Della Couling, 63-120. London: Hern, 1997.

Horace. *Satires. Epistles. The Art of Poetry.* Transl. by H. Rushton Fairclough. Cambridge, MA: Harvard University Press, 2014.

Horváth, Ödön van. "Hin und her". In Ödön von Horváth. *Prosa und Stücke,* 920-984. Frankfurt am Main: Suhrkamp, 2008.

Howard, Pamela. "What is Scenography? Or what's in a name". *Theatre Design and Technology* 37, No. 3 (2001): 13-17.

Hulfeld, Stefan, ed. *Scenari più scelti d'istrioni. Italienisch-Deutsche Edition der einhundert Commedia all'improvviso-Szenarien aus der Sammlung Corsiniana.* Göttingen: Vienna University Press bei V&R unipress, 2014.

Hulfeld, Stefan. "Einführung in die Lektüre der *Scenari più scelti d'istrioni*". In *Scenari più scelti d'istrioni. Italienisch-Deutsche Edition der einhundert Commedia all'improvviso-Szenarien aus der Sammlung Corsiniana,* ed. Stefan Hulfeld, 9-112. Göttingen: Vienna University Press bei V&R unipress, 2014.

Jans, Erwin. "Drama na het drama? Een overzicht van postdramatische theaterteksten in Vlaanderen". In *Het statuut van de tekst in het postdramatische theater,* eds. Claire Swyzen and Kurt Vanhoutte, 53-68. Brussel: UPA/Research Centre for Visual Poetics, 2011.

Jans, Erwin. *Interculturele intoxicaties. Over kunst, cultuur en verschil.* Berchem: EPO, 2006.

Jelinek, Elfriede. *Die Schutzbefohlenen; samt Appendix; Coda, Europas Wehr. Jetzt staut es sich aber sehr! (Epilog auf dem Boden); Ende (4.3.2016) sowie Philemon und Baucis (05.04.2016).* Reinbek: Rowohlt Theater Verlag, 2019.

Jelinek, Elfriede. *Charges (The Supplicants).* Transl. by Gitta Honegger. London, New York, Calcutta: Seagull Books, 2016.

Jelinek, Elfriede. *Grensgeval. Coda,* adapt. and transl. by Tom Kleijn. 2016 (script).

Jones, John. *On Aristotle and Greek Tragedy.* London: Chatto & Windus, 1962.

Kennedy, Dennis. *Looking at Shakespeare. A visual history of twentieth-century performance.* Cambridge: Cambridge University Press, 2001.

Kerkhoven, Marianne van. "De drager van het verhaal. Over monologen". In *Van het kijken en van het schrijven. Teksten over theater,* ed. Peter Anthonissen et al., 171-179. Leuven: Van Halewyck, 2002.

Kerkhoven, Marianne van. "Een reis in de ruimte/een wereld zonder middelpunt". In *Van het kijken en van het schrijven. Teksten over theater,* ed. Peter Anthonissen et al., 65-79. Leuven: Van Halewyck, 2002.

Kerkhoven, Marianne van. "Het gewicht van de tijd". In *Van het kijken en van het schrijven. Teksten over theater,* ed. Peter Anthonissen et al., 47-57. Leuven: Van Halewyck, 2002.

Kerkhoven, Marianne van. "Het theater ligt in de stad en de stad ligt in de wereld en de wanden zijn van huid". In *Van het kijken en van het schrijven. Teksten over theater,* ed. Peter Anthonissen et al., 137-143. Leuven: Van Halewyck, 2002.

Kerkhoven, Marianne van. "Kijken zonder potlood in de hand". In *Van het kijken en van het schrijven. Teksten over theater,* ed. Peter Anthonissen et al., 127-129. Leuven: Van Halewyck, 2002.

Kerkhoven, Marianne van. "Looking without a pencil in the hand". *Theaterschrift. On dramaturgy* 5-6 (1994): 140-149.

Kerkhoven, Marianne van. "Over kritiek". In *Van het kijken en van het schrijven. Teksten over theater,* ed. Peter Anthonissen et al., 95-99. Leuven: Van Halewyck, 2002.

Kerkhoven, Marianne van. "Samenvallen met wat je denkt". In *Van het kijken en van het schrijven. Teksten over theater,* ed. Peter Anthonissen et al., 181-189. Leuven: Van Halewyck, 2002.

Kerkhoven, Marianne van. "Van de kleine en de grote dramaturgie". In *Van het kijken en van het schrijven. Teksten over theater,* ed. Peter Anthonissen et al., 197-203. Leuven: Van Halewyck, 2002.

Kerkhoven, Marianne van. "Vervaging aller grenzen". In *Van het kijken en van het schrijven. Teksten over theater,* ed. Peter Anthonissen et al., 23-33. Leuven: Van Halewyck, 2002.

Kerkhoven, Marianne van. "Werkverslag. Hoofdstuk 1: Nuanceren. Over het innemen van standpunten". In *Van het kijken en van het schrijven. Teksten over theater,* ed. Peter Anthonissen et al., 241-263. Leuven: Van Halewyck, 2002.

Kerkhoven, Marianne van. *Van het kijken en van het schrijven. Teksten over theater,* ed. Peter Anthonissen et al. Leuven: Van Halewyck, 2002.

Klinkenberg, Rob. *Drie kluiten op een hondje. Klein lexicon van het theater.* Amsterdam: International Theatre & Film Books, 2005.

Kolesch, Doris, and Jenny Schrödl. *Kunst-Stimmen.* Berlin: Theater der Zeit, 2004.

Kolesch, Doris, and Sibylle Krämer, eds. *Stimme: Annäherung an Ein Phänomen.* Frankfurt am Main: Suhrkamp, 2006.

Kolesch, Doris, and Sybille Krämer. "Stimmen im Konzert der Disziplinen". In *Stimme. Annäherung an ein Phänomen,* eds. Doris Kolesch and Sybille Krämer, 7-15. Frankfurt am Main: Suhrkamp, 2006.

Kolesch, Doris. "Shakespeare hören. Theatrale Klangwelten in der griechischen Antike, zu Zeiten Shakespeares und in gegenwärtigen Shakespeare-Inszenierungen". *Shakespeare Jahrbuch (Shakespeares Klangwelten)* 144 (2008): 11-27.

Kwinter, Sanford. "The Reenchantment of the Interior. Olafur Eliasson's Weather Project". *Harvard Design Magazine,* No. 29 (2008): 70-74.

Laera, Margherita. *Theatre and Adaptation: Return, Rewrite, Repeat.* London: Bloomsbury, 2014.

Lang, Theresa. *Essential Dramaturgy. The Mindset and the Skillset.* New York & London: Routledge, 2017.

Langen, Marijn de. "Geräuschemacher, Klangkünstler und Musikarchitekten". *Theater der Zeit (Holland Flandern Spezial)* 9 (September 2001): 32-34.

Langen, Marijn de. "Mime denken. Nederlandse mime als manier van denken in en door de theaterpraktijk". Dissertation, Universiteit Utrecht 2017.

Leabhart, Thomas. *Modern and Post-Modern Mime.* Basingstoke: Macmillan Education, 1989.

Lecoq, Jacques. *Theatre of Movement and Gesture,* ed. David Bradby. London: Routledge, 2006.

Leeuw, Saskia de. "Peter Sjarov – 'Grootmeester Van Het Detail' in Nederland". Doctoraalscriptie, Universiteit van Amsterdam, 1989.

Lehmann, Hans-Thies. *Postdramatic Theatre.* Transl. by Karen Jübs-Munby. London, New York: Routledge, 2006.

Lehmann, Hans-Thies. *Postdramatisches Theater.* Frankfurt am Main: Verlag der Autoren, 1999.

Lessing, Gotthold Ephraim. *Hamburgische Dramaturgie.* Stuttgart: Reclam jun., 1981.

Luckhurst, Mary. *Dramaturgy: A Revolution in Theatre.* Cambridge: Cambridge University Press, 2006.

Maanen, Hans van. *Het Nederlandse toneelbestel van 1945 tot 1995.* Amsterdam: Amsterdam University Press, 1997.

MacKinney, Joslin, and Philip Butterworth. *The Cambridge Introduction to Scenography.* Cambridge: Cambridge University Press, 2009.

Marx, Peter W. ed. *Handbuch Drama. Theorie, Analyse, Geschichte.* Stuttgart, Weimar: Metzler, 2012.

Matzke, Annemarie. *Arbeit am Theater. Eine Diskursgeschichte der Probe.* Bielefeld: Transcript, 2012.

Meerkerk, Edwin van, and Quirijn Lennert van den Hoogen, eds. *Cultural Policy in the Polder. 25 Years Dutch Cultural Policy Act.* Amsterdam: Amsterdam University Press, 2018.

Meyer, Dennis. "1989. Teneeter speelt Ifigeneia Koningskind. Opbloei van het jeugdtheater". In *Een theatergeschiedenis der Nederlanden*, ed. R. L. Erenstein et al., 832-839. Amsterdam: Amsterdam University Press, 1996.

Mitchell, Katie. *The Director's Craft. A Handbook for the Theatre.* New York: Routledge, 2009.

Mitter, Shomit. *Systems of Rehearsal. Stanislavsky, Brecht, Grotowski and Brook.* London: Routledge, 2015.

Mol, Pauline. *Ifigeneia Koningskind.* Amsterdam: De Nieuwe Toneelbibliotheek, 1989.

Mouffe, Chantal. "Art and Democracy. Art as an Agonistic Intervention in Public Space", *Open! Platform for Art, Culture & the Public Domain,* January 1, 2007, https://www.onlineopen.org/art-and-democracy.

Müller, Heiner. "The Hamletmachine", transl. by Carl Weber. *Performing Arts Journal* 4, No. 3 (1980): 141-146.

Müller, Heiner. *Gesammelte Irrtümer. Interviews und Gespräche.* Frankfurt am Main: Verlag der Autoren, 1986.

Ovadija, Mladen. *Dramaturgy of Sound in the Avant-Garde and Postdramatic Theatre.* Montreal: McGill-Queens University Press, 2013.

Panken, Ton. *Een geschiedenis van het jeugdtheater. De ontwikkeling van het kindbeeld in het jeugdtheater. Een historisch-sociologische studie.* Amsterdam: Boom, 1998.

Pavis, Patrice. *Analyzing Performance: Theater, dance, and film.* Ann Arbor, MI: University of Michigan Press, 2006.

Peterson, Richard A. "Understanding Audience Segmentation: From elite and mass to omnivore and univore". *Poetics* 21, No. 4 (1992): 243-258.

Pfister, Manfred. *The Theory and Analysis of Drama.* Cambridge: Cambridge University Press, 1991.

Poschmann, Gerda. *Der nicht mehr dramatische Theatertext. Aktuelle Bühnenstücke und ihre dramaturgische Analyse.* Tübingen: Niemeyer, 1997.

Radosavljević, Duška. *Theatre-Making. Interplay between Text and Performance in the 21st Century.* Basingstoke: Palgrave Macmillan, 2013.

Rancière, Jacques. "The Emancipated Spectator". In *The Emancipated Spectator*, transl. by Gregory Elliott, 6-21. London/New York: Verso, 2009.

Reason, Matthew. *The Young Audience: Exploring and Enhancing Children's Experiences of Theatre*. London: Trentham Books, 2010.

Romanska, Magda, ed. *The Routledge Companion to Dramaturgy*. New York, London: Routledge, 2015.

Schadewaldt, Wolfgang. "Furcht und Mitleid? Zur Deutung des Aristotelischen Tragödiensatzes [1955]". In Wolfgang Schadewaldt, *Antike und Gegenwart: über die Tragödie*, 16-60. München: dtv, 1966.

Schechner, Richard. "6 Axioms for Environmental Theatre". *The Drama Review* 2, No. 3 (1968): 41-64.

Schechner, Richard. *Environmental Theater*. New York: Applause, 1994.

Schrijvers, Erik, Anne-Greet Keizer, and Godfried Engbersen, eds. *Cultuur herwaarderen*. Amsterdam: WRR/Amsterdam University Press, 2015.

Shakespeare, William. *Hamlet*. Ed. Ann Thompson and Neil Taylor. London: Arden Shakespeare/ Bloomsbury, 2006.

Shakespeare, William. *King Richard III*. Ed. James E. Siemon. London: Methuen Drama, 2009.

Sontag, Susan. "Against Interpretation". In *Against Interpretation and Other Essays*, 1-10. London: Penguin, 2009.

Sontag, Susan. "Approaching Artaud". In *Under the Sign of Saturn. Essays*, 13-73. New York: First Vintage Books, 1981.

Spoelstra, Berthe. "De mens is een hompelaar – Een verkenning van de hedendaagse maatstaven waarmee jeugdtheater wordt beoordeeld ". *Theater Schrift Lucifer* 5 (2007): 43-53.

Spregelburd, Rafael. "Life, of Course". *Theatre Journal* 59, No. 3 (2007): 373-377.

Stanislavski, Constantin. *An Actor Prepares*. Transl. by Elizabeth Reynolds Hapgood. London: Bless, 1964.

Stein, Gertrude. "Plays". In *Writings and Lectures 1911-1945*, ed. Patricia Meyerowitz, 58-81. London: Peter Owen, 1967.

Swyzen, Claire, and Kurt Vanhoutte, eds. *Het statuut van de tekst in het postdramatische theater*. Brussel: UPA/Research Centre for Visual Poetics, 2011.

Szondi, Peter. *Theory of Modern Drama*. Cambridge: Polity, 1987.

Theaterschrift. (*On dramaturgy*) 5-6 (1994).

Trencsényi, Katalin, and Bernadette Cochrane, eds. *New Dramaturgy. International Perspectives on Theory and Practice*. London: Bloomsbury, 2014.

Trencsényi, Katalin. *Dramaturgy in the Making. A User's Guide for Theatre Practitioners*. London/ New York: Bloomsbury Methuen Drama, 2015.

Turner, Cathy, and Synne K. Behrndt. *Dramaturgy and Performance*. Basingstoke: Palgrave Macmillan, 2008.

Twaalfhoven, Anita, "Hoezo is er geen verhaal? Er zijn wel vijf verhaallijnen!" *Trouw,* 18 september 2018. https://www.trouw.nl/cultuur-media/hoezo-is-er-geen-verhaal-er-zijn-wel-vijf-verhaallijnen~be8d9d64/

Verhagen, Balthazar. *Dramaturgie.* Amsterdam: Moussault's Uitgeverij 1963 [1927].

Water, Manon van de. *Theatre, Youth, and Culture. A Critical and Historical Exploration.* New York, NY: Palgrave Macmillan, 2012.

Winner, Ellen, Thalia R. Goldstein and Stéphan Vincent-Lancrin. *Art for Art's Sake. The Impact of Arts Education.* Educational Research and Innovation. Paris: OECD Publishing, 2013. https://read.oecd-ilibrary.org/education/art-for-art-s-sake_9789264180789-en

Websites

ICK Amsterdam. "Emio Greco | Pieter C. Scholten". 'Emio Greco | Pieter C. Scholten', https://www.ickamsterdam.com/en/company/choreographers/emio-greco-pieter-c-scholten-1; last accessed 2 December 2019.

In reprise. http://www.inreprise.org/; last accessed 29 December 2019.

Sarma. Laboratory for discursive practices and expanded publication. "Anthology Marianne van Kerkhoven". http://sarma.be/pages/Marianne_Van_Kerkhoven; last accessed 3 June 2021.

Dries Verhoeven. "You are here". https://driesverhoeven.com/en/project/u-bevindt-zich-hier/; last accessed 3 June 2021.

Theater Artemis. "About us", Theater Artemis. https://artemis.nl/en/company/about-us/; last accessed 12 March 2021.

Index

Printed in the United States
by Baker & Taylor Publisher Services